D1179898

# CITY ON EDGE

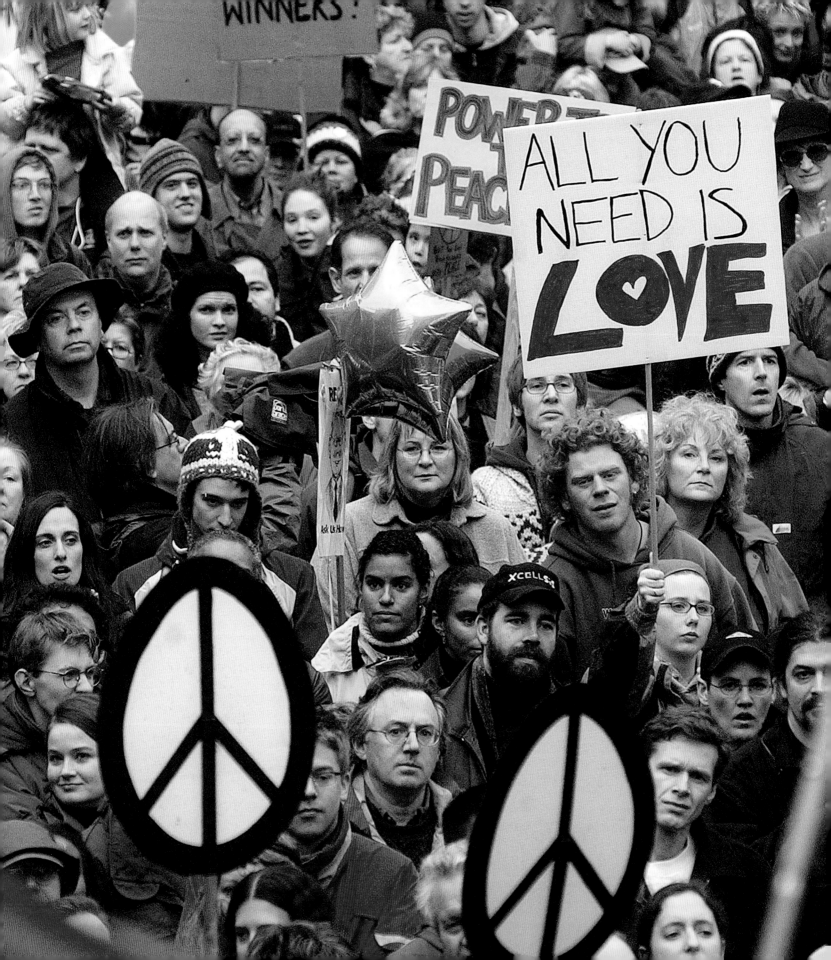

FOREWORD BY **CHARLES DEMERS** KATE BIRD

# CITY ON EDGE

A REBELLIOUS CENTURY OF VANCOUVER PROTESTS, RIOTS, AND STRIKES

GREYSTONE BOOKS
VANCOUVER/BERKELEY

## Acknowledgements

This book would not have been possible without the photojournalists who documented these important moments in history, and without all the people, past and present, who try to make the world a better place.

My gratitude to Harold Munro, Editor-in-Chief of the *Vancouver Sun* and the *Province*, for his support for this project, and my heartfelt appreciation to the fabulous folks at Greystone Books—Rob Sanders, Jennifer Croll, Alice Fleerackers, Peter Cocking, and Jen Gauthier. Thanks also to proofreader Jennifer Stewart, and to John Denniston, who optimized the early-90s digital images.

Bill and Darius—your love and support mean the world to me.

This book is dedicated to my colleagues in the Press Library who, for more than eighty years, labeled, indexed, and filed photographs, negatives, and newspaper articles, catalogued books, created and maintained databases, sold and licensed content, and answered a myriad of research requests for *Vancouver Sun* and *Province* reporters and other staff, on deadline. The legacy of your work endures.

*Frontispiece:* Forty thousand people attended an anti-war protest in Vancouver on February 15, 2003. The peace sign has been a worldwide symbol ever since Gerald Holtom designed it as a logo for the 1958 Campaign for Nuclear Disarmament in Britain. Nick Procaylo/*Province*

Copyright © 2017 by Kate Bird
Foreword copyright © 2017 by Charles Demers

17 18 19 20 21    5 4 3 2 1

All rights reserved. No part of this book may be reproduced, stored in a retrieval system or transmitted, in any form or by any means, without the prior written consent of the publisher or a licence from The Canadian Copyright Licensing Agency (Access Copyright). For a copyright licence, visit www.accesscopyright.ca or call toll free to 1-800-893-5777.

Greystone Books Ltd.
www.greystonebooks.com

Cataloguing data available from Library and Archives Canada
ISBN 978-1-77164-313-9 (cloth)
ISBN 978-1-77164-314-6 (epub)

Editing by Jennifer Croll
Jacket design by Peter Cocking
Interior design by Peter Cocking with Taysia Louie
*Vancouver Sun* and *Province* photos courtesy of Pacific Newspaper Group
Printed and bound in China on ancient-forest-friendly paper by 1010 Printing International Ltd.

We gratefully acknowledge the support of the Canada Council for the Arts, the British Columbia Arts Council, the Province of British Columbia through the Book Publishing Tax Credit, and the Government of Canada for our publishing activities.

# CONTENTS

**CHARLES DEMERS**

# FOREWORD

There is no Canadian big city that feels less like Canada than Vancouver does. Even Montréal, a city that for decades nurtured a literal separatist movement—as well as being pretty much our town's only competition for generalized discontent, rebellion, and hockey-loss-related rioting—feels more tightly knit into the national story than does Lotusland. But that's because when Montréalers rise up against the powers that be, their beef is with the neighbours—ours is with absentee landlords.

Canada is a lot of things, but one of the big ones is a colonial settler project that helped to sell a railroad, and vice versa. Vancouver, Terminal City, was literally the end of the line—as far away as you could be from the capitalist spiders who wove their iron web across the continent, while still being one of the flies. The financial, corporate, and law enforcement authorities that seem so solid, so firmly planted out East have always felt more remote, more contingent out here. Central Canada, centralized authority—I mean, I guess? We'll have to take your word for it. We're from the city whose first labour union was a mostly Indigenous local of the anarcho-syndicalist Industrial Workers of the World, and the waterfront they worked fronted onto the Pacific Ocean rather than the Atlantic—the one treated as a lake owned by white men in top hats.

But if the city is physically marginal to the rest of the country, and marginal in the great sweep of its broader narrative, it has been anything but marginal in terms of providing Canada's rebels, revolutionaries, and outlaws. Somewhere along the way, we got the reputation of being laid-back, which only really applies to sock-sandal combinations and leaving work early on Fridays. Instead, we're the place that gave the rest of the country Chief Dan George, David Suzuki, Greenpeace, Rosemary Brown, and Svend Robinson (who was my MP, all through my childhood and adolescence). We're the town where the On to Ottawa Trek got started, where we stopped the highways from running through downtown, showed the Rolling Stones who the real street-fightin' men were in a gang-manipulated concert riot, filled the streets with an anti-nuclear movement, and elected a mayor on the power of a massive housing squat ("squat" perhaps being a fair word to describe what that mayor proceeded to do for those protesters, but I digress).

When Vancouver is all you've known, protest and rebellion are mother's milk—which is perhaps why my friends and I organized a walkout from our high school on International Human Rights Day in grade eleven, to protest Canada's complicity in the genocide in East Timor. Our placards were provided by Jaggi Singh (my pal, but viewed by my vice-principal as an outside agitator), who went on to a great deal of prominence a short while later when the APEC police riot broke out (I wasn't there, but don't tell anybody). Still, I spent my early twenties illegally pasting posters for anti-war rallies up and down the streets of the most beautiful city in the world.

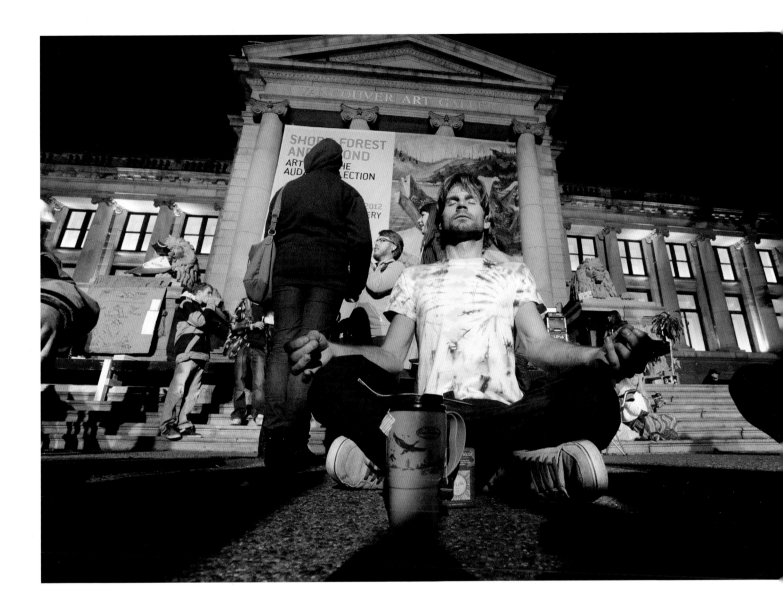

Everyone who lives outside of Vancouver thinks it's peaceful here, but nobody who truly knows (or, I would venture, truly loves) the city falls for that. Class war, gang war, colonialism and its discontents; there's some core, kinetically unsettled truth about Vancouver, which is not to say the city can't change: over the course of our first century, give or take a few years, we went from anti-Asian race riots to multiracial hockey riots. Vancouverite or not, you've gotta admit that's progress. We've learned at least a few lessons from our decades of upheaval, and taught a few to the stuffed suits back East, to boot.

Protesters, including Jared Eglinski, camped on the north plaza of the Vancouver Art Gallery on October 17, 2011, during Occupy Vancouver, a global movement against economic inequality and corporate greed. Stuart Davis/PNG

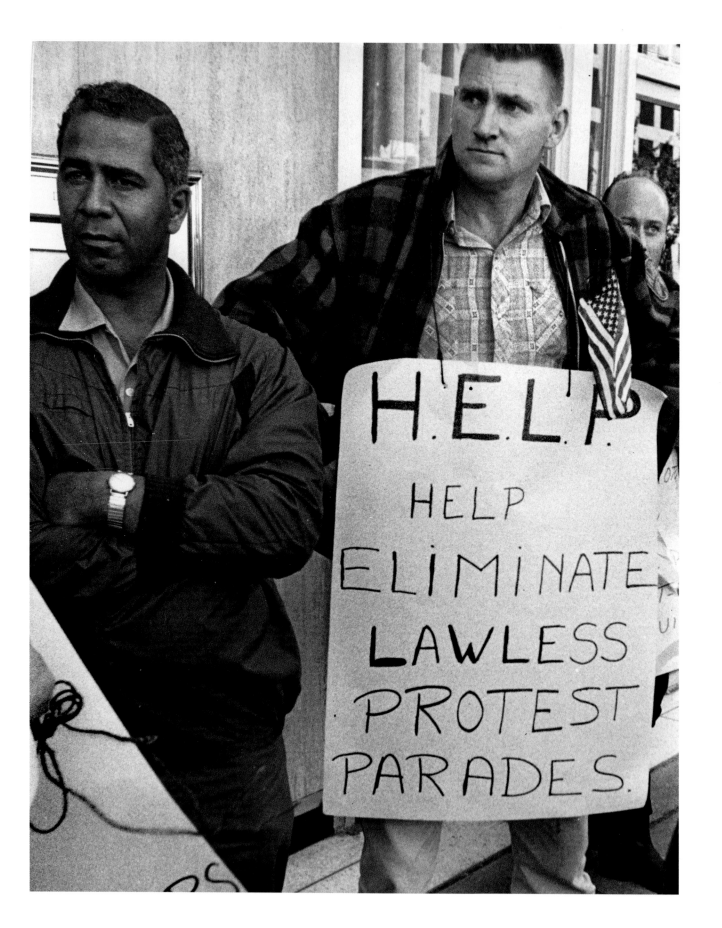

CITY ON EDGE

Vancouver has long been a city on edge. From the 1907 anti-Asian race riot to the 1971 Amchitka protests, the 1946 occupation of the Hotel Vancouver by homeless Second World War veterans to the 2011 Stanley Cup riot and the 2016 pipeline protest, Vancouver has a rich history of making its viewpoints known and, in some cases, felt.

The motto on Vancouver's coat of arms, "By Sea Land and Air We Prosper," encapsulates the city's history as a working person's coastal seaport—a city of fishers and fish packers, shipbuilders and sailors, loggers and millworkers, farmworkers, longshoremen, and factory workers—defined by a strong legacy of union activism. Beneath its genteel veneer, behind its glittering city-of-glass backdrop of majestic mountains and shimmering ocean, lives Vancouver's dark and scrappy on-the-waterfront soul.

In a 2012 B.C. Day piece, *Vancouver Sun* columnist Stephen Hume wrote, "We're not a placid people here. We never were and we never will be." Hume was right: our reputation as rough-and-ready rabble-rousers with a predisposition to dissent is well earned. Amor de Cosmos, one of our province's early premiers, noted: "I would not object to a little revolution now and again in British Columbia, after Confederation, if we were treated unfairly; for I am one of those who believe that political hatreds attest the vitality of the state."

And oh, how we have risen to the challenge. It seemingly doesn't take much for our volcanic temper to boil over and erupt, and for the brooding grudges and festering grievances we harbour to surface. Laid-back Vancouver? Hardly. Protests—and their close cousins, riots—are in our DNA.

Vancouver has often been at the vanguard of protest activism. In 1970, the Vancouver Women's Caucus organized the Abortion Caravan, Canada's first national feminist protest, and the 1993 blockade to protest MacMillan Bloedel's plan to log Clayoquot Sound became the largest act of civil disobedience in Canadian history at the time. Violent labour clashes and protest demonstrations throughout the city's history have left hundreds bloodied but unbowed—the sacrifice of a few for the sake of many.

Greenpeace founding member Bob Hunter, a former reporter for the *Vancouver Sun*, was once asked why the environmental organization evolved in Vancouver, of all places. He replied that Vancouver had "the biggest concentration of tree-huggers, radicalized students, garbage-dump stoppers, shit-disturbing unionists, freeway fighters, pot smokers, ageing Trotskyites, condo killers, farmland savers, fish preservationists, animal rights activists, back-to-the-landers, vegetarians, nudists, Buddhists, and anti-spraying, anti-pollution marchers and picketers in the country, and per capita, in the world."

But what is it that makes Vancouver so prone to protest?

Perhaps it has something to do with being Terminal City, the last stop for free spirited souls heading west and a melting pot of Pacific Rim and South Asian

*Facing:* On May 30, 1970, while several hundred protesters demonstrated against the Vietnam War, Frank Vogel protested against protest demonstrations. Ross Kenward/*Province*

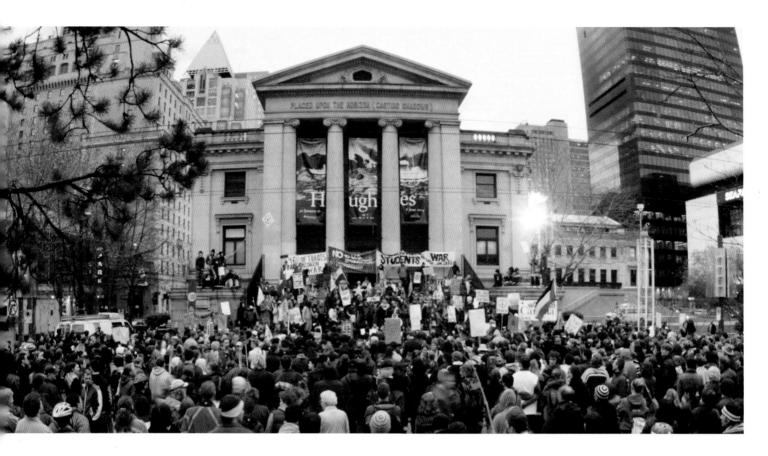

immigrants from the east, all pursuing dreams of a better life in Lotusland. Or it could be that there's a restlessness in this city of newcomers and transients where the Vancouver-born are the minority, and the roots we've planted are still tenuous, don't go deep enough, haven't taken.

You can put it down to geography—specifically to the Rocky Mountains, which have cut us off, sometimes insulated and other times isolated us, and set us apart as distinct from the rest of Canada and even Western Canada, relegating us to the periphery of federal politics. Divides within the city play their role, too; the schism between the city's haves and the have-nots—"West Van Morrison" versus "East Van Halen"—is deep and ever-widening, and has given rise to divisive protests about poverty, unemployment, urban development, and housing for a century. But our discontent could also be a perpetual case of western alienation, an estrangement from emotionally

distant eastern Canada, which treats us as zany Wild West Van-coo-coo, especially compared to Toronto the Good.

Or maybe it's just the weather—the lack of sunshine, or the rain, the rain, the rain—that makes us so ornery.

You can argue, too, that Vancouverites have always felt more ideologically and temperamentally aligned with Cascadian left coasters to the south. Ideas and tactics for protest demonstrations have flowed north from the U.S. for a century, from the Industrial Workers of the World, who found support with resource workers in the early 1900s, to American draft resisters, who got involved in local politics and joined the faculties of UBC and SFU in the 1960s, to radical groups whose direct action tactics inspired local militants in the 1980s.

Physical divides have crept into our thinking, as well. Our politics are polarized between left and right, between urban and suburban, and we tend to dislike

On March 19, 2003, people gathered at the Vancouver Art Gallery, Vancouver's primary protest site, to demonstrate against the start of the U.S. war in Iraq. Arlen Redekop/*Province*

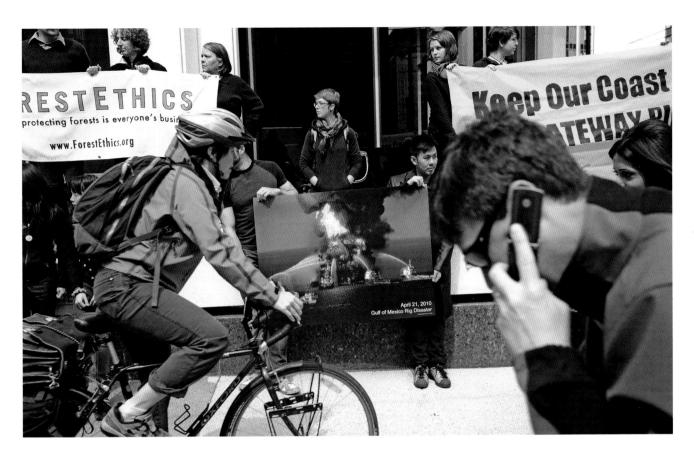

the politicians we elect. Anti-government sentiment fuels protests about hot-button issues such as immigration and refugees, the environment, reproductive rights, taxation, the economy, assisted suicide, and crime. Early anti-militarism by pacifist groups such as the Doukhobors during the Second World War was the precursor to large demonstrations: Vietnam War protests in the 1960s, peace marches in the 1980s, and anti–Iraq War protests in 2003. Vancouver's peace activism endures to the present day.

Vancouver's diversity also makes us keen supporters of human rights: the fight for equality for women, the LGBTQ community, the disabled, First Nations and other ethnic communities, and religious groups continues to bring people out into the streets to fight for justice. Youth and students—from children protesting the price of a candy bar in 1947 to 10,000 Lower Mainland school kids demonstrating against the Amchitka nuclear test—have been at the fore-

front of activism. And in our multicultural city, immigrants from countries around the globe protest for justice and improved conditions in their homelands where, in some cases, protesting can get you jailed or even killed.

The economy plays a role, too. Vancouver, historically, has been a resource-based city, and protests, riots, and strikes due to militant unionism have been a constant. From a strike by salmon fishermen in 1900, to longshoremen strikes in 1935 and 1949, to job action by forest industry workers, miners, teachers, health care workers, and municipal, provincial, and federal government employees of all descriptions, workers have made their voices heard. May Day, a day of labour solidarity first observed more than a century ago, remains an annual Vancouver event.

Most protest demonstrations here are orderly, if not necessarily peaceful—but there have been times when, due to unforeseen forces, volatile conditions,

Greenpeace activists protested the proposed oil exploration and tanker project on B.C.'s coast outside Enbridge's Northern Gateway pipeline offices on May 5, 2010. Jason Payne/PNG

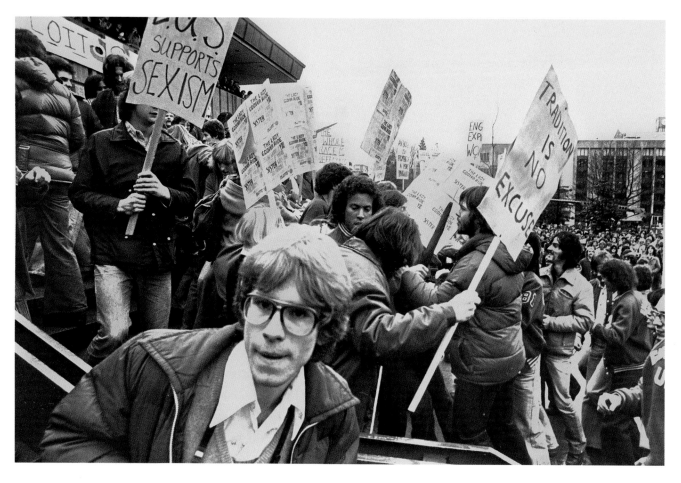

an angry mob mentality, or political or other motives, protests have turned into riots. A 1907 meeting of the Asiatic Exclusion League inflamed racist fury, which ignited a violent rampage targeting businesses in Chinatown and Japantown. In 1935, a long-standing and acrimonious conflict between striking longshoremen and law enforcement incited a violent three-hour confrontation known as the Battle of Ballantyne Pier. At a pro-marijuana smoke-in at Maple Tree Square in 1971, the police's heavy-handed crowd control tactics provoked the Gastown Riot.

But not all of Vancouver's riots have been rooted in social strife. A unique form of homegrown hooliganism, more wantonly destructive than revolutionary, has evolved and flourished here—from Halloween and park gang rumbles, to Rolling Stones and Guns N' Roses concert riots, to the Grey Cup and Stanley Cup riots. Are our sports and music riots due to No Fun City boredom, or are they a destructive catharsis for disenfranchised people who have lost their civic pride? Perhaps being called pretty but vacuous, a bimbo of a city, provokes us into showing how badass we really are? Or maybe it's just, in the words of Yippie leader Abbie Hoffman, "revolution for the hell of it." Whatever the reason, these riots are part of who we are.

Evidence of Vancouver's seemingly perpetual state of unrest fills the Pacific Newspaper Group's photograph collection. Some of the photographs in this book originated as hard copy prints that have languished in photo files since the 1930s and 1940s, as crisp and unfaded as the day they were printed. But negatives for some 1950s and 1960s photo assignments also reveal images that never saw the light of day; while the smiling face of a visiting politician graced the front

*Sun* photographer Mark van Manen (foreground) covered a 1978 protest against the UBC engineering students' annual Lady Godiva Ride. **George Diack/***Vancouver Sun*

page of the newspaper, hidden amongst the negatives were images of placard-waving protesters.

Some folks believe the glory days of protest demonstrations are in the past and that clicktivism has reduced activism to social media and online petitions, but *Vancouver Sun* and *Province* photojournalists still shoot dozens of protests every year. On November 19, 2016, 5,000 Vancouverites marched to protest Prime Minister Justin Trudeau's approval of the Trans Mountain pipeline expansion. And on January 21, 2017, more than 15,000 demonstrated in support of the Women's March on Washington, a global protest advocating for women's rights in the wake of Donald Trump's inauguration as U.S. president.

Vancouver's protest culture, born from our rebellious and turbulent history, is bred into our city's blood; our citizens' passionate engagement with a wide range of social and political issues, from hyperlocal to global, cannot be denied. And while a simmering opposition to authority in this city of extremes can take us to the edge and sometimes over, at the heart of our city's culture of resistance is the utopian ideal of social order and peace and the desire for community belonging. It is this optimistic idealism that drives Vancouverites to continually show up, step up, and seek a better path— and a better world—in our own fiercely independent West Coast way.

## A Note on the Photographs

In the early 1900s, newspapers published international news on the front page, covering politics, war, royalty, and disasters, with local news appearing on inside pages. News events were often depicted by cartoons and illustrations, as on the May 1, 1909, front page—"*Province* artist Fitz-Maurice pictures the events of the week in cartoon"—while the few published photographs, supplied by photo agencies, ran in the entertainment and sports sections.

And while the *Vancouver Sun* and *Province* reported on many local protests, riots, and strikes in the early 1900s, most articles appeared without photographs. It was difficult to acquire local photos in a timely manner back then, and the technical ability to print them in the newspaper was in its infancy. That is why it is so remarkable that on September 9, 1907, the *Province* published three photographs of the anti-Asian race riot that rocked Vancouver's Chinatown and Japantown on September 7. Those images, like so many others, are now lost to history. The Press Library wasn't established until the 1930s, and photos taken after that time weren't always filed to the Library; others were misfiled, lost, or stolen over the years. In the few cases where *Sun* or *Province* photographs no longer exist, archival images from other sources have been included in this book.

By the 1920s, newspapers began to publish more photographs, and local studio photographers, who owned their own photographic equipment, sold freelance photographs to the *Sun* and *Province*. The newspapers first employed staff photographers in the 1930s, and while photo credits such as "Staff Photographer" or "*Sun* Cameraman" sometimes appeared in captions, it took until the late 1930s before photographers' names were published. Throughout *City on Edge,* photographer credits are included whenever known. These days, photography departments at newspapers are shrinking. In 2010, to reduce duplicate photo assignments and optimize the deployment of staff photographers for the 2010 Winter Olympics in Vancouver, the photography departments at the *Vancouver Sun* and the *Province* merged, and the credit PNG (Pacific Newspaper Group) is used.

In 1995, the *Vancouver Sun* and the *Province* became the first newspapers in North America to switch entirely to digital cameras. As the technical quality of these early digital photographs is poor, former *Province* photographer and photo editor John Denniston did his best to optimize them for publication.

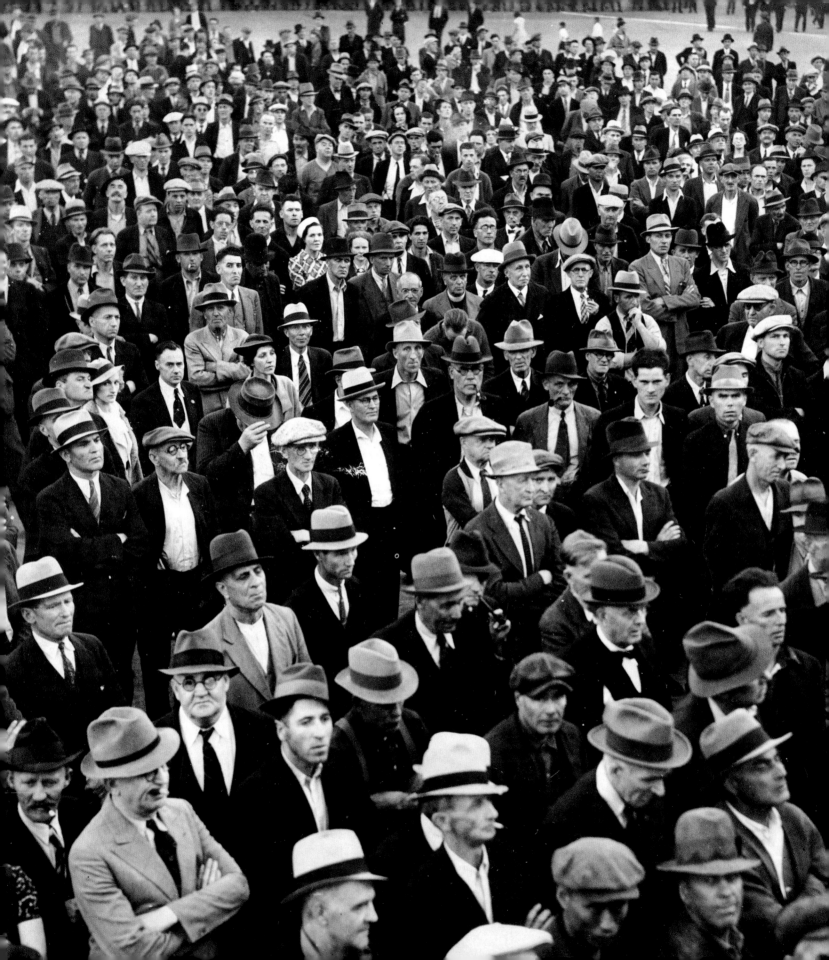

# 1900–39

Immigration, freedom of speech, labour activism, and First Nations land claims: unrest in the first three decades of the twentieth century was spurred by issues that persist to this day.

Federal immigration policies sparked racist reactions which led to the 1907 anti-Asian riot and the 1914 *Komagata Maru* incident. There was a strike by salmon fishermen in 1900, general strikes in 1918 and 1919, Chief Joe Capilano petitioned King George VII for aboriginal land title in 1906, and in 1935 Mayor McGeer read the riot act at Victory Square.

When homeless unemployed men occupied the Hotel Georgia, the Art Gallery, and the Post Office in 1938, they garnered wide public support for their plight, including this *Vancouver Sun* editorial, which begins:

*Since last Friday certain public and semi-public buildings in Vancouver have been invaded and occupied by a host of unemployed men who have drifted into Vancouver from many Canadian points. This invasion and this occupation were not unforeseen. Ever since the forestry camps closed and jobless men, disinherited by the Federal Government whose responsibility they are, commenced to gather in this city, it has been plain that, unless Ottawa awakened to its obvious duty, some sort of lawlessness was bound to ensue. So far these men have exhibited amazing restraint. They have demonstrated, of course, a deep contempt for Government and their actions have given Vancouver much unfavourable publicity throughout the continent. But the contempt for Government they have exhibited is not very much greater than that felt by the average citizen. What the foreign news services and foreign broadcasting stations have been saying about this situation is not very much stronger than what Vancouver people have themselves been saying about Ottawa.*

On June 19, after a month-long occupation, the RCMP used tear gas and billy clubs to forcibly evict the Post Office sit-downers, and later that day 10,000 citizens protested police brutality.

*Facing:* On May 26, 1938, 4,000 people at the Powell Street Grounds listened to speakers, including Alderwoman Helena Gutteridge, and showed support for the unemployed men, known as sit-downers, occupying the Post Office, the Vancouver Art Gallery, and the Hotel Georgia to protest for government relief. **W.B. Shelly/*Vancouver Sun***

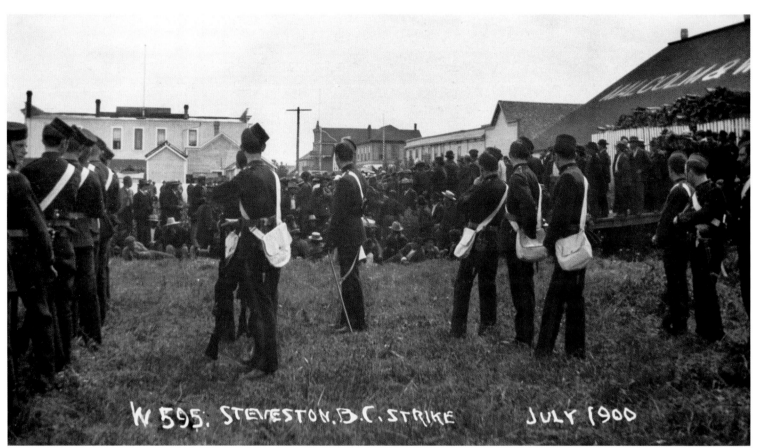

W 595. STEVESTON. B.C. STRIKE          JULY 1900

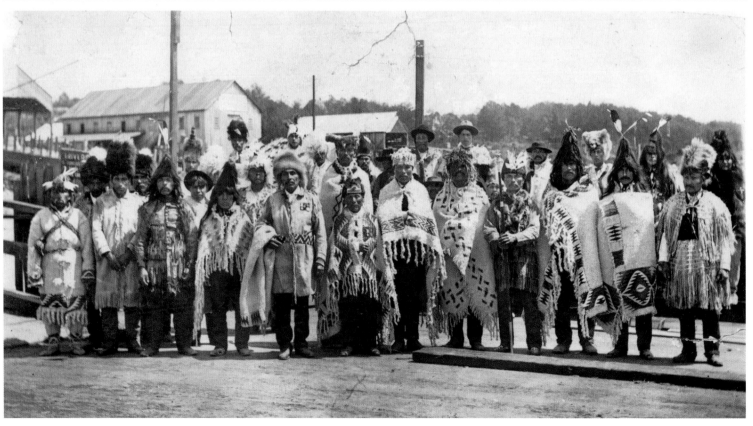

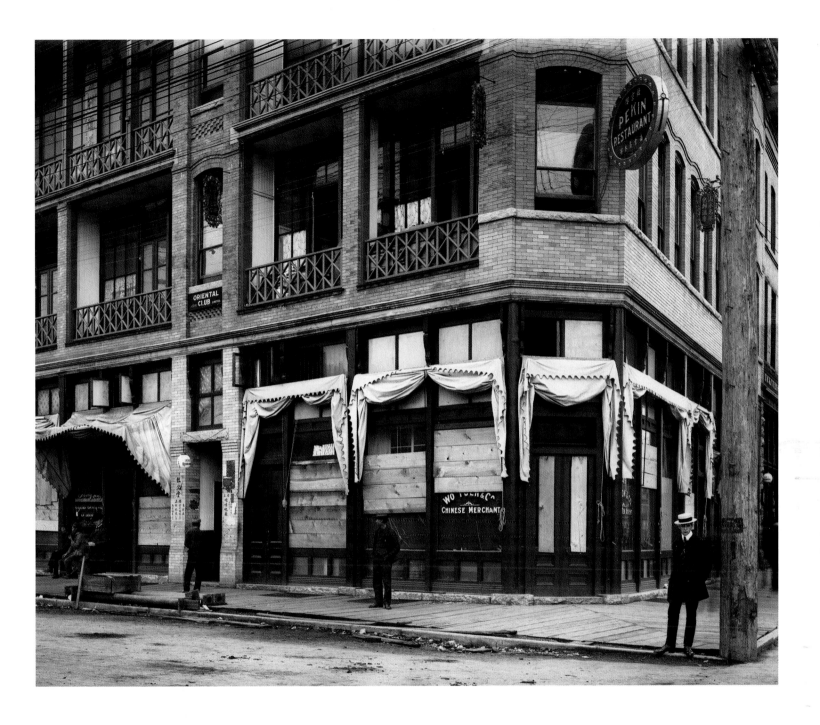

*Above:* After a September 7, 1907, rally of the Asiatic Exclusion League, thousands of rioters vandalized businesses in Chinatown and Japantown, leaving few windows unbroken, including these at Carrall and Pender. **Philip Timms/ Vancouver Public Library 940**

*Facing top:* In July 1900, striking salmon fishermen—a mix of Caucasian, First Nations, and Japanese men— demanded 25 cents per fish. The Duke of Connaught's Own Rifles were sent to maintain order in Steveston, and the fishermen and cannery settled on a price of 19 cents per fish. **Henry Joseph Woodside/Library and Archives Canada PA-017203**

*Facing bottom:* Squamish Chief Joe Capilano (front row, blanket over arm) and a delegation of chiefs at the North Vancouver ferry wharf left for England on July 3, 1906, to petition King Edward VII for First Nations rights. **City of Vancouver Archives CVA In.P41**

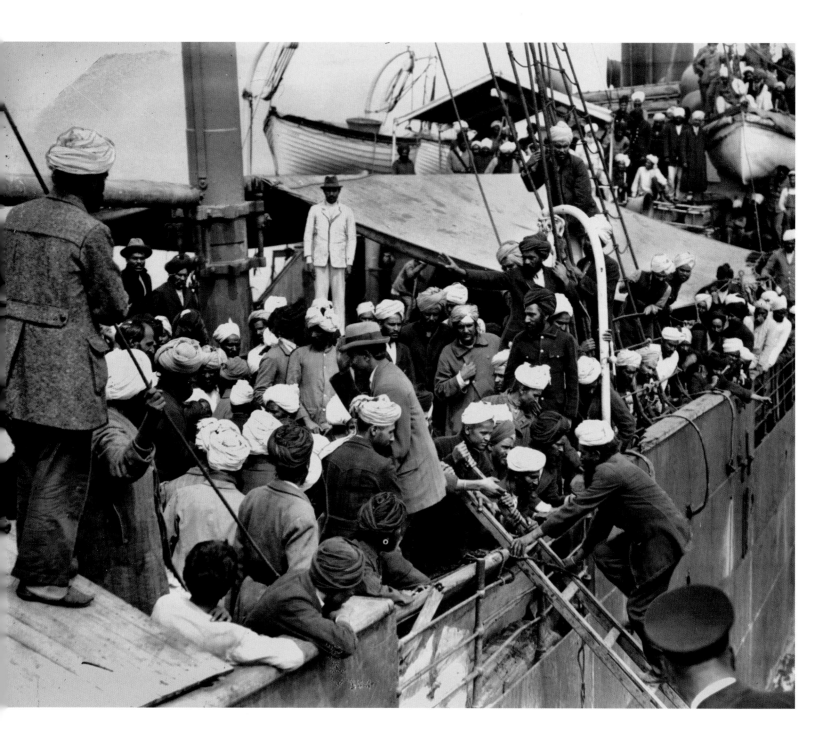

*Above:* On May 23, 1914, the ss *Komagata Maru* arrived in Vancouver with 376 would-be immigrants. They were denied entry to Canada, and had to remain on the ship for two months before being forced to leave under armed escort on July 23rd. **Leonard Frank/Vancouver Public Library 6232**

*Facing top:* The passengers on the ss *Komagata Maru* were led by Indian businessman Gurdit Singh, who sought to challenge Canada's exclusionary immigration policy towards Asians. **John Thomas Woodruff/Library and Archives Canada PA-034015**

*Facing bottom:* Twenty-four men were arrested and many others injured at a demonstration at the Powell Street Grounds organized by the Industrial Workers of the World on January 28, 1912, to protest for the right to free speech after a city council ban on public meetings. **City of Vancouver Archives CVA 371-971**

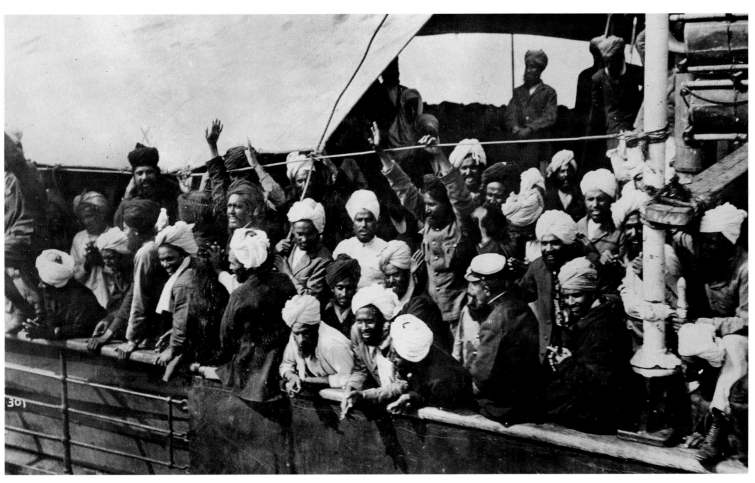

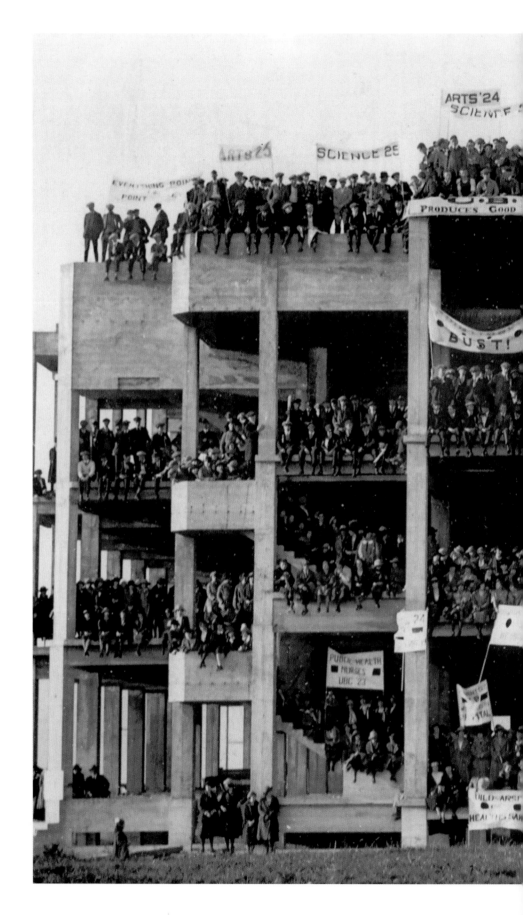

On October 28, 1922, 1,200 UBC students marched in the Great Trek from downtown to the unfinished Science building at the Point Grey campus to draw attention to overcrowding and the need to resume construction of the university after the First World War. **University of British Columbia Archives** UBC 1.1/1315

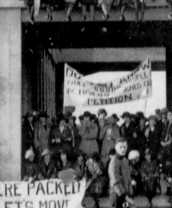
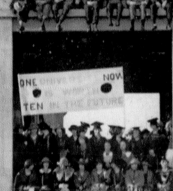

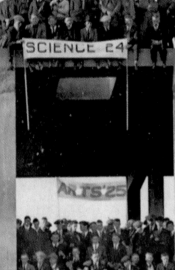
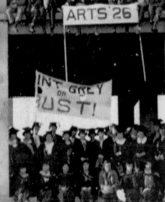
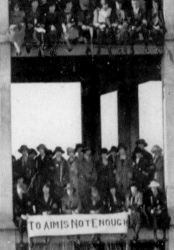

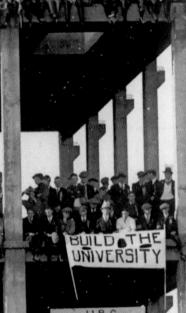

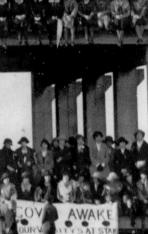

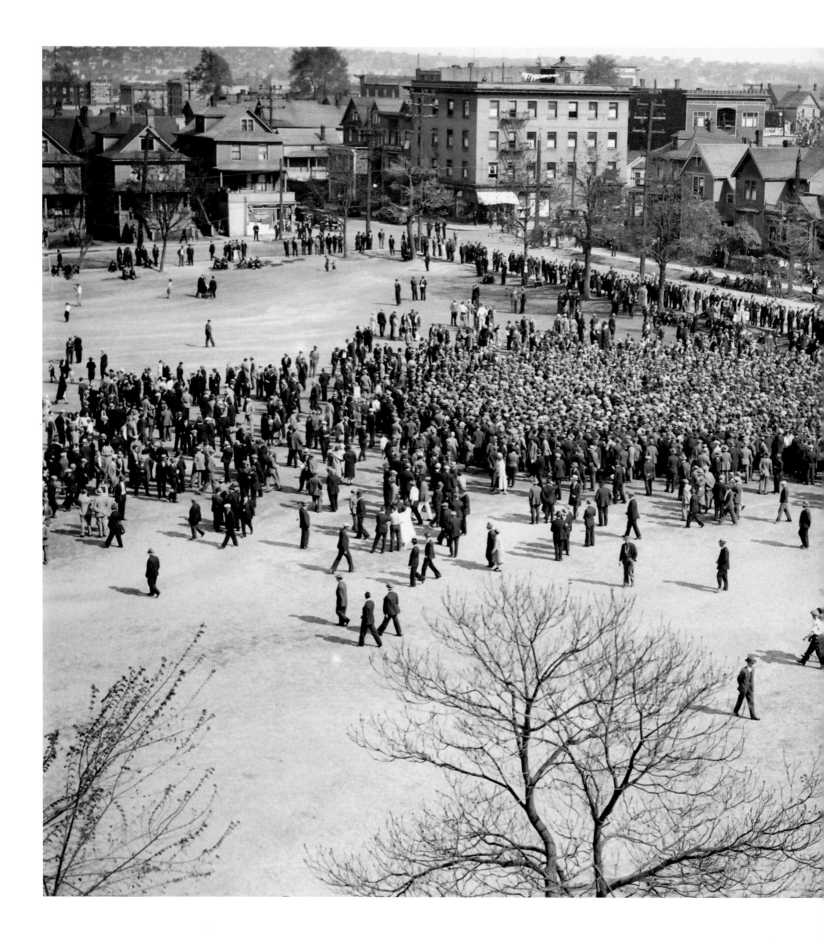

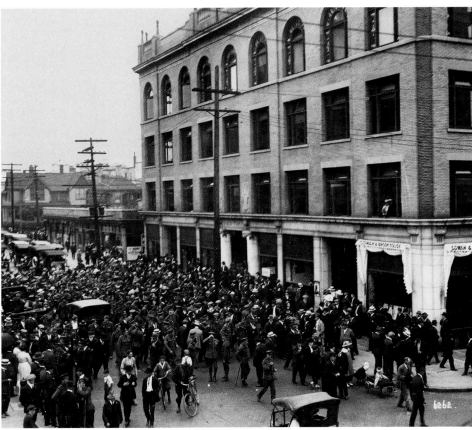

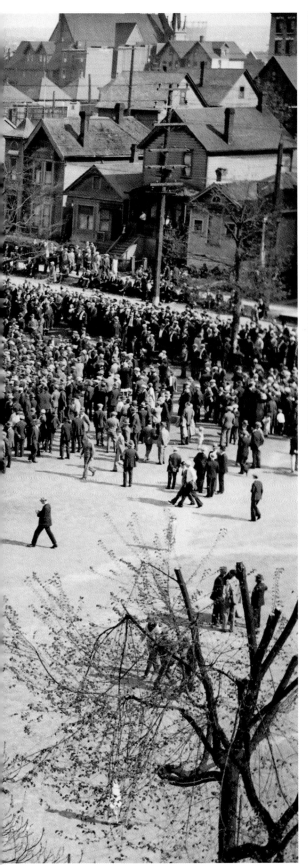

*Above:* On August 2, 1918, three hundred former WWI soldiers stormed the Labor Temple at Dunsmuir and Homer to protest the calling of a general strike, the first in Canadian history, following the killing of labour organizer Arthur "Ginger" Goodwin by police in Cumberland. **Stuart Thomson/ Vancouver Public Library 18264**

*Facing:* A 1930s May Day protest at the Powell Street Grounds. **Stuart Thomson/ City of Vancouver Archives CVA 99-2643**

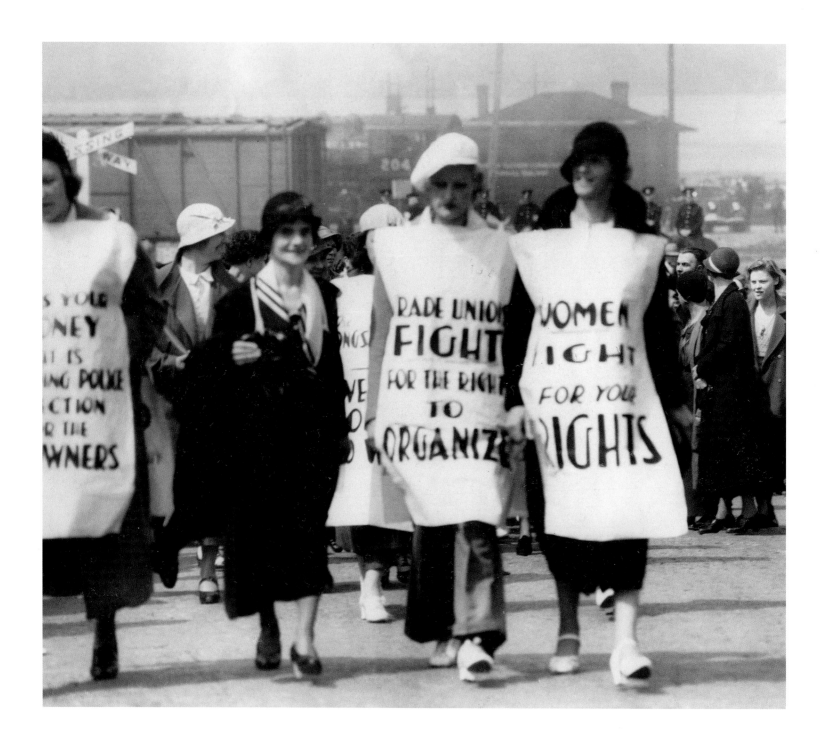

*Above:* On June 13, 1935, members of the Ladies Auxiliary led striking longshoremen from Ballantyne Pier to the Powell Street Grounds, where a mass meeting followed the failure to obtain permission to board the ships being manned by strike-breakers. *Vancouver Sun*

*Facing top:* Three hundred members of the Mothers' Council of Vancouver and one thousand relief camp men gathered to form the shape of a heart at Stanley Park on Mother's Day, May 12, 1935, in support of relief camp workers. *Vancouver Sun*

*Facing bottom:* On April 28, 1935, 2,000 women mustered at the Cambie Street Grounds and marched to the Denman Arena in a mass citizens' protest organized by the Cooperative Commonwealth Federation in support of relief camp strikers. Over 16,000 people packed the arena. *Vancouver Sun*

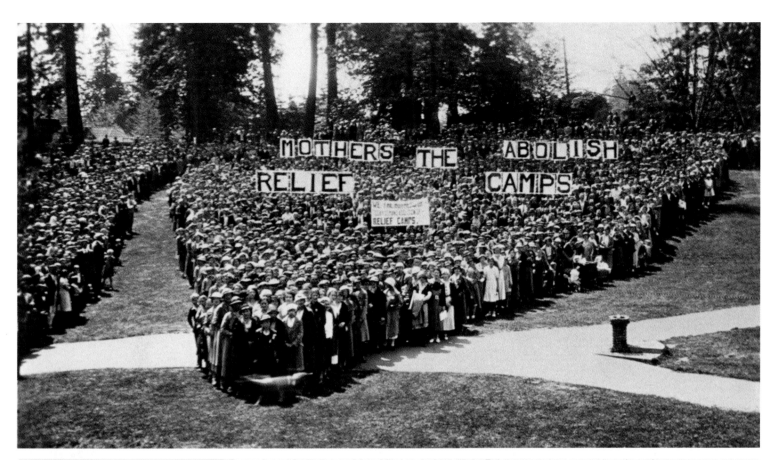

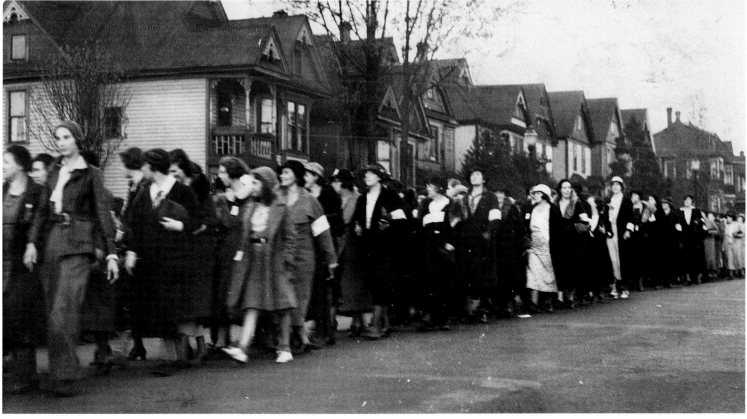

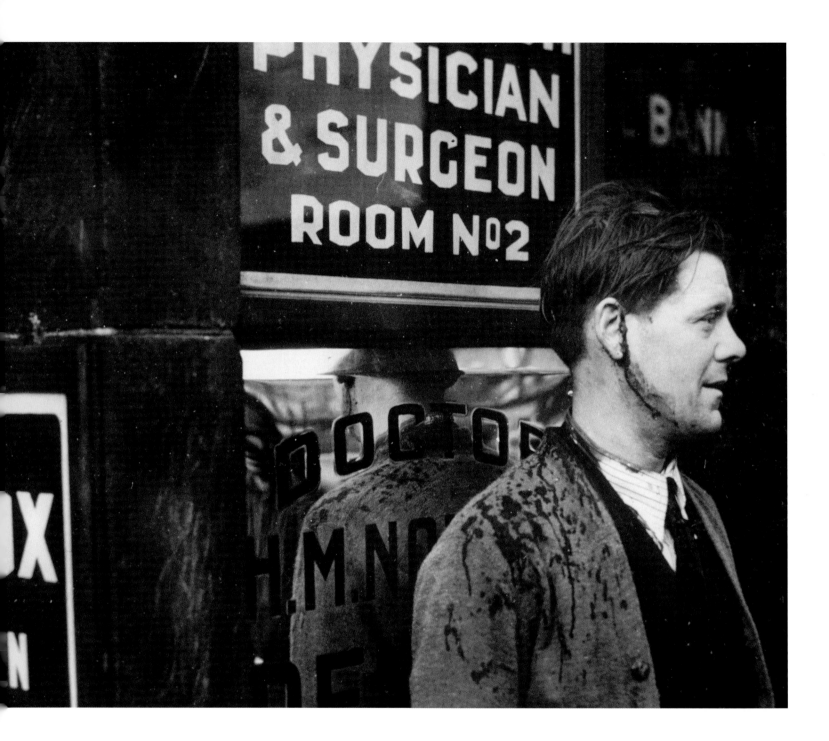

*Above:* Steve Brodie, the leader of the relief camp workers occupying the Post Office, was injured when the RCMP used tear gas and billy clubs to evict the men on June 19, 1938, bringing the thirty-day occupation to an end. *Province/*CVA 2011-010.1696

*Facing top:* Police remove a man from the Post Office on June 19, 1938. After the eviction, angry protesters damaged stores along Hastings Street. *Province/* CVA 2011-010.1695

*Facing bottom:* A man affected by tear gas leaves the Post Office after the violent eviction by RCMP on June 19, 1938—an event known as Bloody Sunday. That evening, 10,000 citizens protested police brutality towards the jobless at the Powell Street Grounds. *Vancouver Sun*

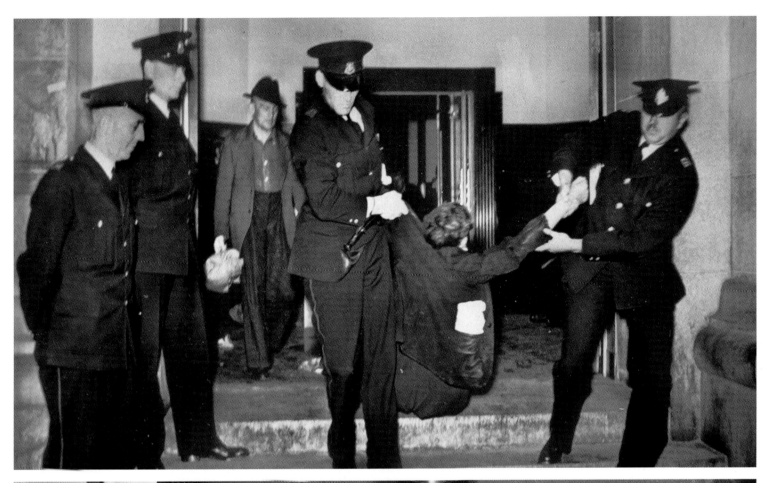

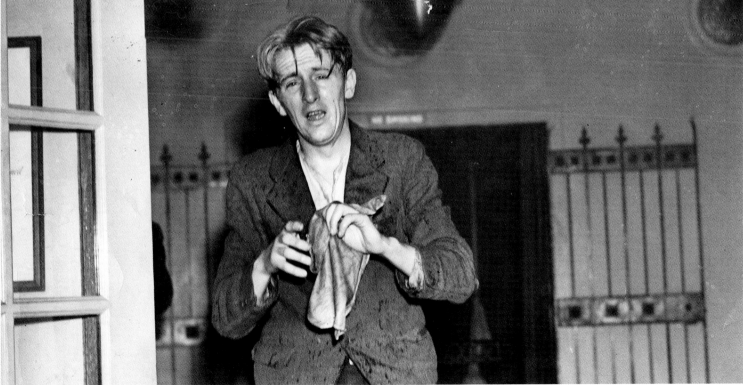

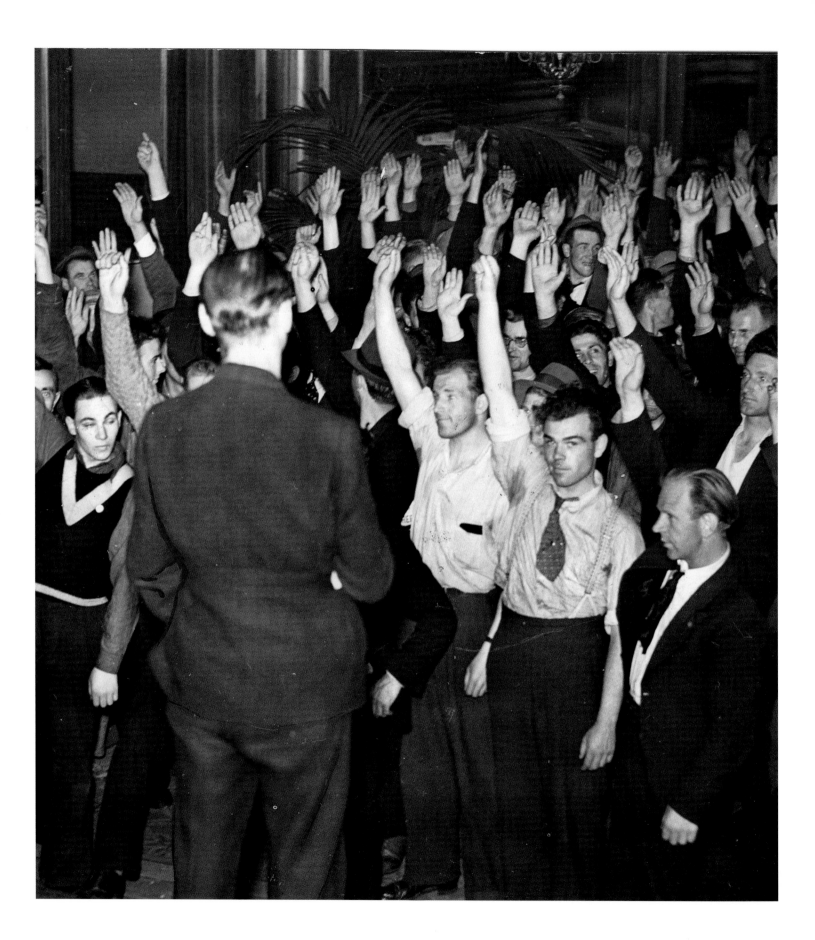

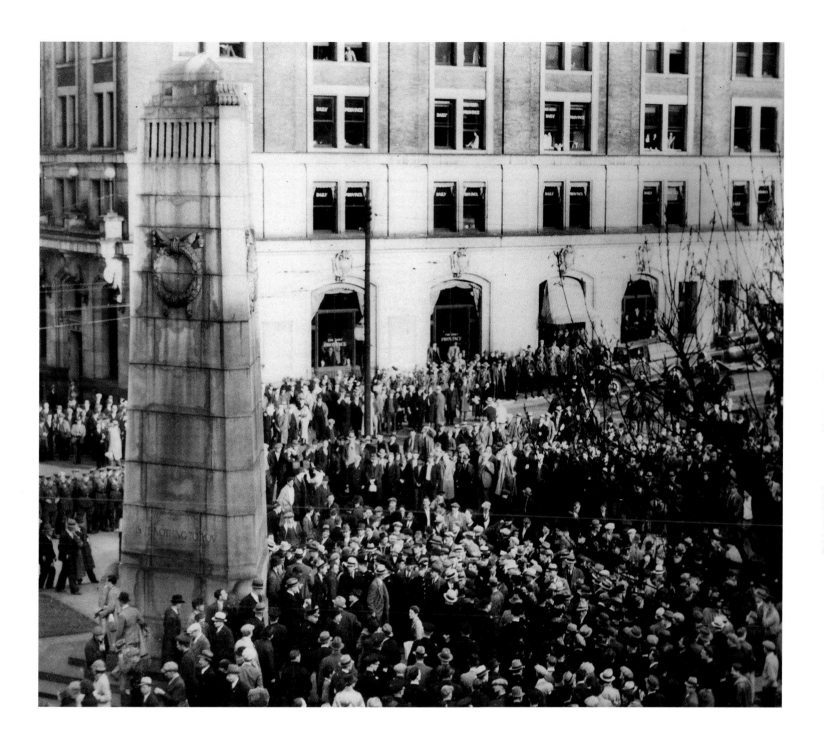

*Above:* On April 23, 1935, relief camp men occupied the Hudson's Bay store before being driven out, with nine arrested. Afterwards, at Victory Square, Mayor Gerry McGeer ordered the protesters to disperse. When they didn't, McGeer shouted, "Okay boys, you asked for it and here it is," and read the Riot Act. **City of Vancouver Archives AM54-S14-Vol 9, No2 503-D-1**

*Facing:* On May 21, 1938, three hundred men occupying the Hotel Georgia voted to accept $500 in relief money and left peacefully after a twenty-eight-hour occupation. *Province*

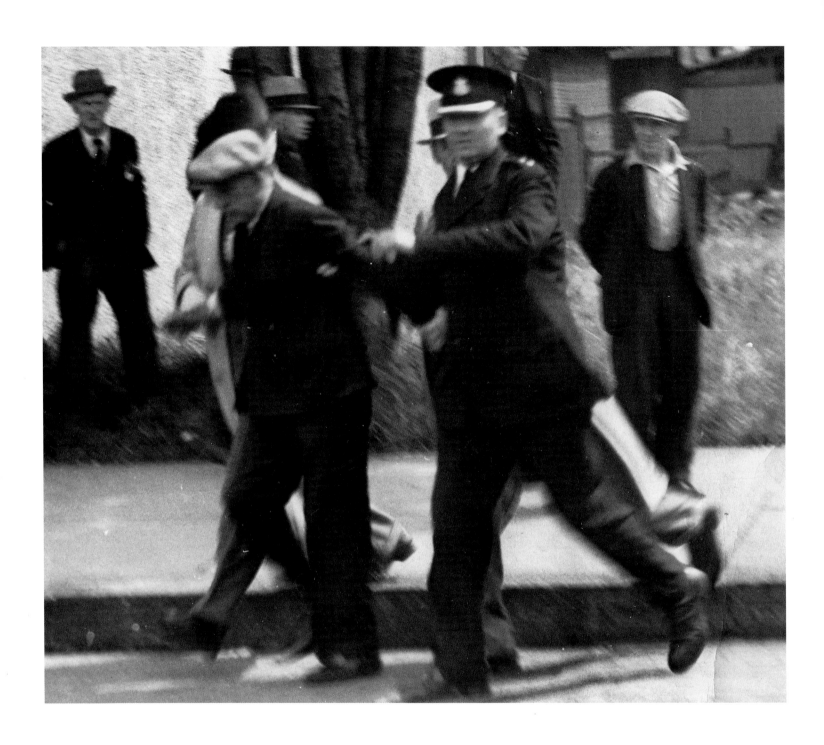

*Above:* A man is arrested in the Battle of Ballantyne Pier on June 18, 1935, when nearly one thousand striking longshoremen marched towards the waterfront to confront non-union workers unloading ships. They were clubbed and tear gassed by police, who arrested sixteen people. **Syd Williamson/** *Vancouver Sun*

*Facing:* On May 18, 1935, supporters of 250 relief camp strikers occupying the top floor of the Public Library and City Museum (now Carnegie Centre) hoisted up buckets with hot coffee and bread, pies, and cakes. *Vancouver Sun*

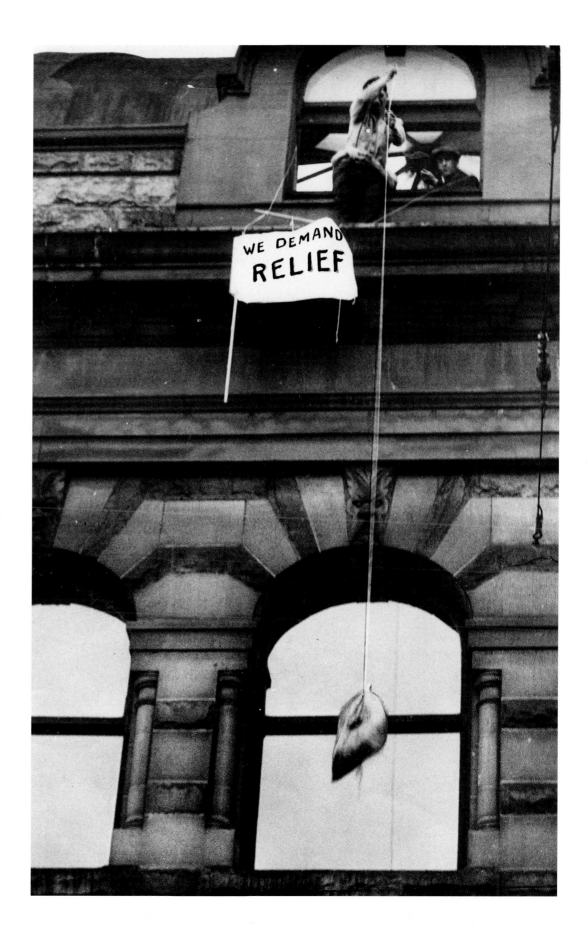

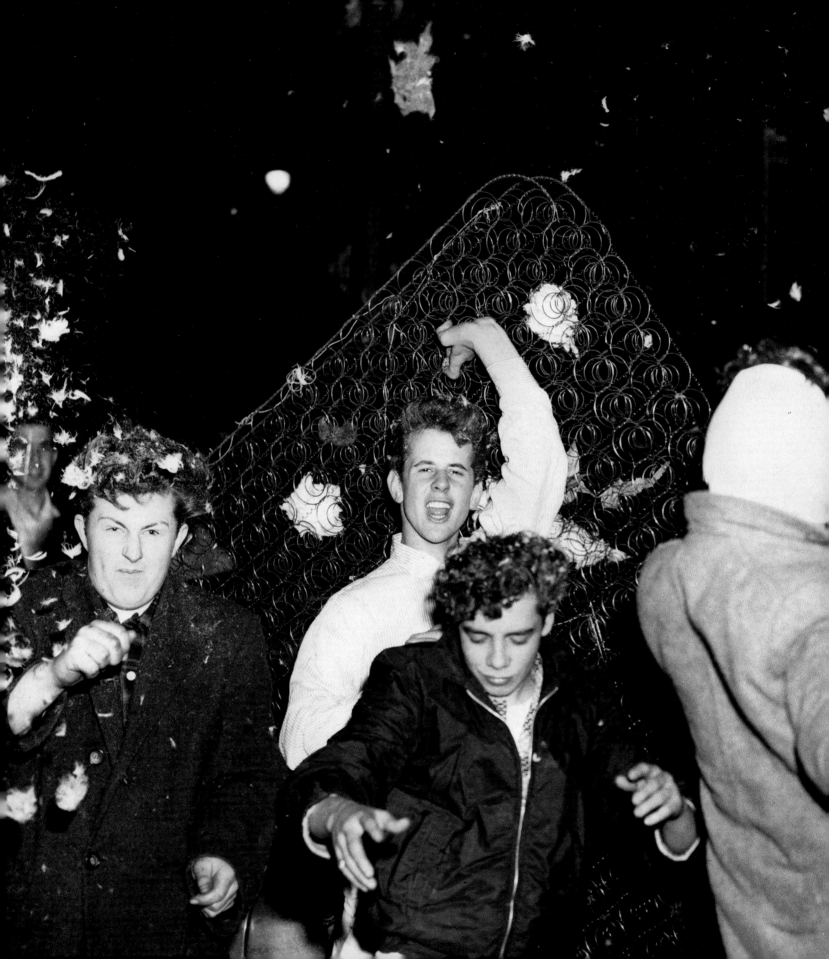

# 1940–59

Beneath the bright veneer of wartime patriotism and victory parades, a dark undercurrent of labour conflict and violence erupted, and teenage hooliganism was on the rise.

A 1946 International Woodworkers of America strike involved 33,000 B.C. woodworkers, and another IWA strike in 1959 affected 12,000 workers from the Vancouver–New Westminster area alone.

During a 1946 strike by the International Typographical Union at the *Province*, which continued to publish the newspaper, union workers clashed violently with newspaper distributors. Prior to the strike, the *Province* led the city in subscribers, but afterwards, unionized workers refused to support the newspaper, and it never regained its pre-strike circulation.

Scab labour also ignited a bitter turf war in 1949 at Lapointe Pier, at the foot of Salsbury Drive, when merchant seamen from the Canadian Seamen's Union rushed police lines in an attempt to keep rival Seafarers' International Union scabs from boarding the SS *Riverside*. The SIU, led by their controversial leader Hal C. Banks, ultimately broke the CSU by 1951.

The social upheaval of the 1940s and 1950s provoked the emergence of teenage hooliganism in the city. The zoot suit gangs—men too young to serve in the Second World War named for their suits with wide-legged pants tapered at the ankle—brawled with merchant marines in the summer of 1944. In the 1950s, rival neighbourhood park gangs, who later spawned the infamous Clark Park and Riley Park gangs, among others, regularly clashed in violent territorial rumbles. And Halloween riots in North Vancouver, Dunbar, Chinatown, and on Main Street became rowdy and destructive annual events.

Thousands of inebriated young people rioted at the 1955 and 1958 Grey Cup games, and a near-riot broke out at the Elvis Presley concert in 1957 after the singer performed for only twenty-two minutes. It was the beginning of a long and raucous history of Vancouver sports and concert riots.

*Facing:* On November 29, 1958, Grey Cup revelers turned into rioters, smashing windows and littering the streets with a snowstorm of stuffing from pillows and mattresses thrown from nearby hotels. **Eric Cable/*Province***

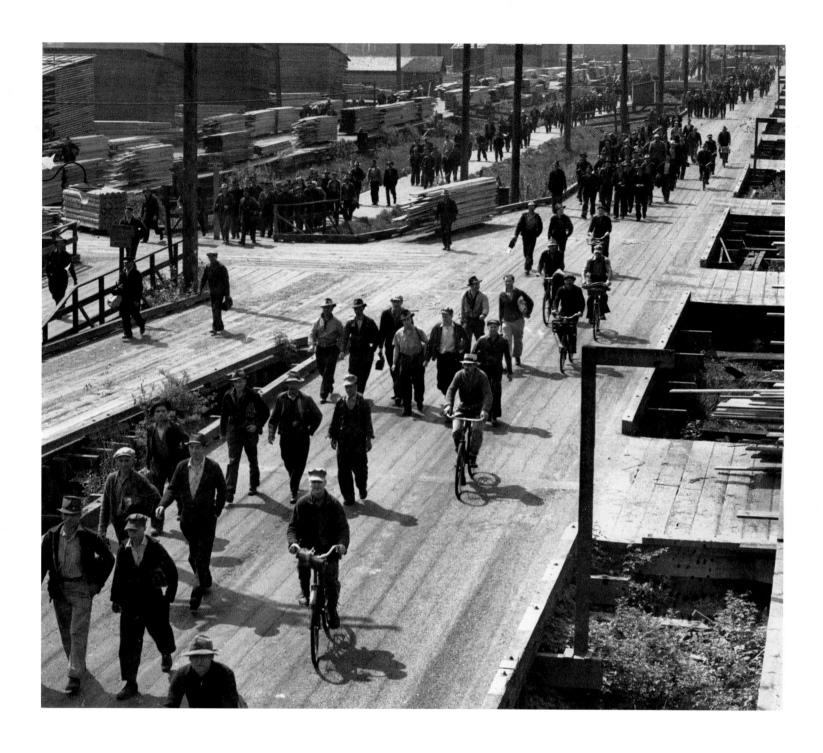

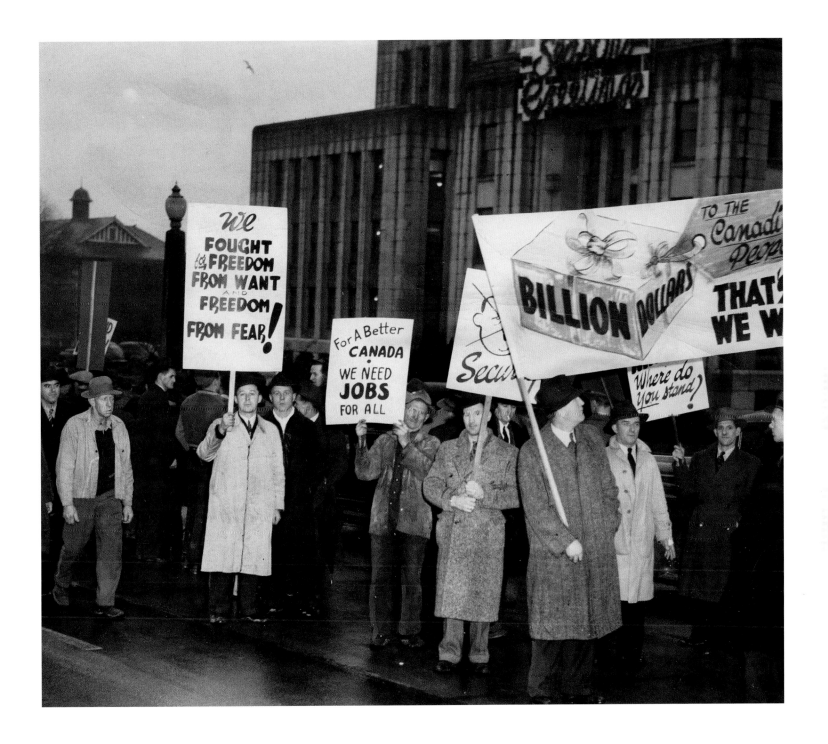

*Above:* The December 22, 1945, *Province* called this "the first unemployment parade since the depressed thirties" at Vancouver City Hall. Representing the marchers were union leader and spokesman W.L. White and Harold Pritchett of the International Woodworkers of America. ***Province***

*Facing:* The biggest strike in British Columbia's history to date was the IWA strike that began May 15, 1946, when the province-wide forest industry, employing 33,000 men and women, came to a halt for thirty-seven days. Here, workers leave the world's biggest lumber yard at Fraser Mills, in Coquitlam. ***Vancouver Sun***

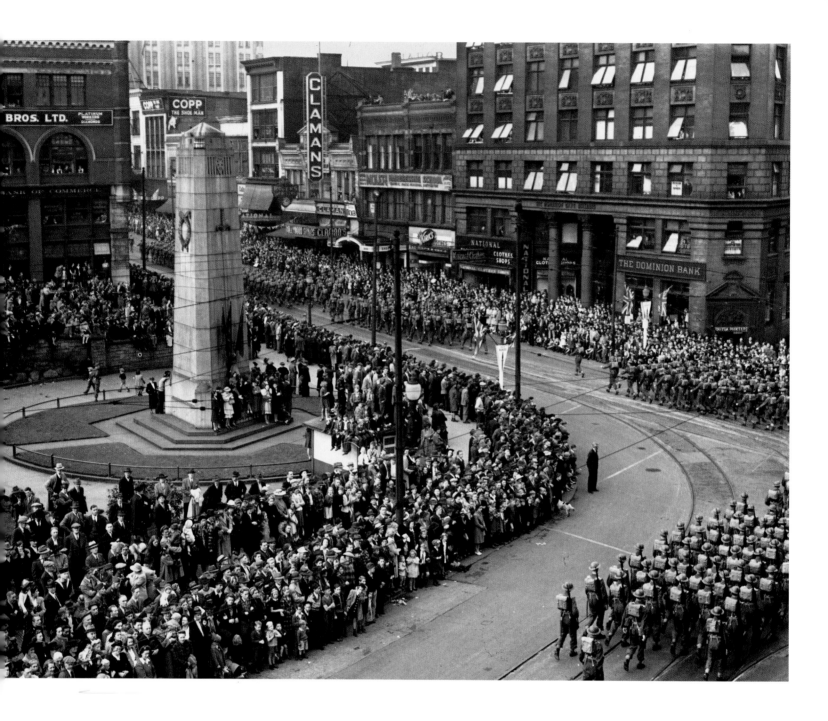

*Above:* A People's Parade on October 18, 1942, was attended by around 120,000 people, one-quarter of Vancouver's citizens, along a three-mile route. The *Vancouver Sun* wrote that the city had never "witnessed such an impressive display of united effort aimed at a single goal—no price too high for victory" in the Second World War. *Vancouver Sun*

*Facing:* A woman waves to a family member being held at the Immigration Building in Vancouver the day after a May 13, 1942, riot by 130 Japanese people being detained for refusing to go to work camps without their families. **Province/Courtesy *Toronto Star* Archives**

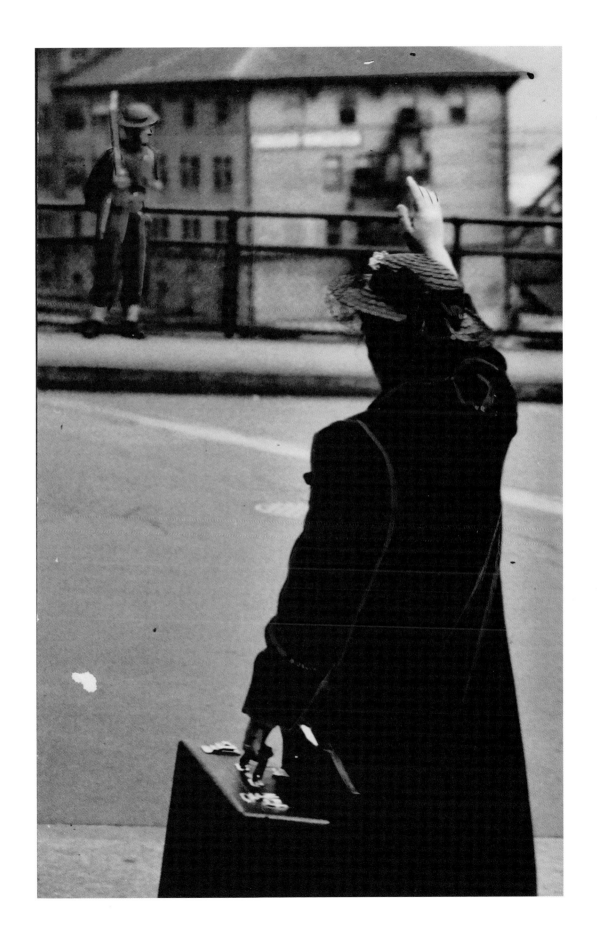

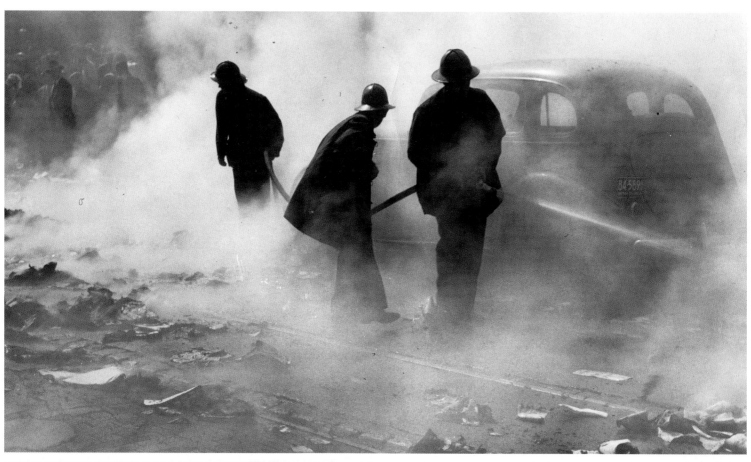

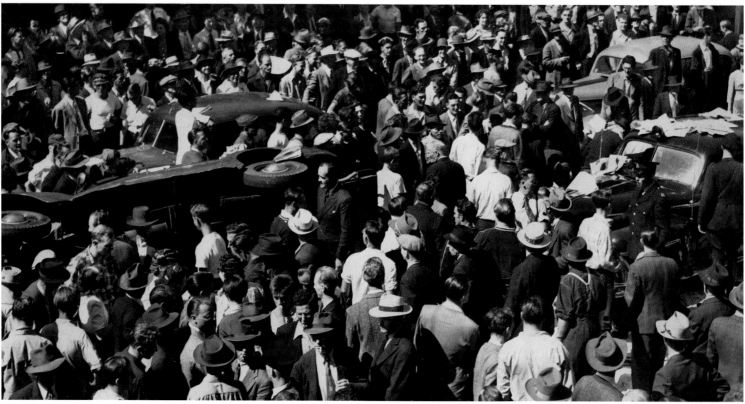

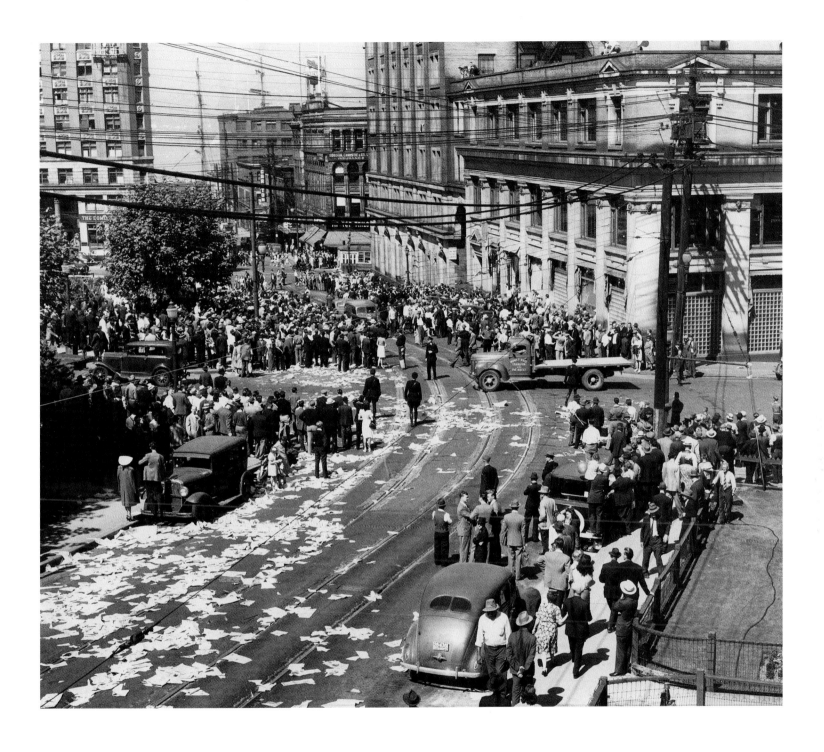

*Above and facing:* On July 23, 1946, the *Province* attempted to dispatch newspapers on trucks from its building on Cambie Street across from Victory Square. Striking workers and their sympathizers overturned vehicles and threw the newspapers into the street, where they caught fire from a spark from a passing streetcar. Police arrested eight men. *Vancouver Sun*

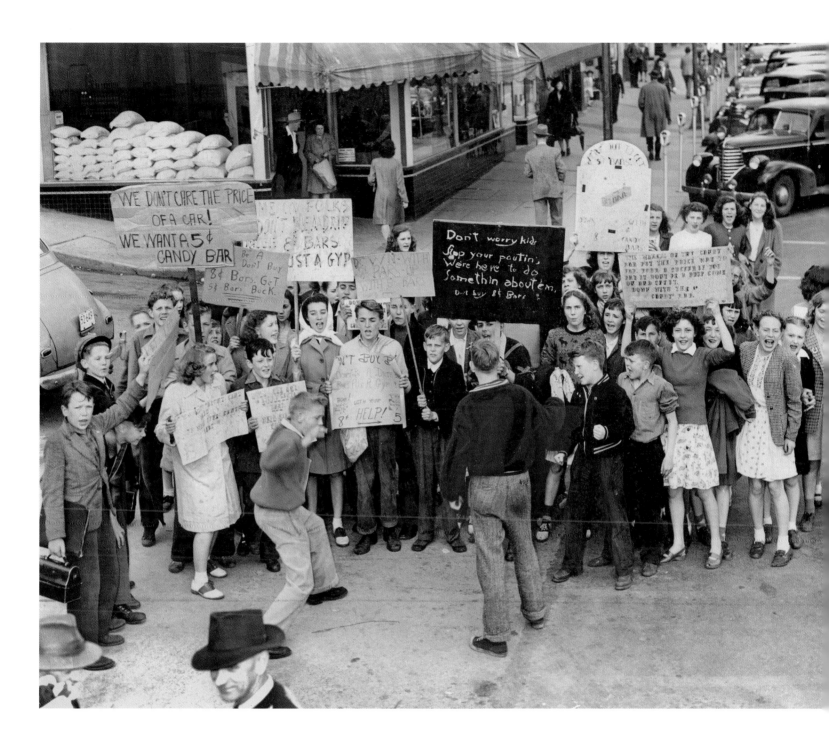

*Above:* Kids picketed on Columbia Street in New Westminster on April 30, 1947, to protest a three-cent increase in the price of chocolate bars to eight cents—one of several protests, including one at the B.C. Legislature in Victoria. **On-the-Spot Photographers/***Vancouver Sun*

*Facing:* In January 1946, Second World War veterans occupied the old Hotel Vancouver, which was empty and slated for demolition, to draw attention to the city's acute housing shortage. Their action resulted in the creation of the Citizens' Rehabilitation Council hostel

in the hotel, which operated until 1948. On February 15, 1946, Mr. and Mrs. Norman Chapman and their three children became its first occupants, in room 1024. *Province*

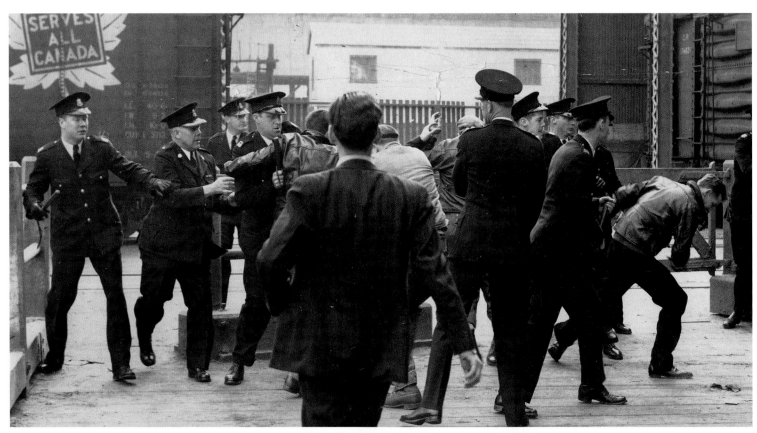

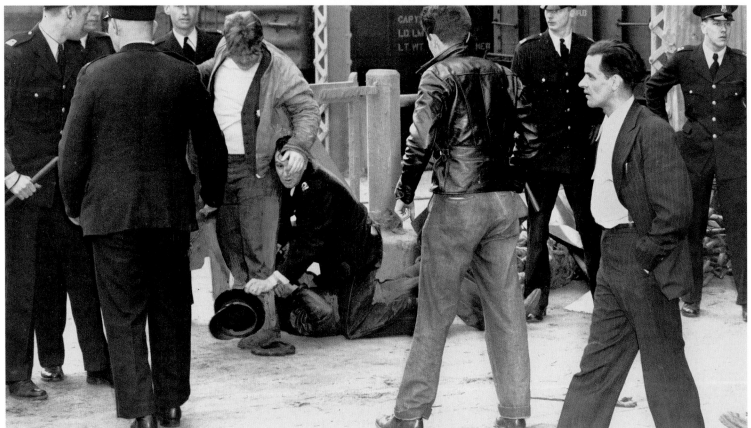

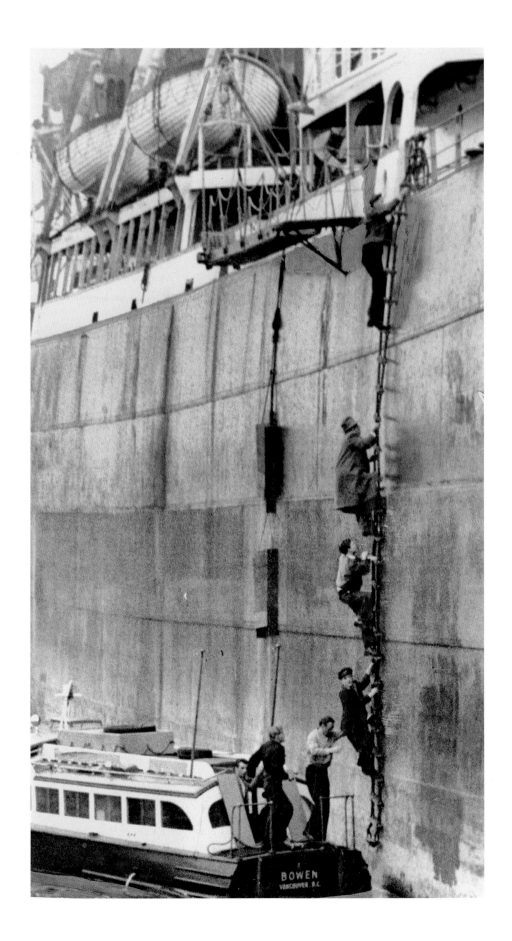

*Left and facing:* Heads were bloodied on April 12, 1949, at Lapointe Pier when Canadian Seamen's Union picketers tried to break through police lines in a failed attempt to keep rival Seafarers' International Union men from boarding the *SS Riverside.* Seafarers' International Union scabs successfully took over the ship (left), from which striking Canadian Seamen's Union crew had been removed by court injunction. **Ray Munro/*Province***

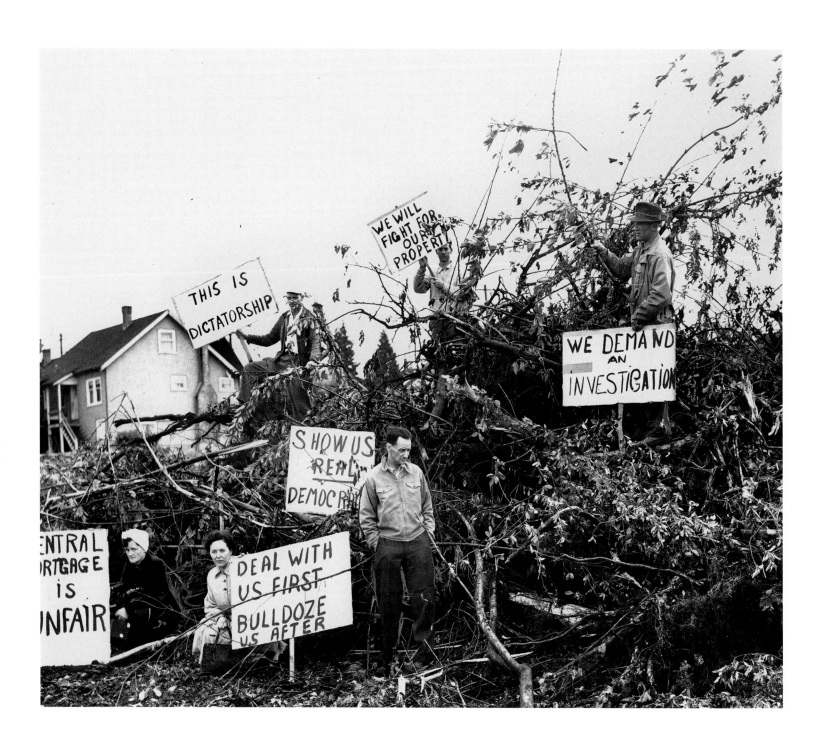

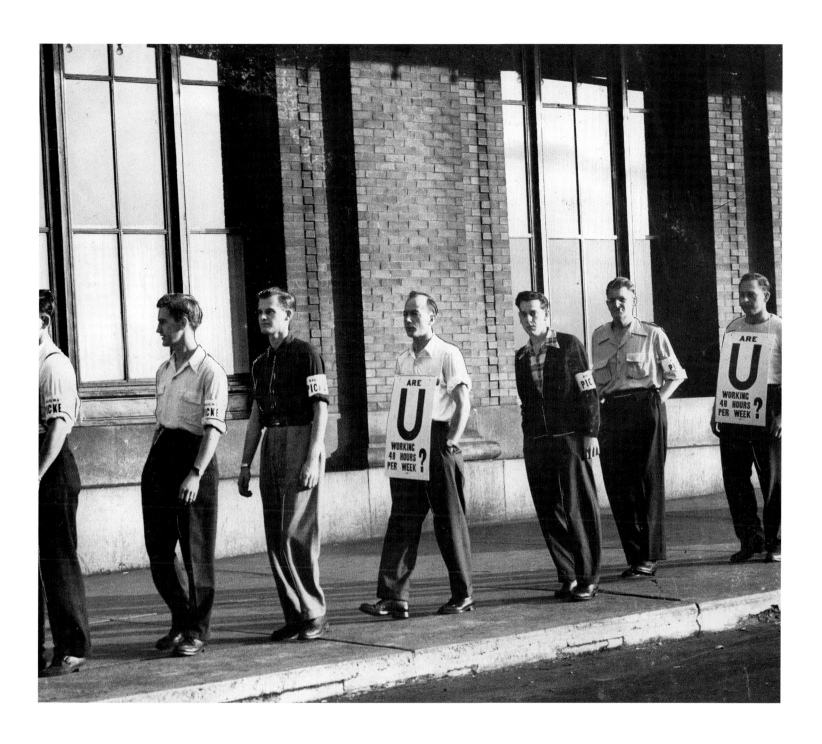

*Above:* At 7 a.m. on August 22, 1950, strike pickets took up position at the Hotel Vancouver, which was owned jointly by the CNR and CPR, regarding the forty-eight-hour work week. *Vancouver Sun*

*Facing:* Property owners and neighbours protested at the site of a Fraserview housing development after a bulldozer destroyed a fifteen-tree cherry orchard on May 19, 1949. The government had expropriated the property, but several holdouts objected to the land price being offered and the method used to divide lots. *Vancouver Sun*

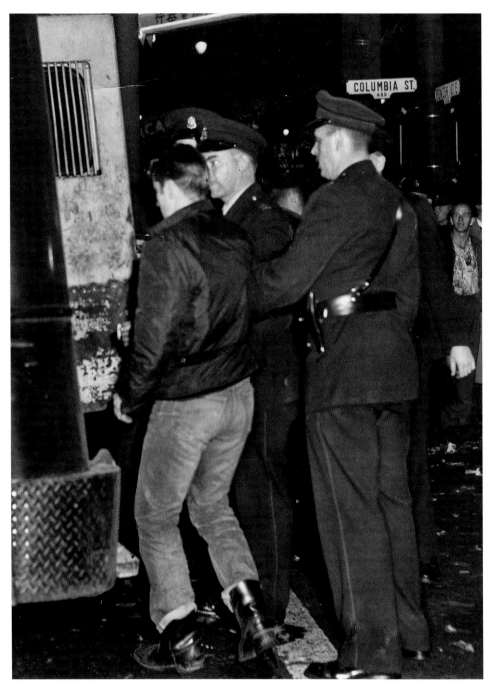

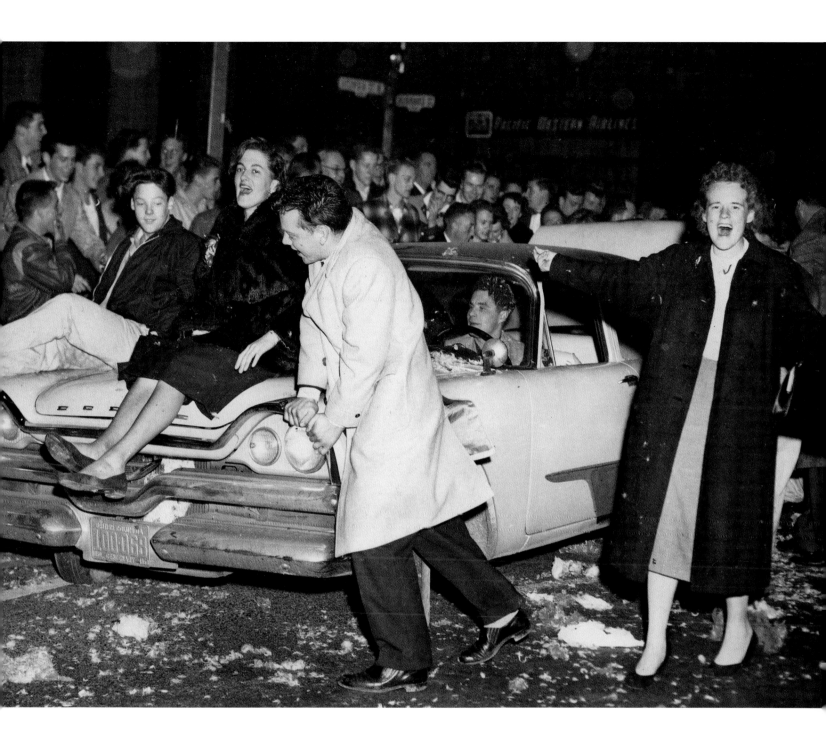

*Above:* On November 29, 1958, Grey Cup revelers smashed downtown windows, threw pillows and mattresses from hotel windows, and insulted police, only three years after the first Grey Cup was held in Vancouver and a mob of 50,000 "hoodlum-gangs spoiled the fun." **Eric Cable/***Province*

*Facing:* In the 1950s, Halloween hooliganism became an annual event. In a Chinatown riot in 1958, "gangs of duck-tail-haircut youth swarmed around, throwing eggs and firecrackers." Thirty police officers arrested eleven youths in the crowd of two thousand. **Brian Kent/** *Vancouver Sun*

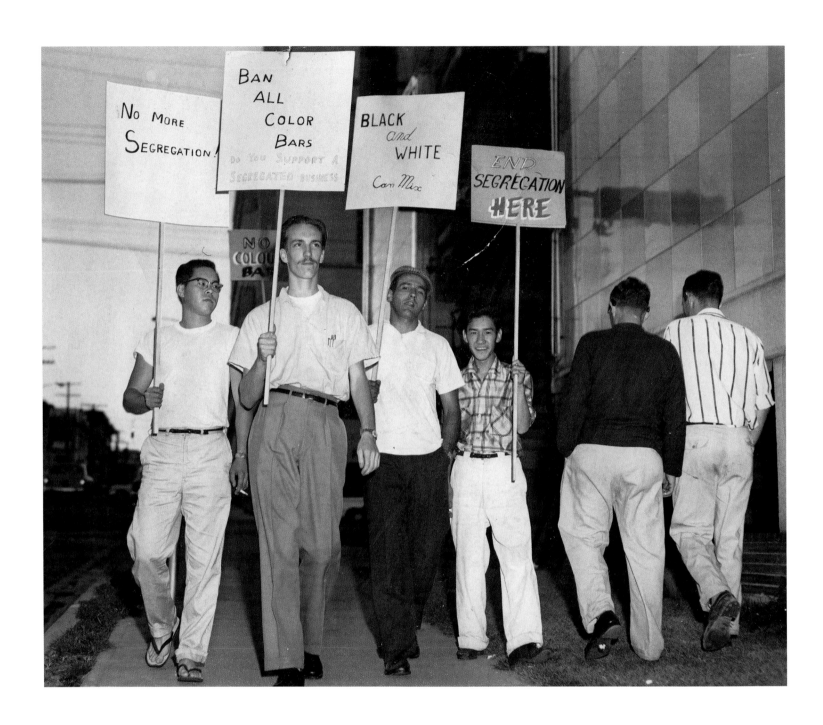

*Above:* Picketers protested racial discrimination outside the Downtowner Motel at 667 Thurlow Street on August 7, 1959, after the *Vancouver Sun* published a story about the eviction of a bi-racial Seattle couple. **Don Timbrell/ Vancouver Sun**

*Facing:* In March 1944, Doukhobors staged a six-hour vigil at the Vancouver courthouse to demand the release of thirteen of their brethren from Oakalla Prison. *Province*

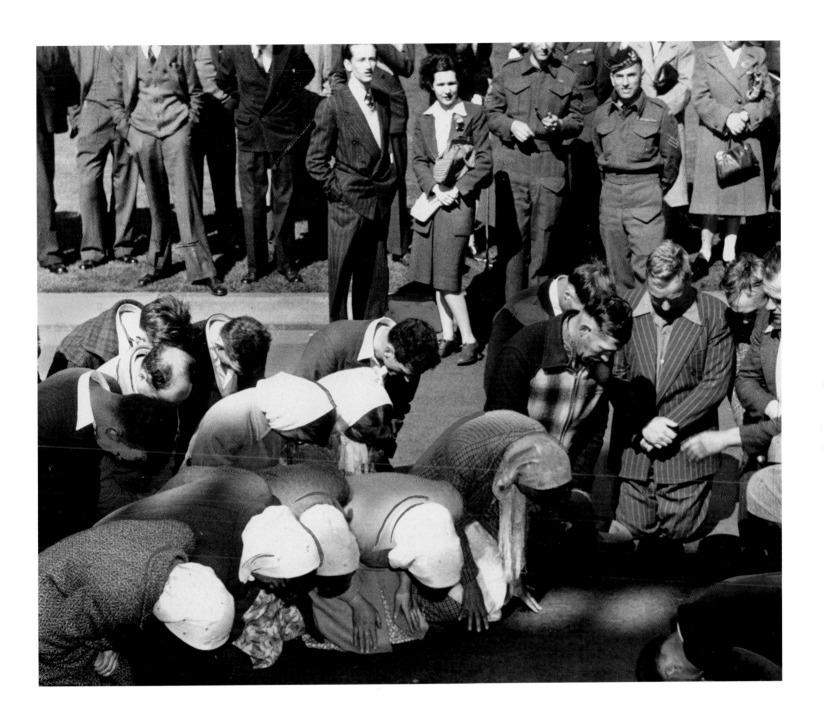

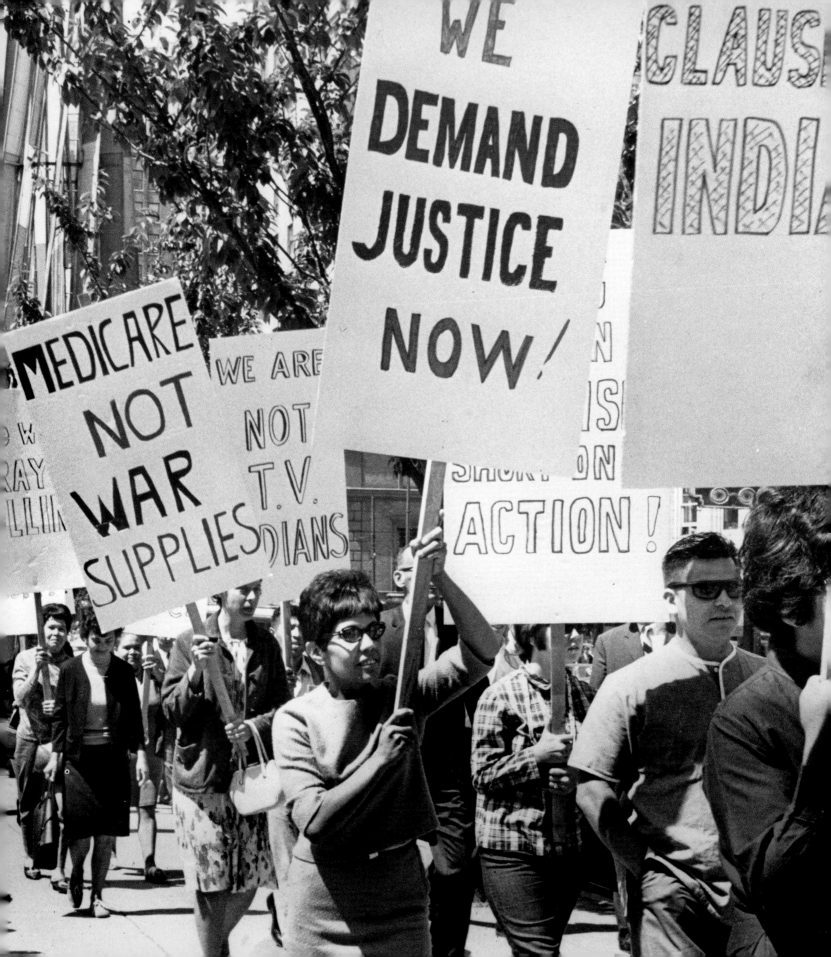

Small gatherings of Doukhobors organized ban-the-bomb protests early in the decade, and by the end of the 1960s large peace marches against the war in Vietnam became regular events with widespread support from all factions of society.

Student activism flourished at high schools and colleges, and at Simon Fraser University and the University of British Columbia, urban planning was a growing issue, and human rights, civil rights, and other organizations promoting social change proliferated.

A growing militancy, inspired by the American Indian Movement, informed First Nations protests and blockades. At a centennial celebration at Empire Stadium on July 1, 1967, Chief Dan George delivered his famous Lament for Confederation, which began:

*How long have I known you, Oh Canada? A hundred years? Yes, a hundred years. And many, many seelanum more. And today, when you celebrate your hundred years, Oh Canada, I am sad for all the Indian people throughout the land.*

*For I have known you when your forests were mine; when they gave me my meat and my clothing. I have known you in your streams and rivers where your fish flashed and danced in the sun, where the waters said "come, come and eat of my abundance." I have known you in the freedom of the winds. And my spirit, like the winds, once roamed your good lands.*

*But in the long hundred years since the white man came, I have seen my freedom disappear like the salmon going mysteriously out to sea. The white man's strange customs, which I could not understand, pressed down upon me until I could no longer breathe.*

*When I fought to protect my land and my home, I was called a savage. When I neither understood nor welcomed his way of life, I was called lazy. When I tried to rule my people, I was stripped of my authority.*

*Facing:* Seventy First Nations people and their supporters marched on June 17, 1968, to protest the issues of education, health, welfare, and job opportunities, and to demand funds to administer their own education and counselling programs. **Chuck Jones/***Province*

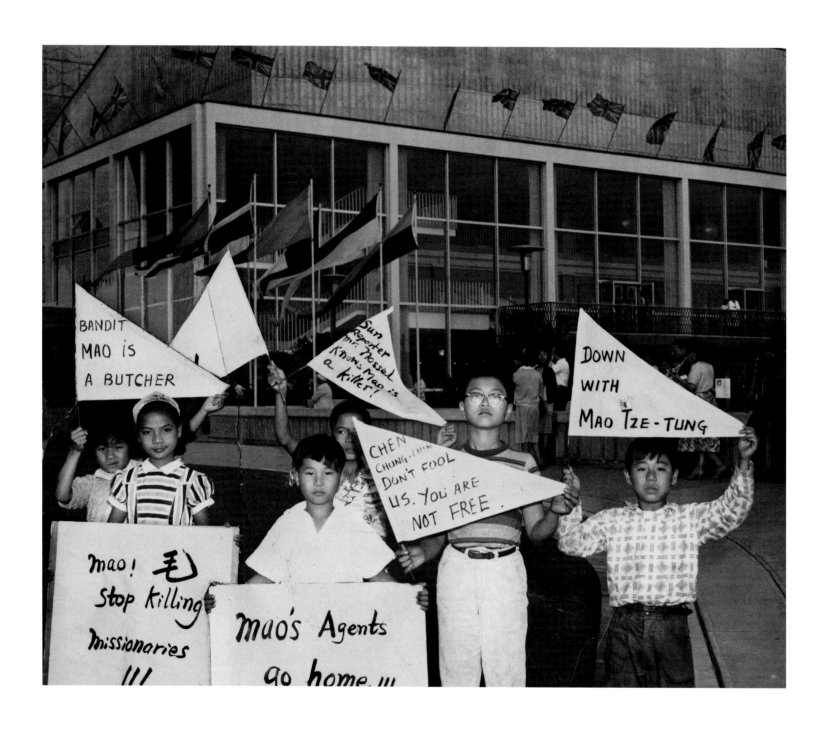

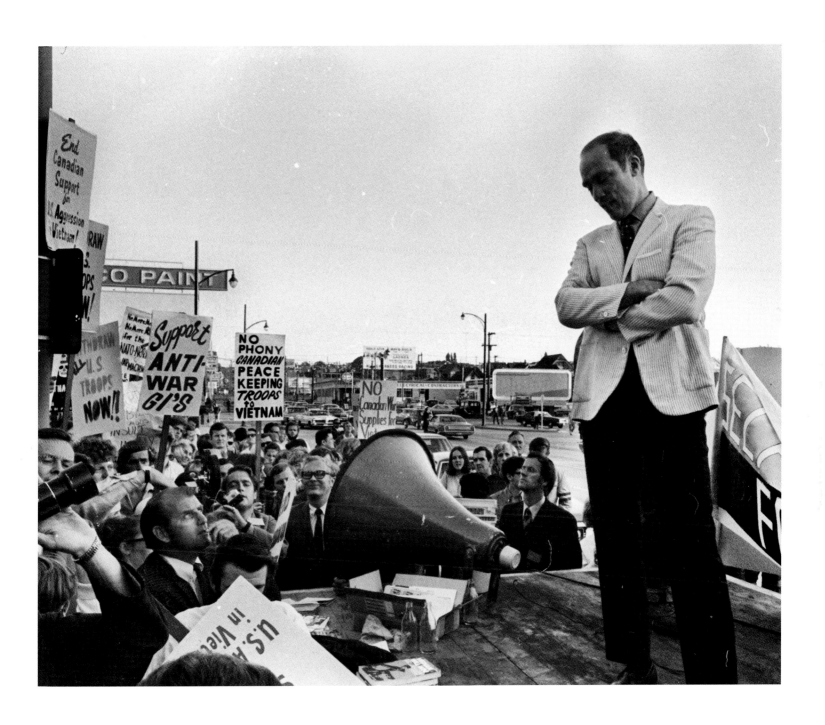

*Above:* Demonstrators protested the war in Vietnam outside the Seaforth Armoury, where Prime Minister Pierre Trudeau attended a dinner on August 9, 1969. **Ralph Bower/***Vancouver Sun*

*Facing:* While the audience cheered for the Peking Opera Company at the Queen Elizabeth Theatre on August 10, 1960, outside, anti-Communist pick-eters protested the group's appearance for the first time in North America. **Ken Oakes/***Vancouver Sun*

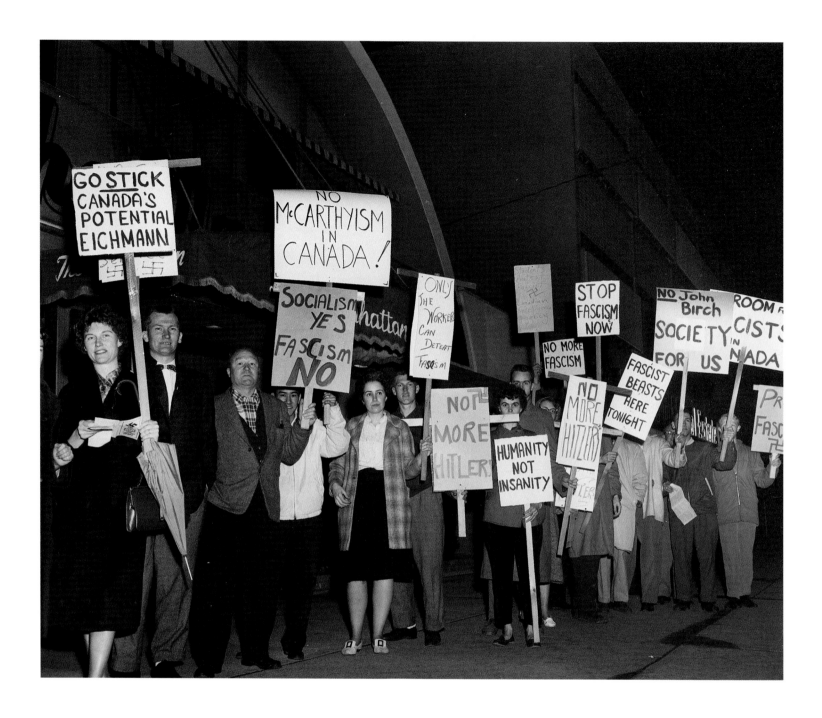

*Above:* Protesters picketed a meeting of the Canadian Anti-Communist League (known as the Canadian Intelligence Service) on April 12, 1961. UBC students and others protested League president Ronald Gostick, "Canada's self-appointed No. 1 Red-hater," in what threatened to turn into a riot. **Ken Oakes/***Vancouver Sun*

*Facing top:* Doukhobors demonstrated outside a rally for Liberal leader Lester Pearson at the PNE Forum on April 1, 1963. The *Vancouver Sun* reported that "Fighting Mike" Pearson won the "battle of bedlam," when protesters shouted and threw spitballs and paper darts at him before a crowd of 6,500. **George Diack/***Vancouver Sun*

*Facing bottom:* At a rally for Prime Minister John Diefenbaker at the PNE Forum on May 30, 1962, before the June federal election, a "wild and unruly" crowd of protesters from the Vancouver Unemployed Council, UBC political clubs, and trade unions almost turned into a riot. **Dan Scott/***Vancouver Sun*

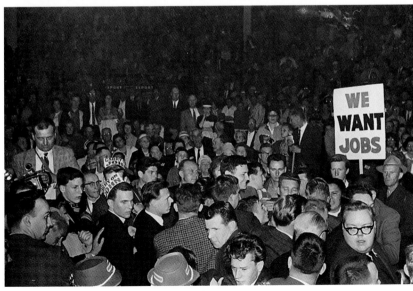

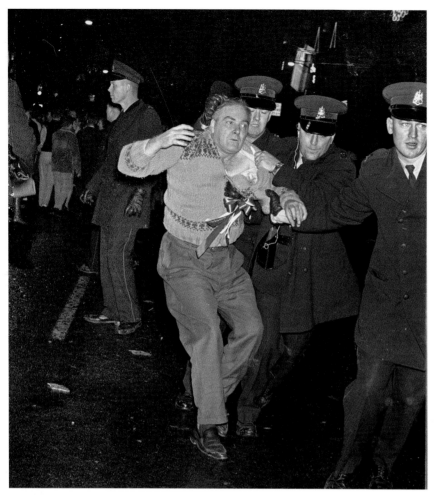

*Above:* The Grey Cup riot on November 25, 1966, was blamed in part on the parade being held at night. Police arrested three hundred people, and thirty-seven injured were taken to hospital, after a four-hour battle. **Dan Scott/*Vancouver Sun***

Right: Police raided the three-day student occupation of Simon Fraser University's administration centre on November 23, 1968, and arrested 114 who defied an ultimatum to leave. The students' concerns were university admissions, transference of credits, access to student records, and education funding. **Dan Scott/*Vancouver Sun***

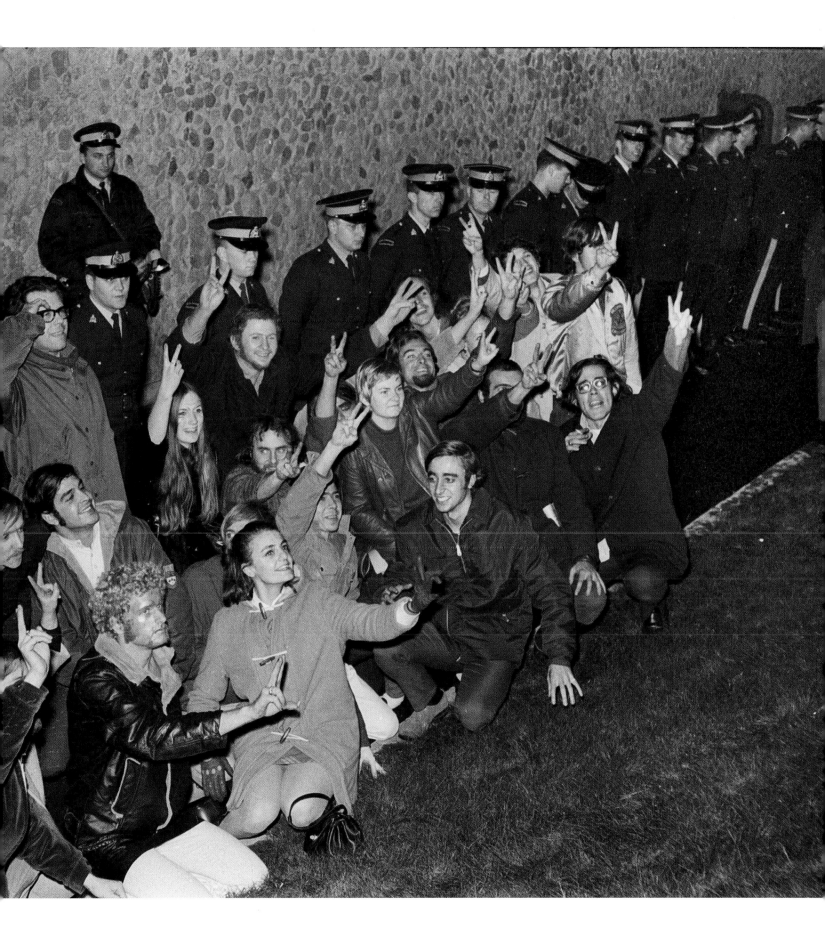

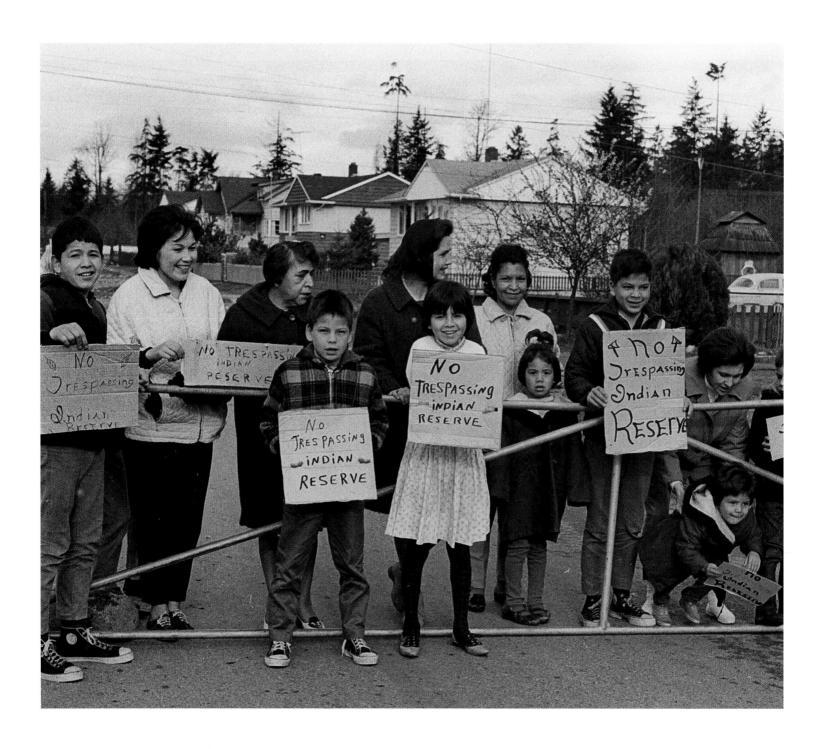

*Above:* On April 13, 1967, First Nations protesters erected a barricade on Lawa Road at 15th Street at the Capilano Indian Reserve in North Vancouver to prevent commuters from using the road as a shortcut to beat traffic congestion leading to the Lions Gate Bridge. **George Diack/*Vancouver Sun***

*Facing:* Geraldine Larkin, 20, of the Native Alliance for Red Power, picketed a meeting of the National Association of Principals and Administrators of Indian Residences at the Blue Boy Motor Hotel on March 12, 1968, to protest the effect of residential schools on First Nations culture. **Ralph Bower/*Vancouver Sun***

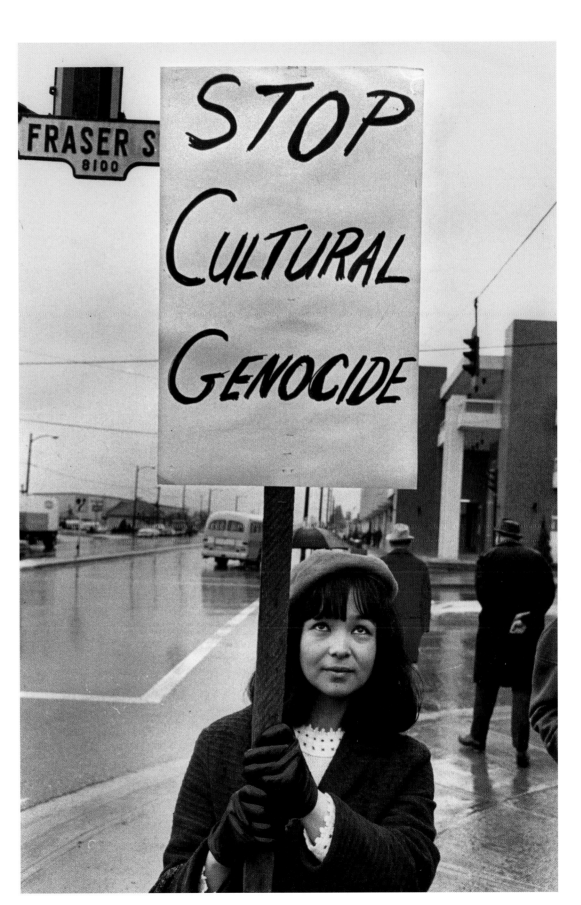

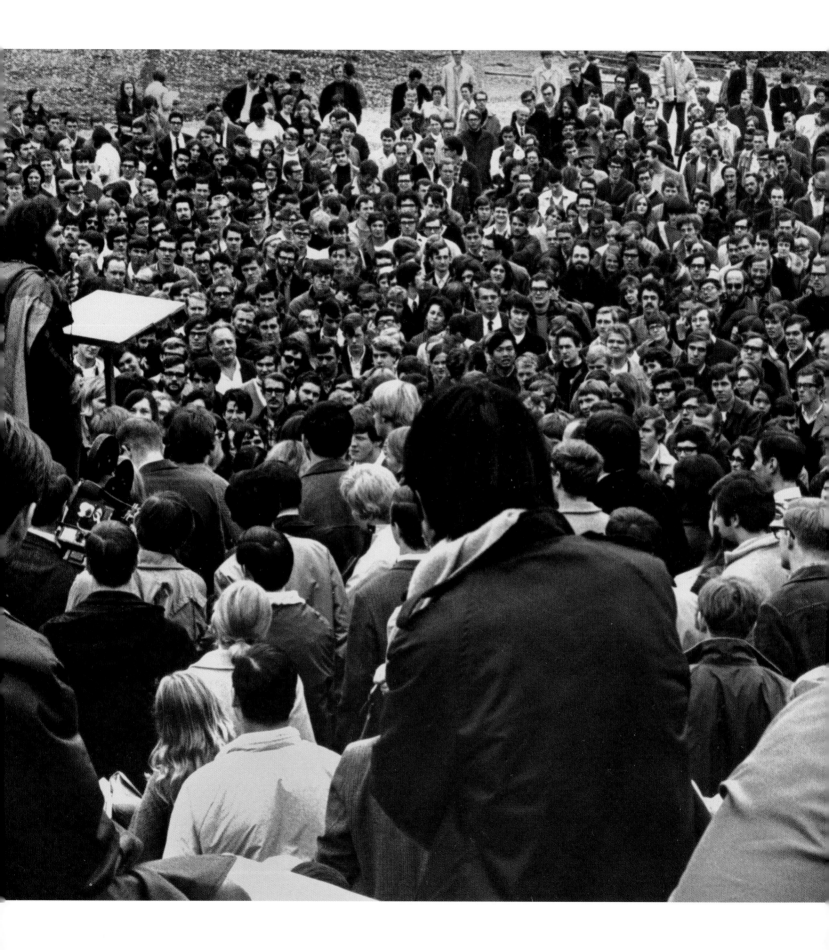

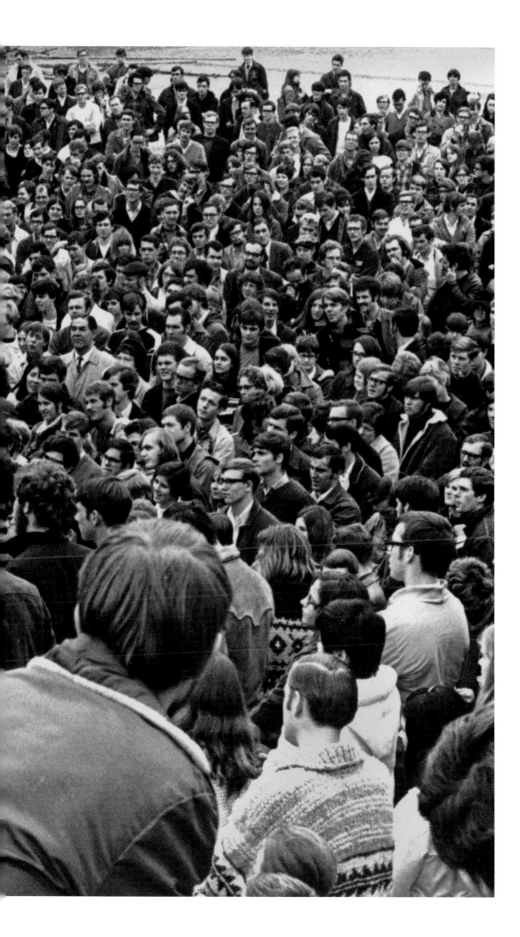

U.S. Yippie (Youth International Party) leader Jerry Rubin addressed a crowd of 2,000 outside the Student Union Building at UBC on October 24, 1968. His speech, which stressed the importance of personal freedom, instigated the overnight occupation by students of the Faculty Club. **Peter Hubert/** *Vancouver Sun*

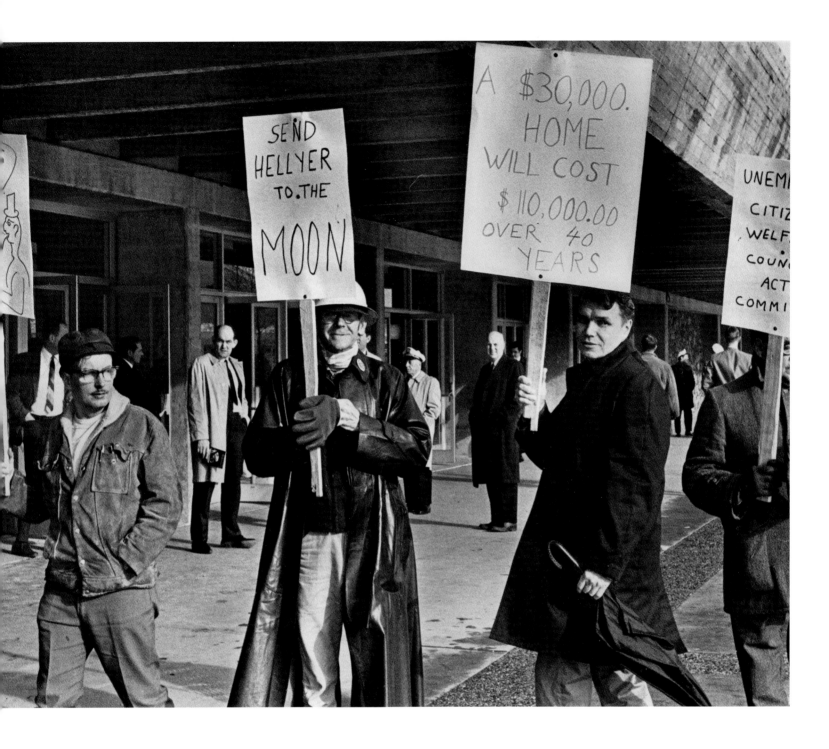

*Above:* A February 1969 demonstration at the Agrodome protested federal minister Paul Hellyer's controversial report on housing and urban development, which called for greater flexibility in Canada's mortgage loan system and the suspension of the "wholesale destruction of older housing." **George Diack/*Vancouver Sun***

*Facing top:* On East Pender Street, October 18, 1967, UBC students and other citizens protested the city of Vancouver's multi-million-dollar freeway proposal, which was slated to cut through Chinatown, destroying the district's character. **Ralph Bower/ *Vancouver Sun***

*Facing bottom:* Young people protested outside the Vancouver police station on January 22, 1968, to complain that they were subject to evictions because they were hippies. **Ray Allan/*Vancouver Sun***

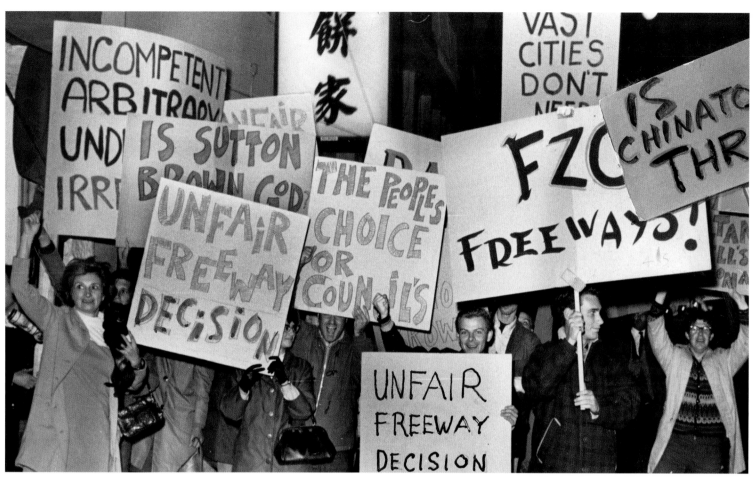

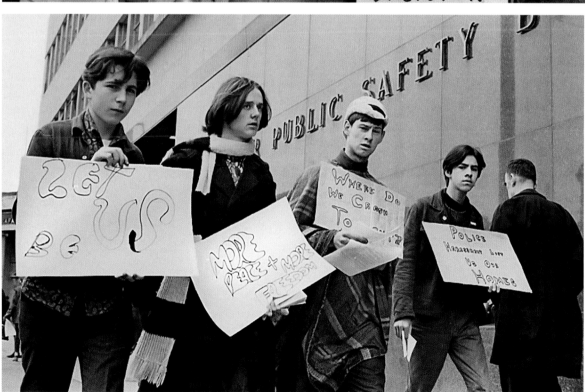

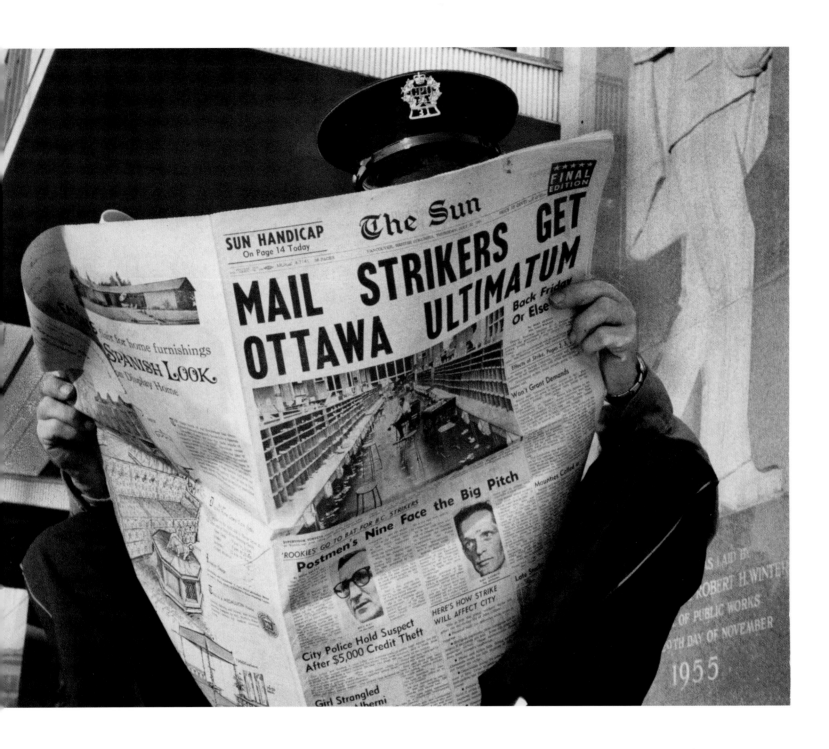

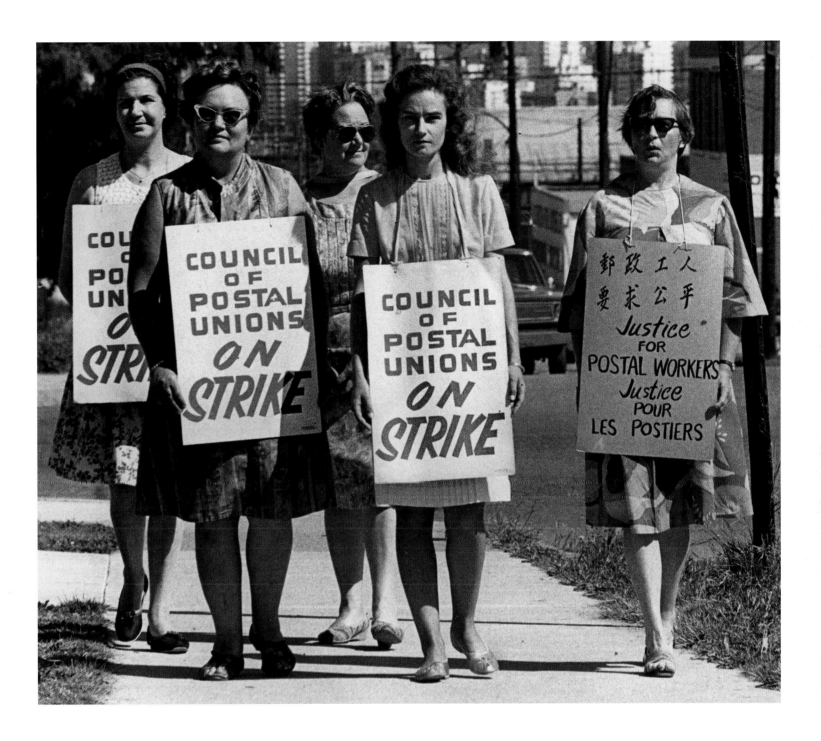

*Above:* Wives of striking postal workers, one bearing a three-language sign, joined the picket line outside the postal station on Pine Street in Vancouver on July 29, 1968. **Peter Hulbert/***Vancouver Sun*

*Facing:* Letter carrier Jack Anderson took time out from picketing in front of the Vancouver Post Office on July 22, 1965, to read about the postal strike in the *Vancouver Sun.* **Ken Oakes/** *Vancouver Sun*

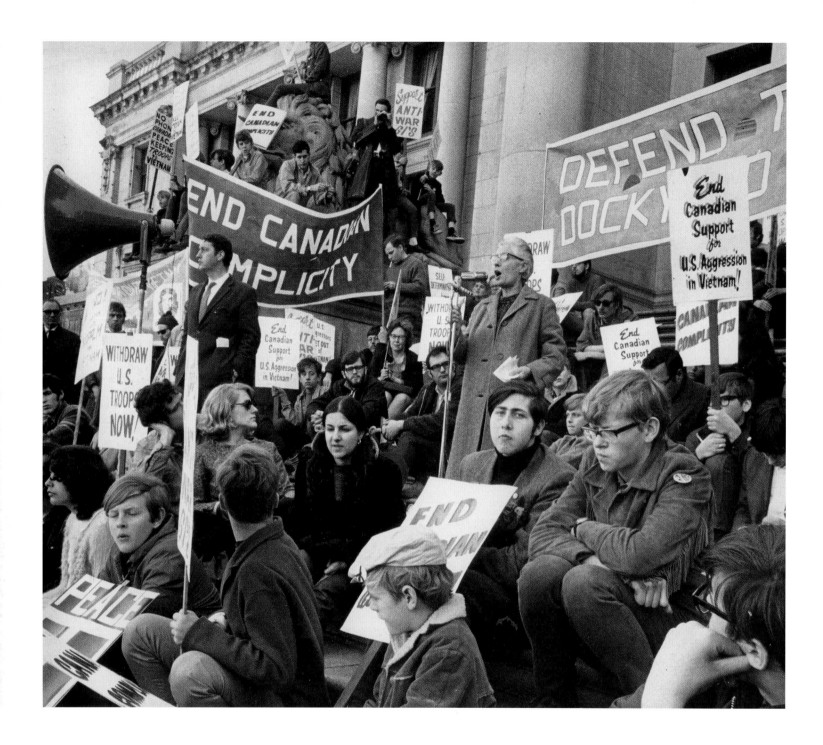

*Above:* Member of Parliament for Vancouver-Kingsway Grace MacInnis, the first woman from B.C. elected to the House of Commons and the only female MP elected in the 1968 election, addressed a protest rally against the U.S. war in Vietnam at the Vancouver courthouse on April 6, 1969. **Ross Kenward/*Province***

*Facing:* 2,000 marchers protesting the Vietnam war held up traffic along Broadway on their trek to the Vancouver courthouse on March 26, 1966. The march was the biggest protest demonstration against U.S. foreign policy to date. ***Province***

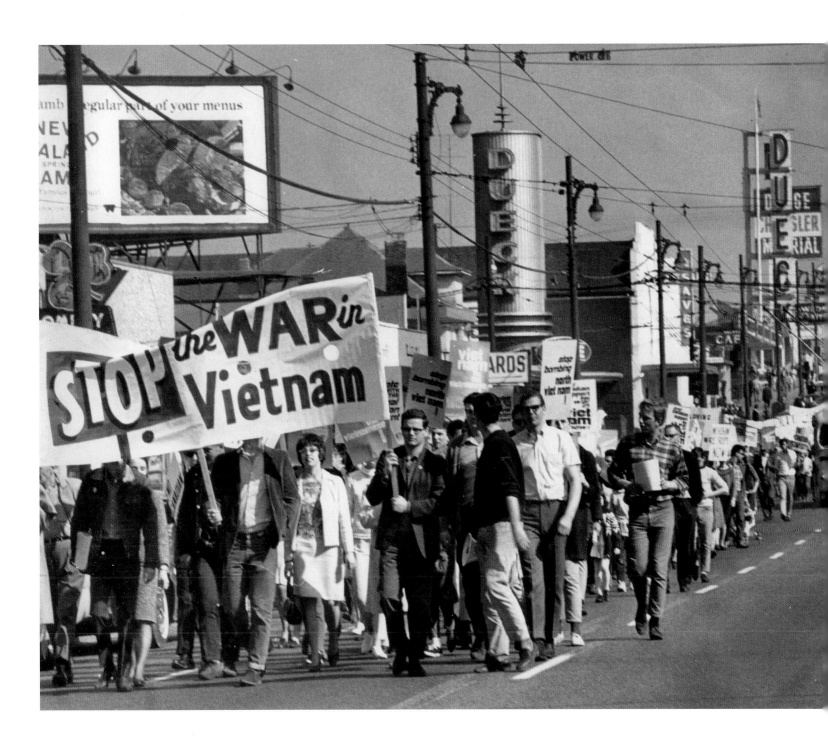

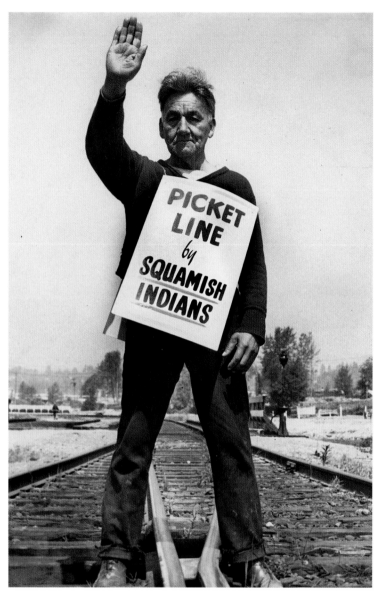

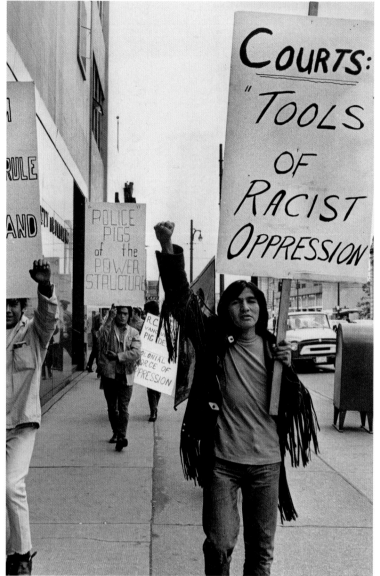

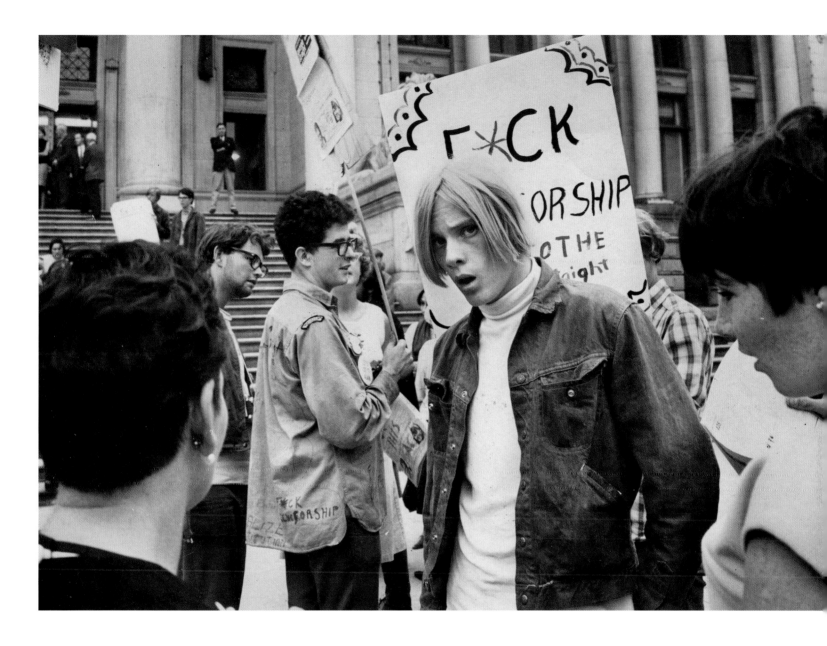

*Above:* At a September 28, 1967, protest at the Vancouver courthouse against the suspension of the *Georgia Straight*'s business license for gross misconduct and indecency, the paper's editor Dan McLeod stated that "even those who pay lip-service to the credo of freedom of the press were shocked to hear that a collector of a $12.50 business license fee has the power to close down a newspaper of 70,000 circulation." **Bill Cunningham/***Province*

*Facing left:* When a CNR work crew started rebuilding railway track through North Vancouver's Mission Reserve on June 10, 1964, three First Nations pickets appeared. The protesters left when they were convinced that the workmen planned no further impingement on their land. **Bill Cunningham/** *Province*

*Facing right:* Demonstration by the Native Alliance for Red Power outside the Vancouver police station on May 24, 1969. **Dan Scott/***Vancouver Sun*

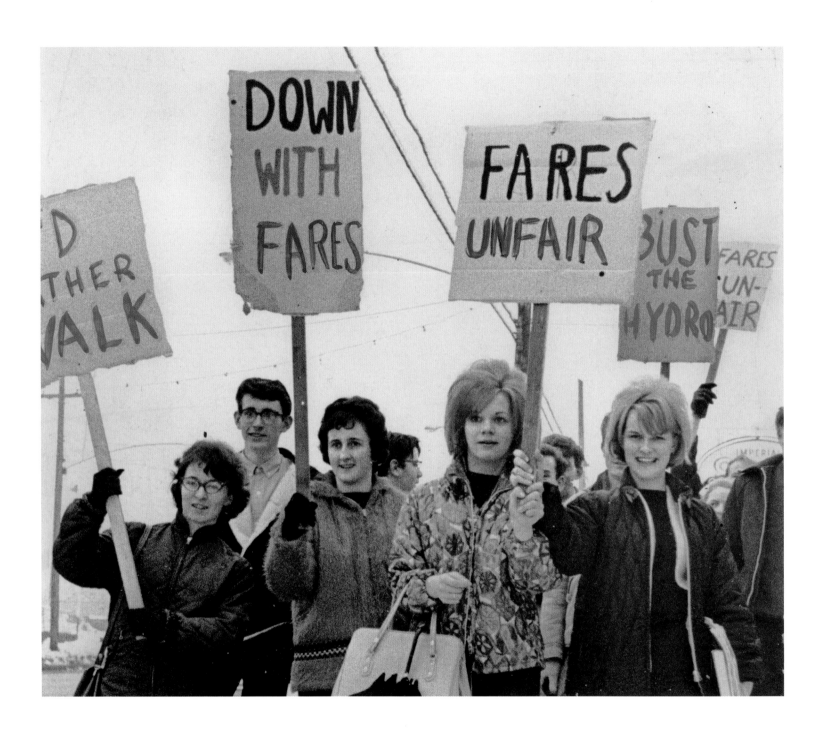

*Above:* Young people on Lonsdale Avenue in North Vancouver protested BC Hydro, which operated transit in Vancouver until 1979, over the rising cost of bus fares on January 9, 1965. **George Diack/***Vancouver Sun*

*Facing:* In May 1965, Mike Wisnici, Peter Light, and Rosemary Salgo trained in how to resist forced evacuation for an upcoming demonstration against nuclear warheads at the Comox RCAF base. **Ken Oakes/***Vancouver Sun*

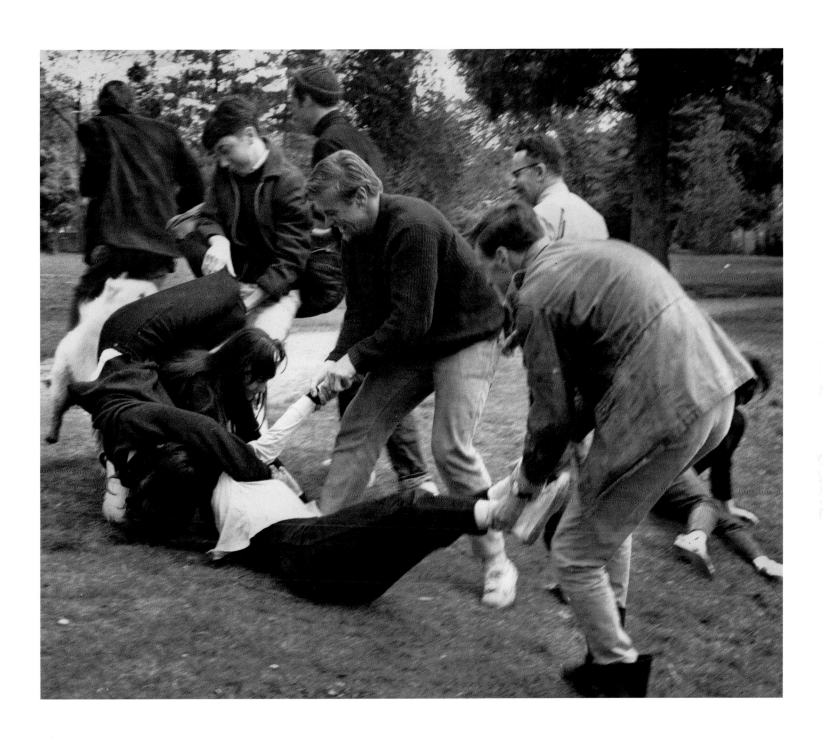

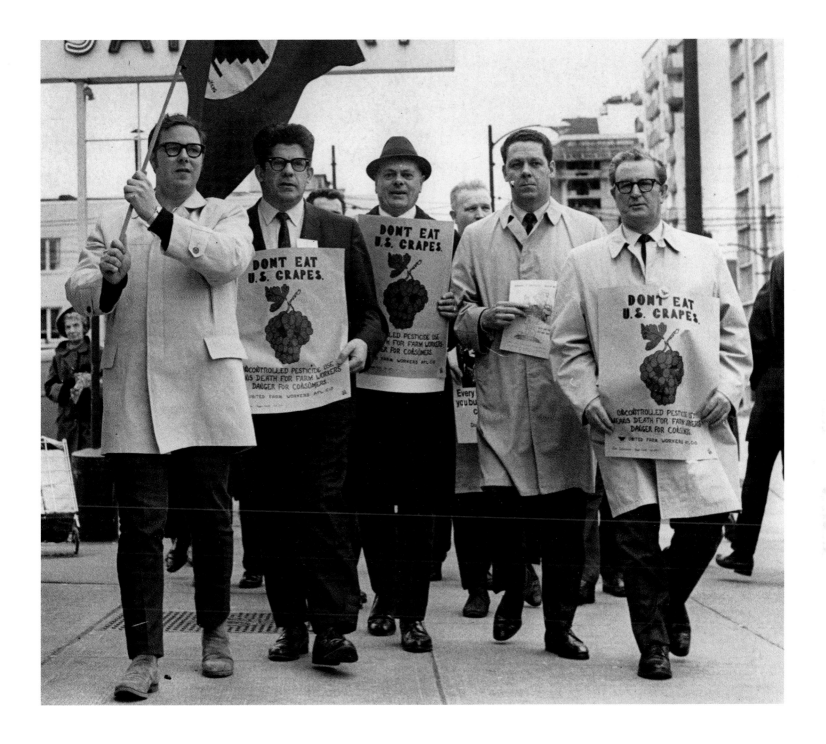

*Above:* Members of the United Farm Workers picketed a Safeway grocery store in November 1969 about pesticides on U.S. grapes. **Ray Allan/***Vancouver Sun*

*Facing:* Sixty housewives and their children protested the high cost of meat and groceries at the Woodward's food store at Oakridge shopping centre on June 3, 1969, the second day of food price demonstrations around Vancouver. **Dan Scott/***Vancouver Sun*

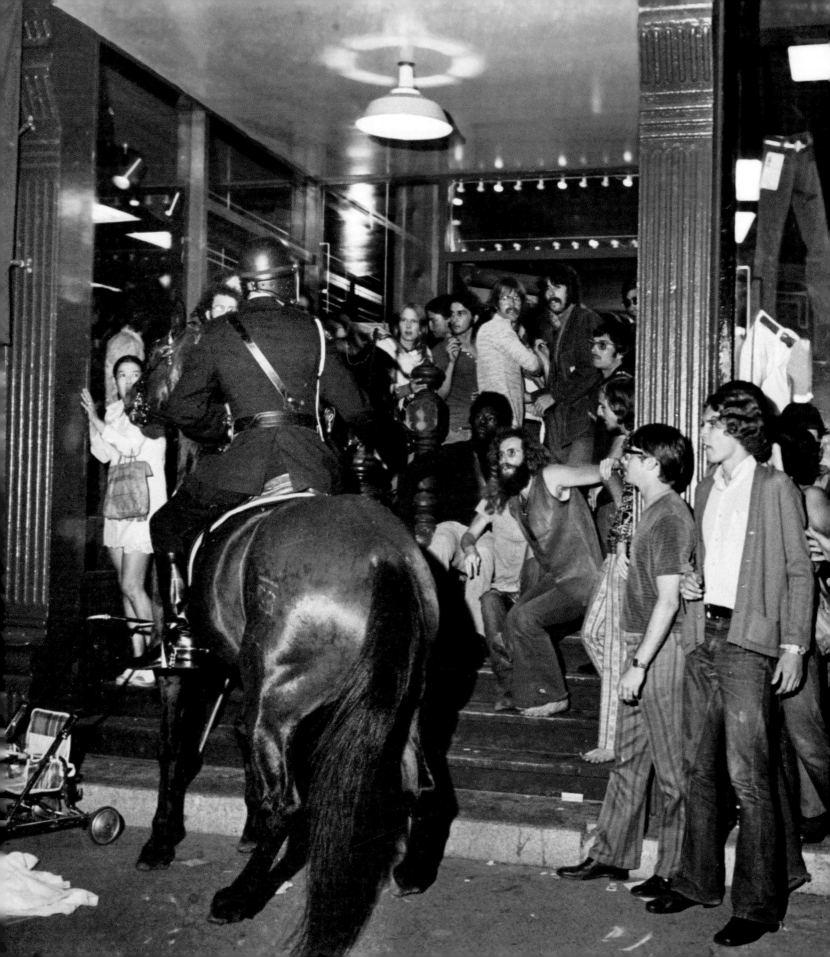

When Mayor Tom Campbell was asked in a 1970 CBC interview what he thought should be done about the hippies, he replied, "Personally I'd just as soon they leave town. They want all the rights and to contribute nothing. Think what would happen if our country continued this way. Within the next two generations there wouldn't be a country. If these young people do get their way they will destroy Canada, and from what I hear across the world, they will destroy the world."

That summer, Campbell equipped the Vancouver Police Department with riot helmets and thirty-six-inch riot batons, effectively declaring war against the city's hippies and transient young people. And while the purchase of riot gear was hotly debated and widely protested, it was put to frequent use over the next few years.

Battles waged between police and young people in 1970 included the English Bay riots in July and the Battle of Jericho in October. Further clashes throughout 1971 culminated in the infamous Gastown Riot on August 7, when mounted police with riding crops charged the crowd at a pro-marijuana rally in Maple Tree Square.

*Vancouver Sun* photographer Glenn Baglo was called before Justice Thomas Dohm's inquiry into the police handling of the Gastown Riot and questioned by George Murray, the lawyer representing the city's police union. While the police claimed they ordered Baglo to disperse for fear that his camera flash would blind them to flying objects, Baglo testified that his flash "lasted one fifty-thousandth of a second" and that the real reason was that "police did not want a record of what was happening."

MURRAY: *Do you consider that after this order to disperse you—as a photographer for the* Sun—*had a free right to range anywhere in the area you wanted?*

BAGLO: *Yes, under my police press card.*

MURRAY: *What legal right does that give?*

BAGLO: *The right to photograph what was happening as a representative of the* Vancouver Sun.

*Facing:* On August 7, 1971, a peaceful pro-marijuana rally turned into the Gastown Riot when police charged the crowd of 2,000, beat them with riot sticks, and charged seventy-nine people. The Dohm inquiry into the riot found that officers used "unnecessary, unwarranted and excessive force."
Glenn Baglo/*Vancouver Sun*

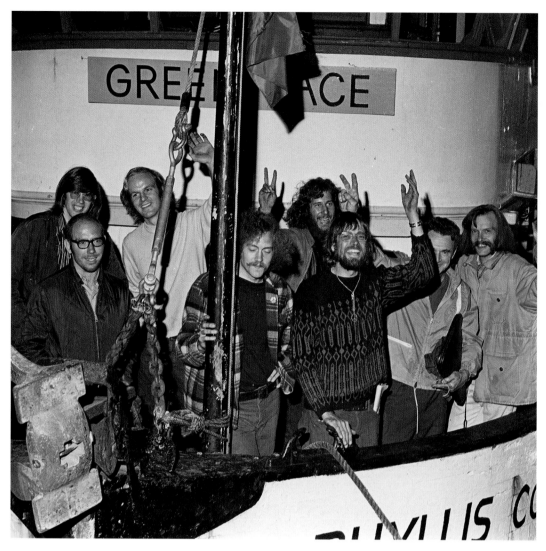

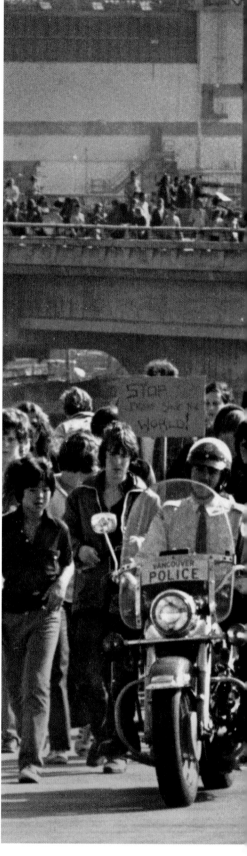

*Above:* A Greenpeace crew manning the *Phyllis Cormack* prepared to set sail on September 15, 1971, to protest the 5-megaton Amchitka nuclear test. Shown are Patrick Moore (front centre, plaid jacket), photographer Rex Wyler (right rear, leather jacket), *Vancouver Sun* reporter Bob Hunter (far right), and others. **Ken Allen/*Province***

*Facing:* On October 6, 1971, 10,000 students from twenty-two Lower Mainland secondary schools demonstrated against the proposed Amchitka nuclear test. **Ross Kenward/*Province***

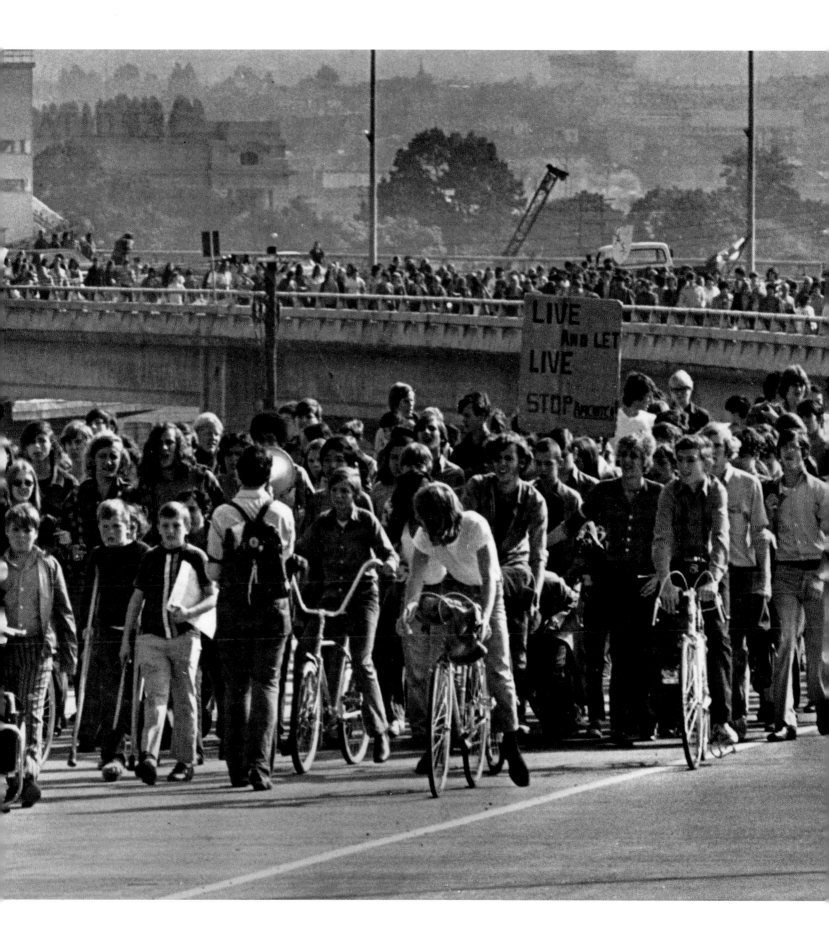

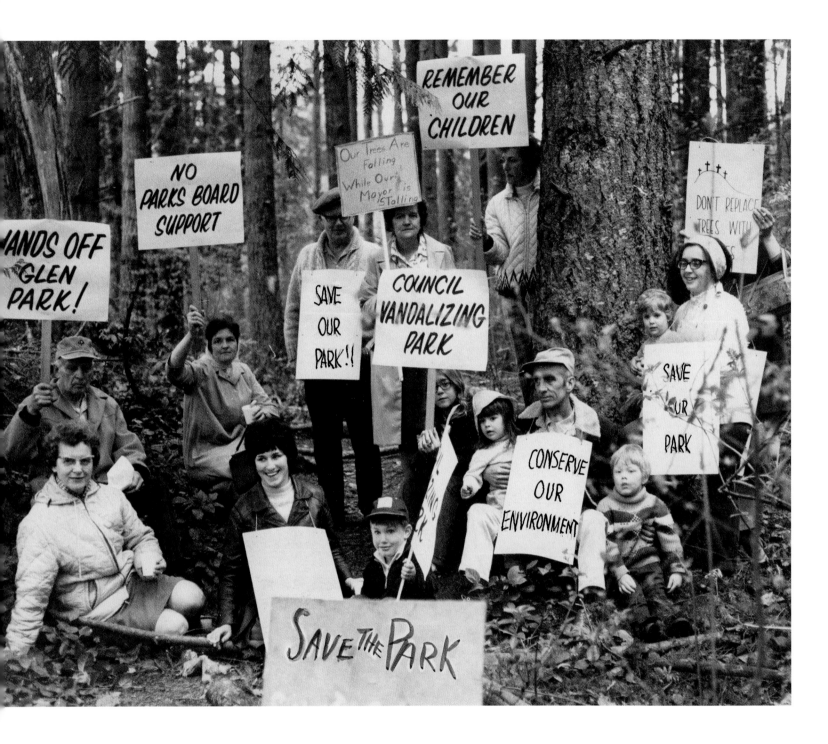

Above: Coquitlam members of SPEC (Society Promoting Environmental Conservation) protested the district's proposed truck route through Glen Park on April 27, 1971. **Peter Hulbert/ Vancouver Sun**

Facing: Protest demonstration by twenty-five Port Moody housewives at the Gulf Oil offices at 1075 West Georgia Street on September 25, 1970, against noise and air pollution at the Gulf refinery in Port Moody. **Gord Croucher/Province**

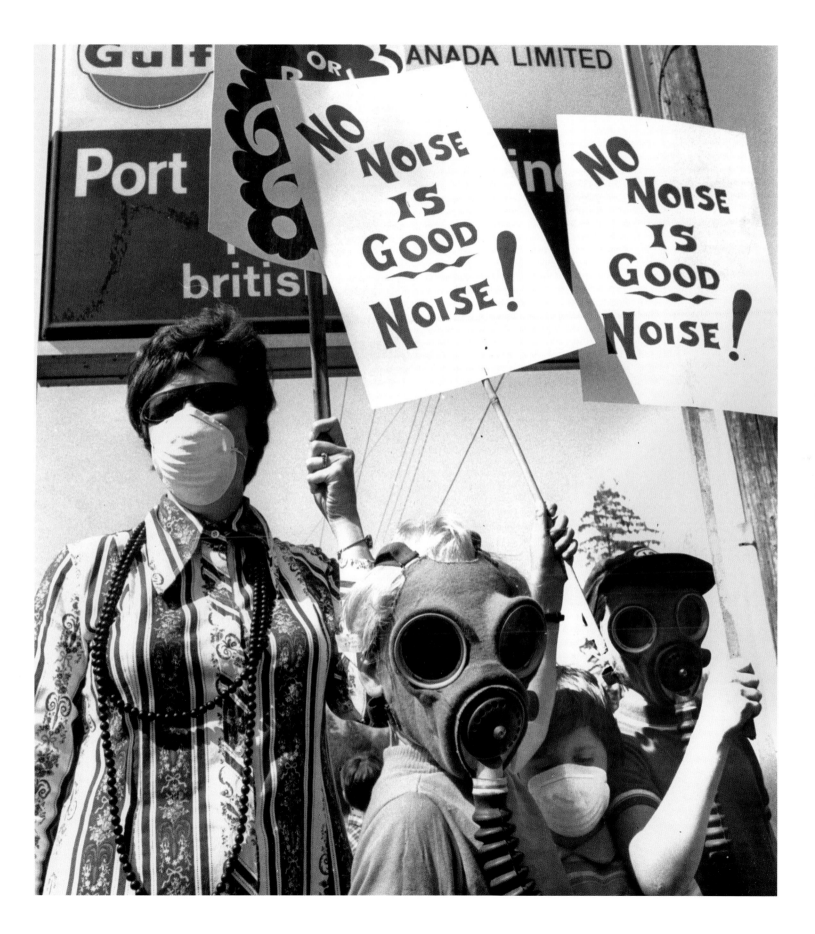

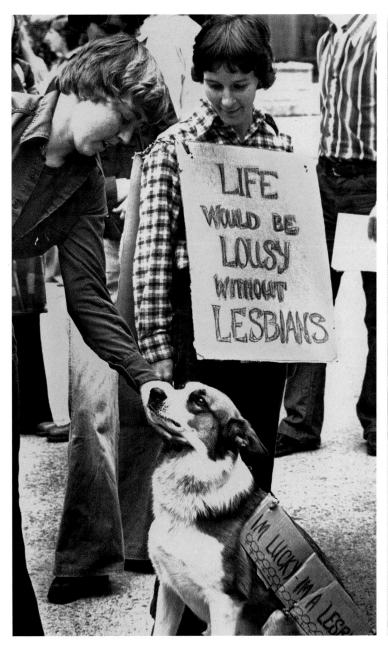

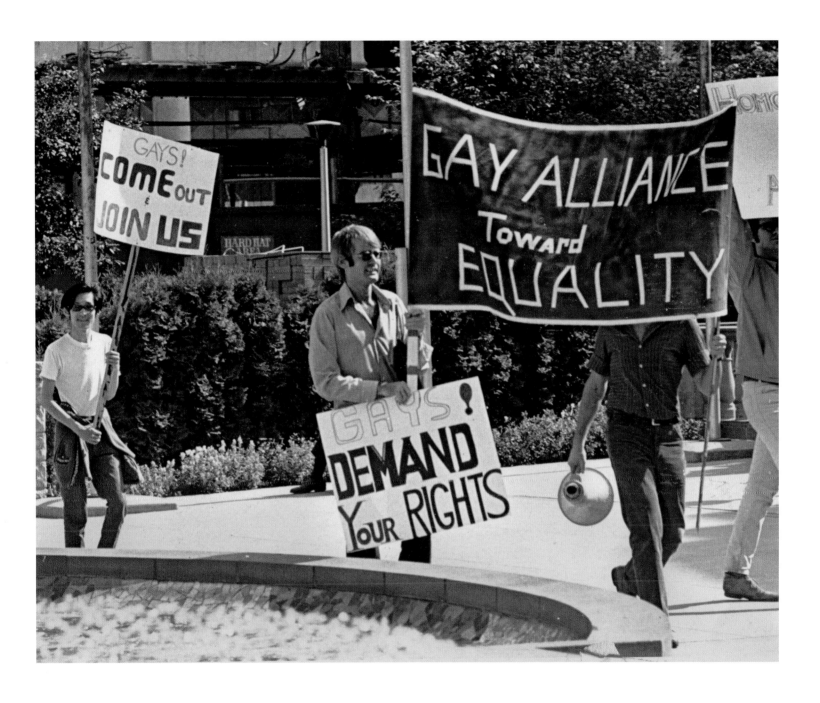

*Above and facing right:* The first gay rights demonstration in Vancouver by Gay Alliance towards Equality at the Vancouver courthouse on August 28, 1971. **Dave Paterson/***Province*

*Facing left:* Lesbians at a June 1977 gay rights demonstration. **Dan Scott/** *Vancouver Sun*

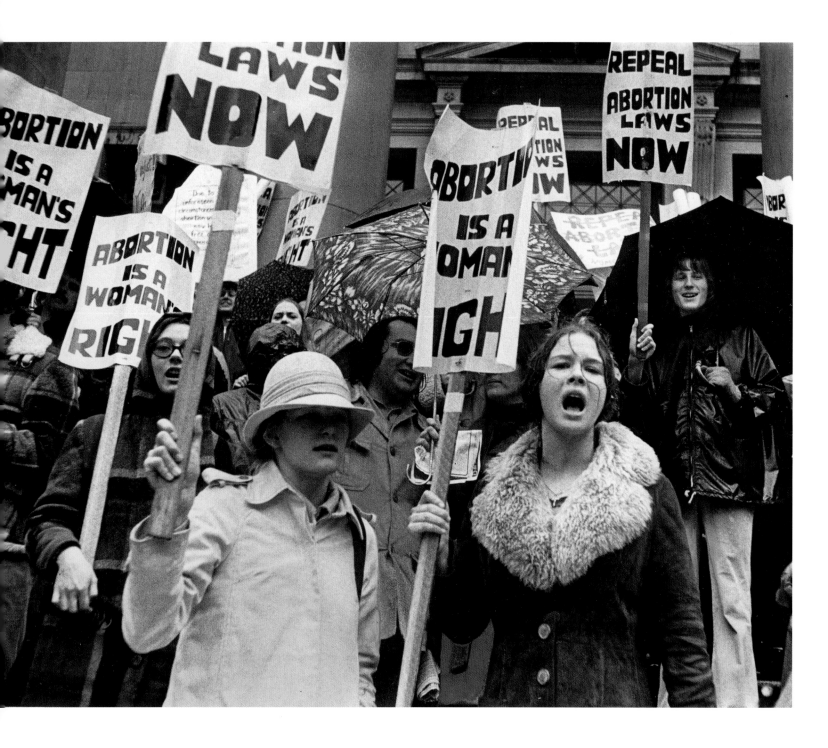

*Above:* Protesters at the Vancouver courthouse on March 9, 1974, demanded the removal of abortion from the Criminal Code and called for the federal government to drop charges against Dr. Henry Mortgentaler. **Dan Scott/*Vancouver Sun***

*Facing top:* A protest demonstration at the Vancouver General Hospital on May 12, 1974, after a report that some hospitals were performing late-term abortions. **Dan Scott/*Vancouver Sun***

*Facing bottom:* Members of the B.C. Abortion Law Repeal Coalition and pro-choice protesters clashed on November 20. 1971. The photographer noted, "this woman kept up a curbside march of her own. The marchers gave her hell for miles. She called them baby killers." **Bill Cunningham/*Province***

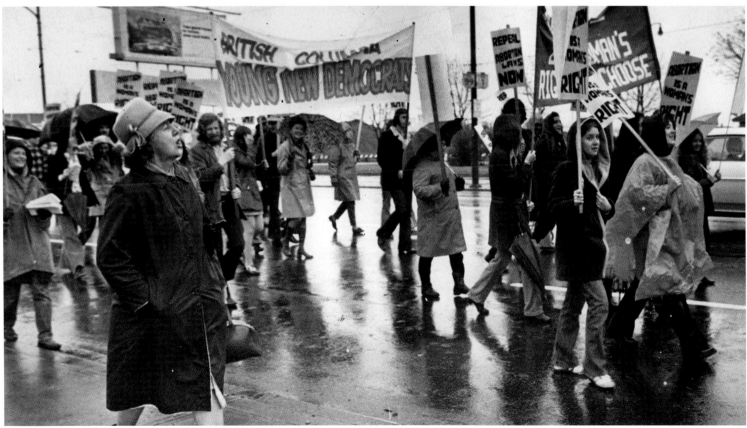

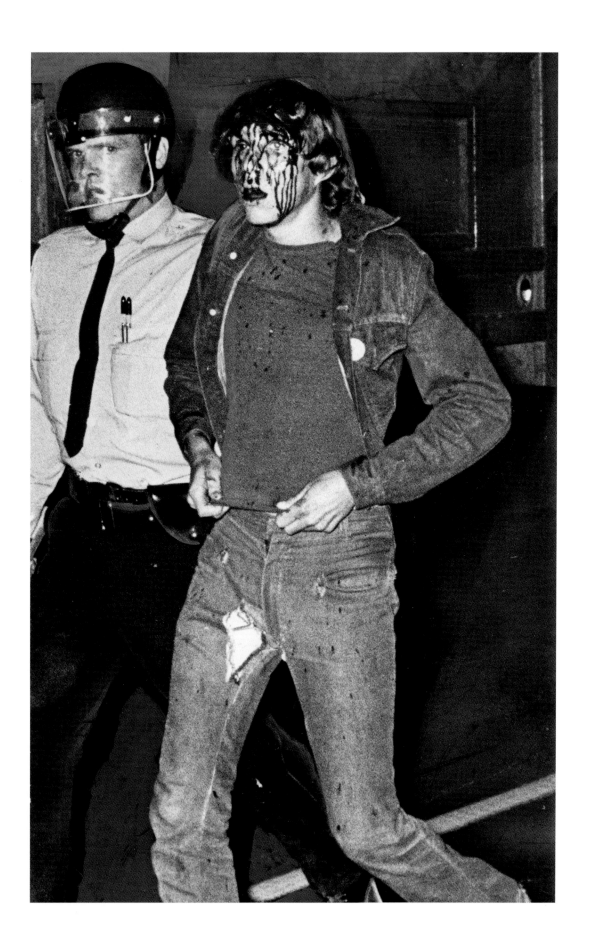

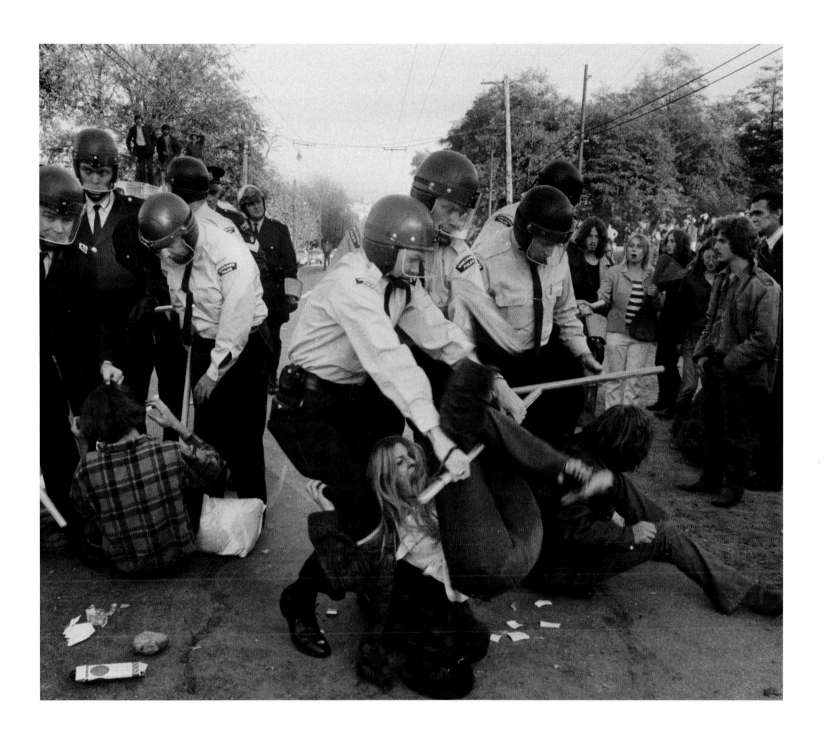

*Above:* On October 15, 1970, in what was dubbed the Battle of Jericho, police evicted squatters who, for six weeks, had occupied empty military barracks at the Jericho armed forces base. **Ken Oakes/** *Vancouver Sun*

*Facing:* A man is arrested on July 14, 1970, at the English Bay riot, where two hundred young people battled forty riot-equipped police for ninety minutes. There were three violent clashes between Sea Festival revelers and police that week, leading to cancellation of the outdoor dances. **Dan Scott/***Vancouver Sun*

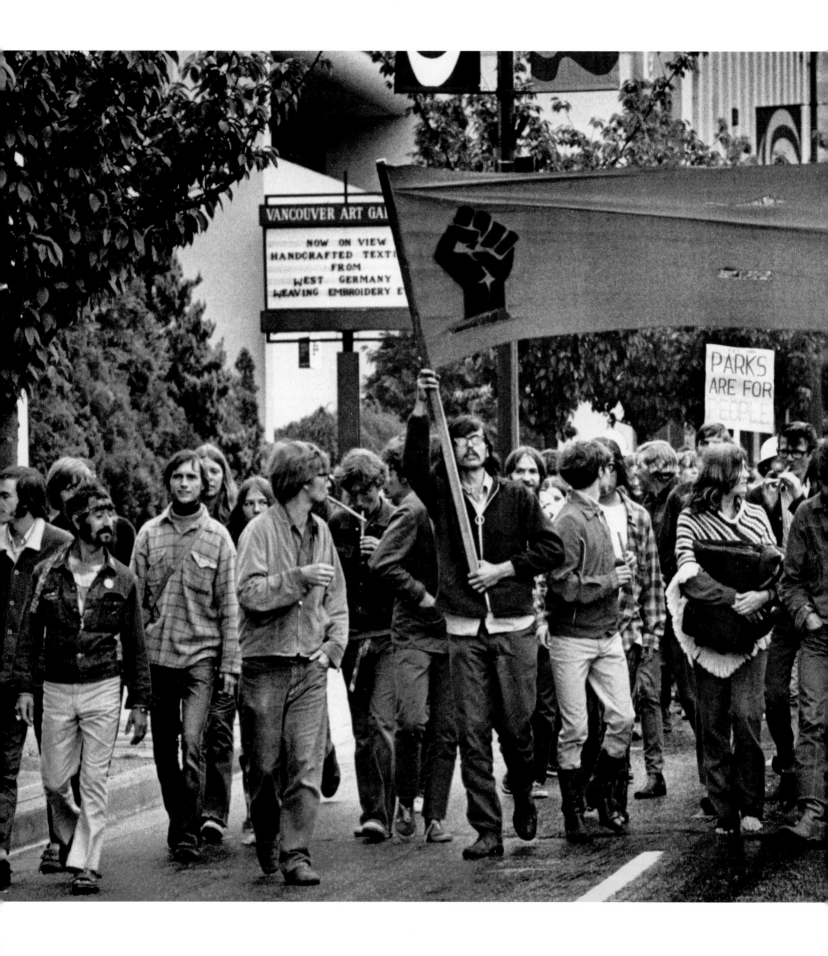

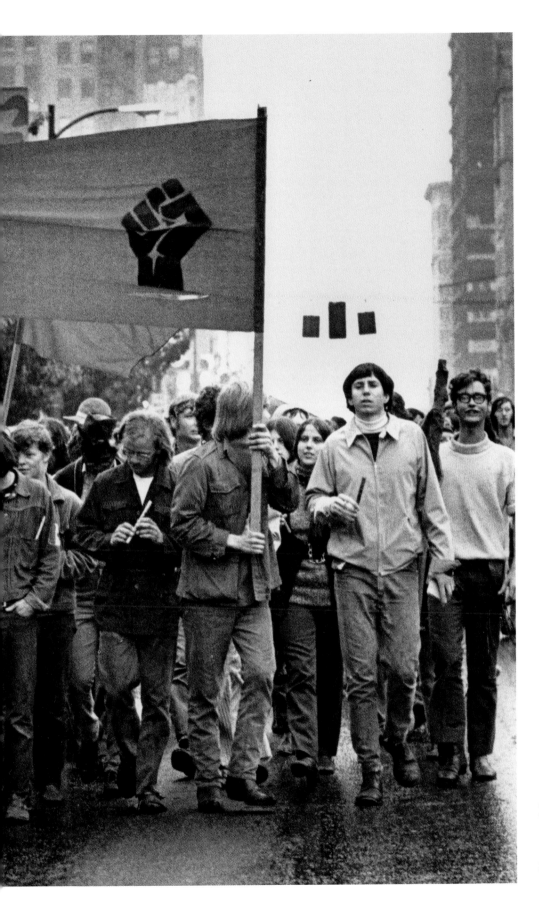

A June 1970 protest march by the Vancouver Liberation Front on Georgia Street near the Vancouver Art Gallery protested police harassment of transient youth in parks and on beaches. **Dan Scott/** *Vancouver Sun*

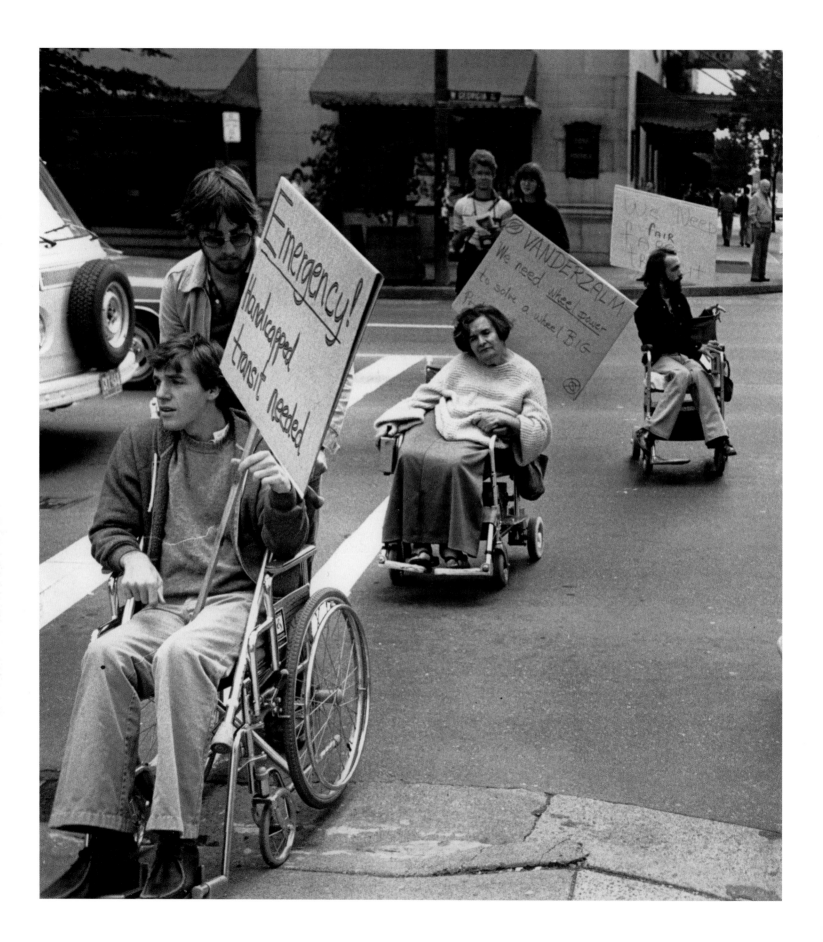

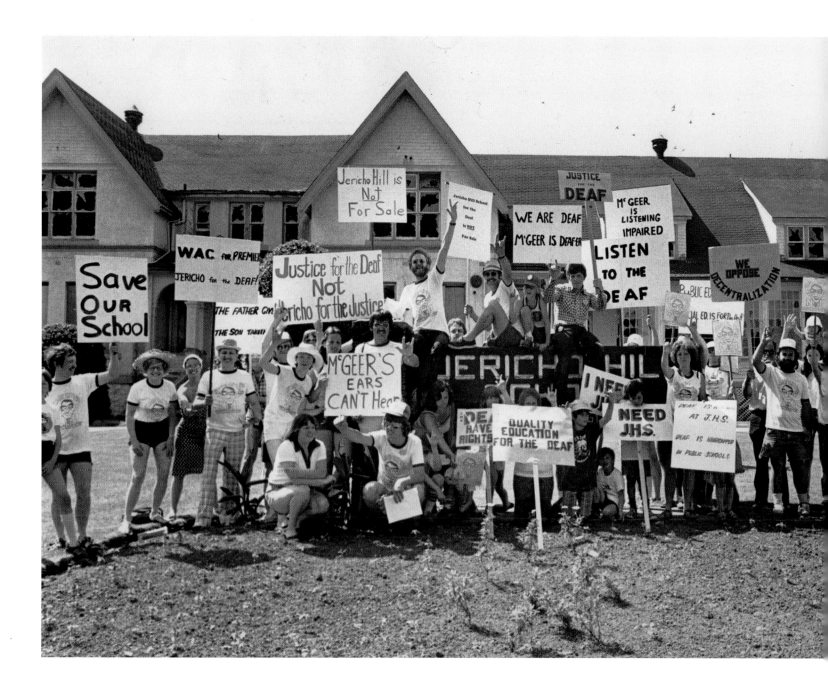

*Above:* On June 3, 1978, parents and students at the Jericho Hill School for the Deaf protested the provincial government's plan to decentralize deaf education and the decision to locate the Justice Institute at Jericho Hill, displacing the school for the deaf. Deni Eagland/*Vancouver Sun*

*Facing:* Protest demonstration by a group of disabled citizens on September 23, 1979, regarding the need for better transit. John Denniston/*Province*

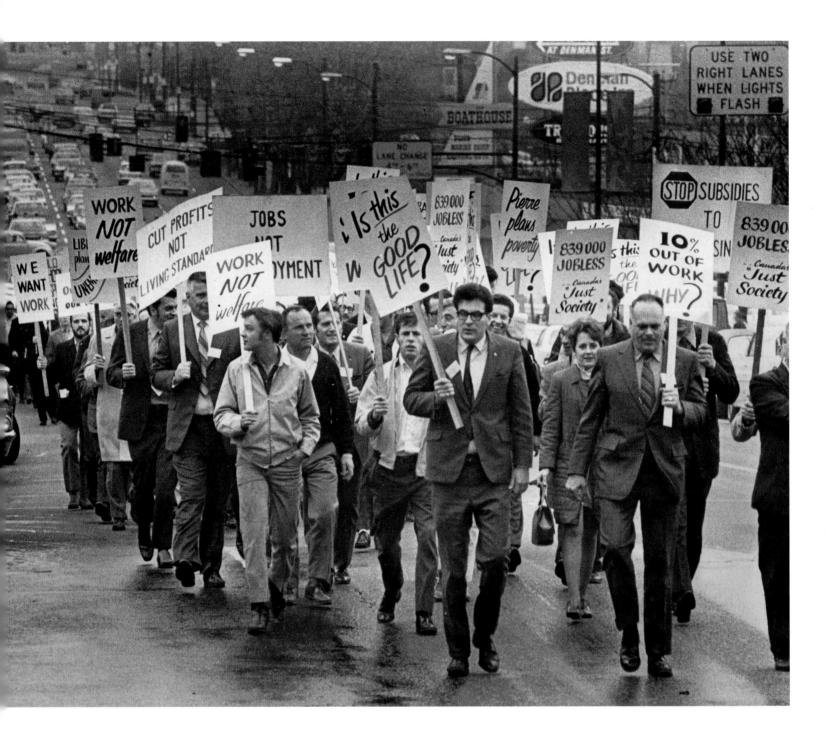

*Above:* Two hundred delegates from the BC Federation of Labour convention marched on November 5, 1970, to protest the unemployment rate of 8.8 percent in B.C. **Ross Kenward/*Province***

*Facing top:* A May Day 1970 protest by Hospital Employees' Union workers was critical of Health Minister Ralph Loffmark's plan to reduce hospital staff. **Ralph Bower/*Vancouver Sun***

*Facing bottom:* Protesters demonstrated on May 16, 1976, against fare increases and the loss of commuter cards on BC Ferries between Horseshoe Bay and Langdale. **Ken Oakes/*Vancouver Sun***

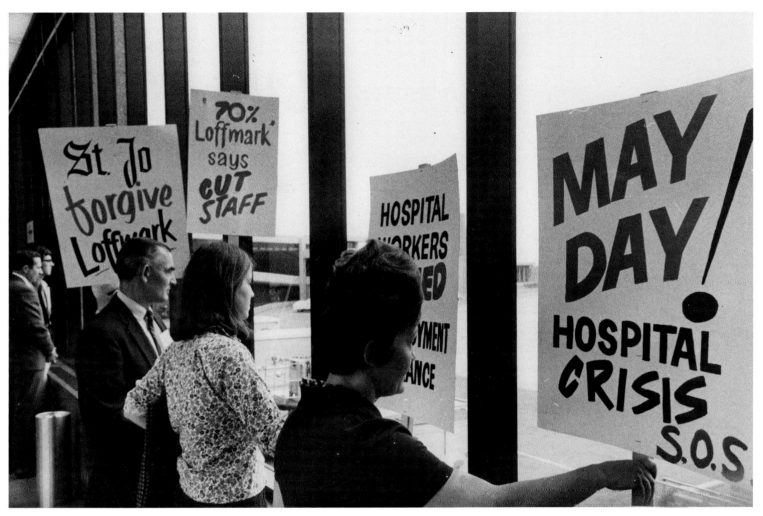

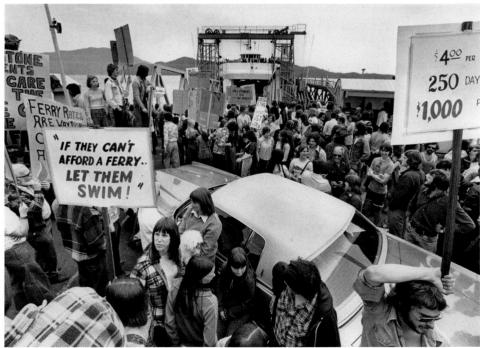

91

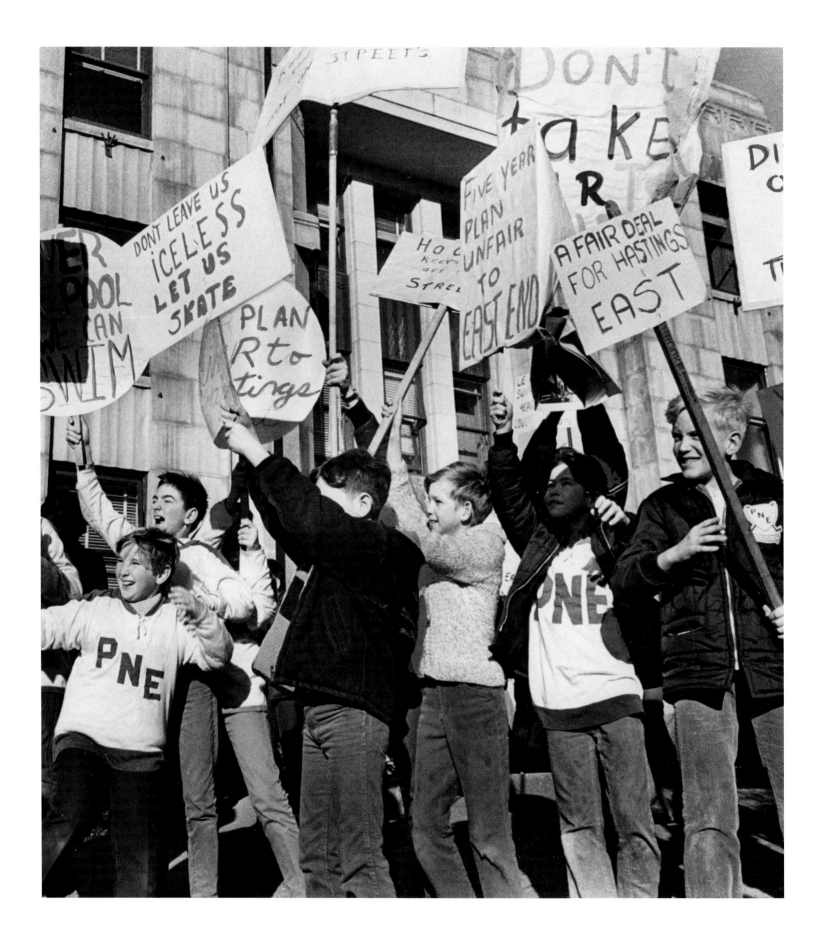

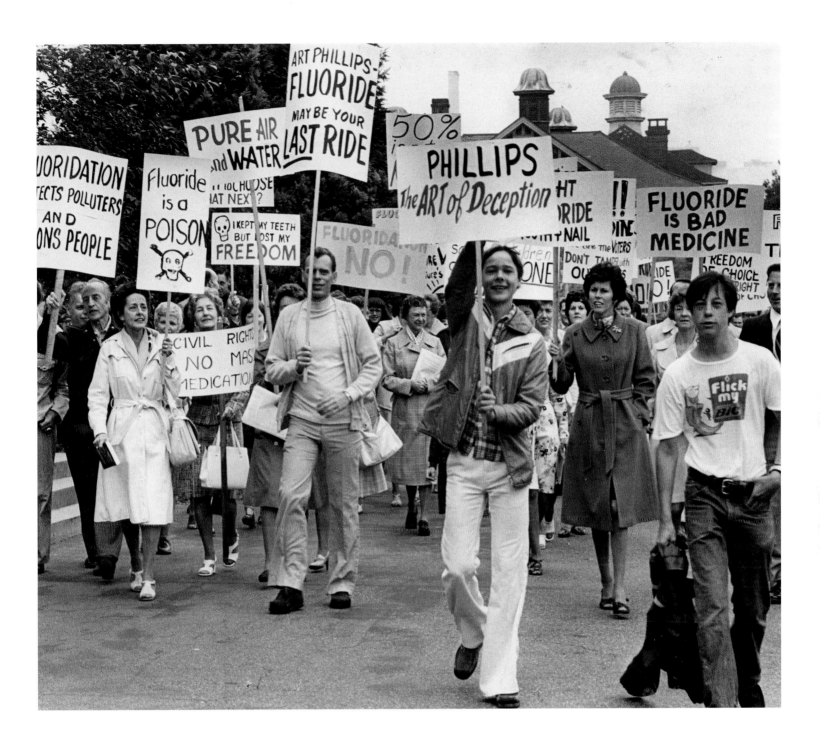

*Above:* A protest demonstration on August 24, 1976, at Vancouver City Hall against fluoride being added to Vancouver's drinking water. The result of the protest campaign was that there is still no fluoride in Vancouver water. **Deni Eagland/*Vancouver Sun***

*Facing:* East Hastings kids demanded an ice rink and other sports facilities for their neighbourhood at Vancouver City Hall on January 2, 1970. **Ray Allan/*Vancouver Sun***

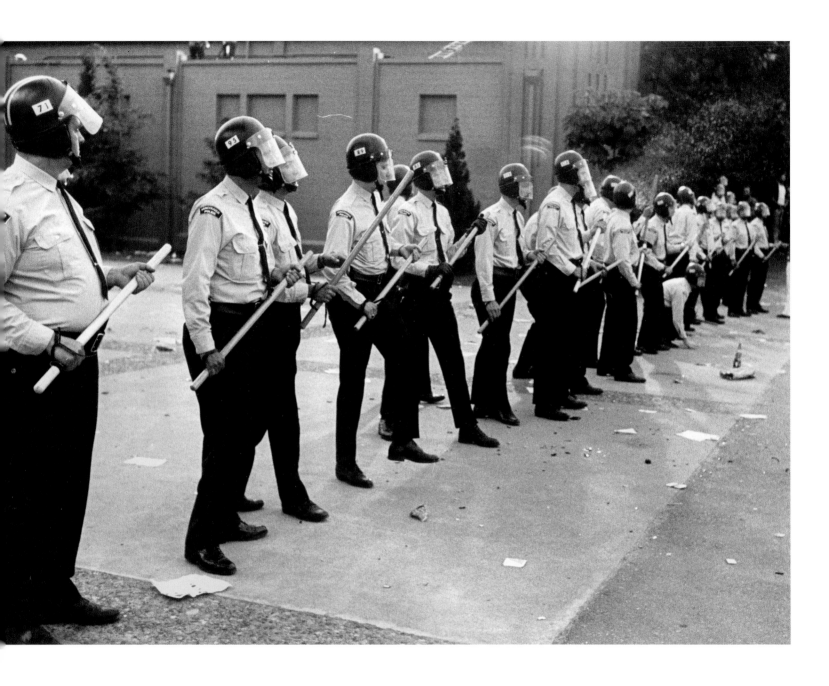

*Above:* During the Rolling Stones concert at the Pacific Coliseum on June 3, 1972, 285 police clashed with 2,000 would-be concert goers, including members of the notorious Clark Park gang, some of whom threw rocks, bottles, and Molotov cocktails. Twenty-two people were arrested and thirty-one police officers injured. **Dan Scott/*Vancouver Sun***

*Facing:* On September 28, 1976, prisoners went on a rampage in the most destructive riot in the hundred-year history of the B.C. Penitentiary. An entire cell block was destroyed, and damages were estimated at 1.6 million dollars. **Peter Hulbert/*Province***

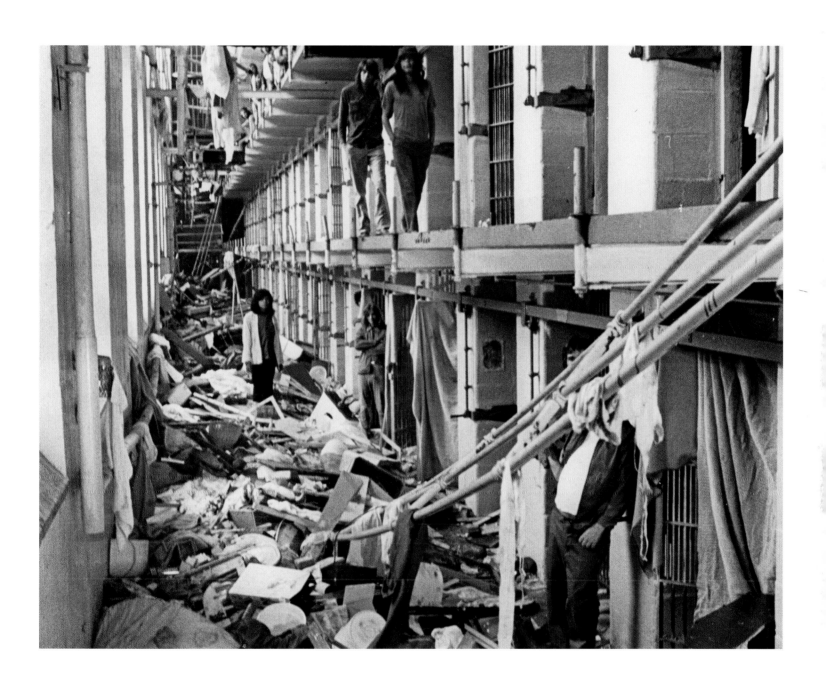

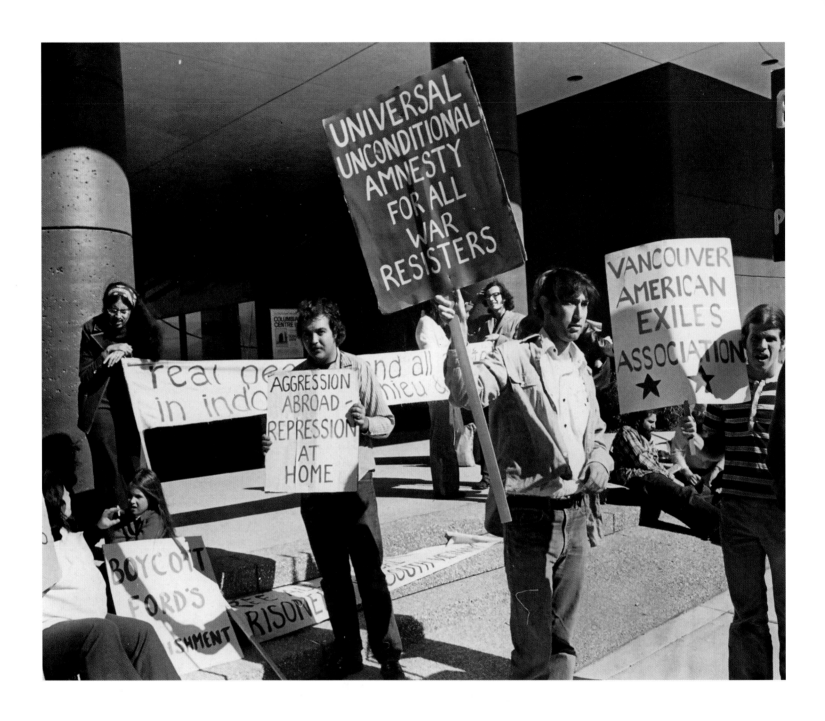

*Above:* In October 1974, exiled American war resisters protested U.S. President Gerald Ford's offer of conditional amnesty for Vietnam draft evaders and deserters, which required reaffirming their allegiance to the U.S. and serving two years in a public service job. Many war resisters chose to become Canadian citizens. **Ralph Bower/***Vancouver Sun*

*Facing:* A September 1974 protest demonstration at the Vancouver courthouse's north plaza for First Nations hereditary rights. **Ralph Bower/***Vancouver Sun*

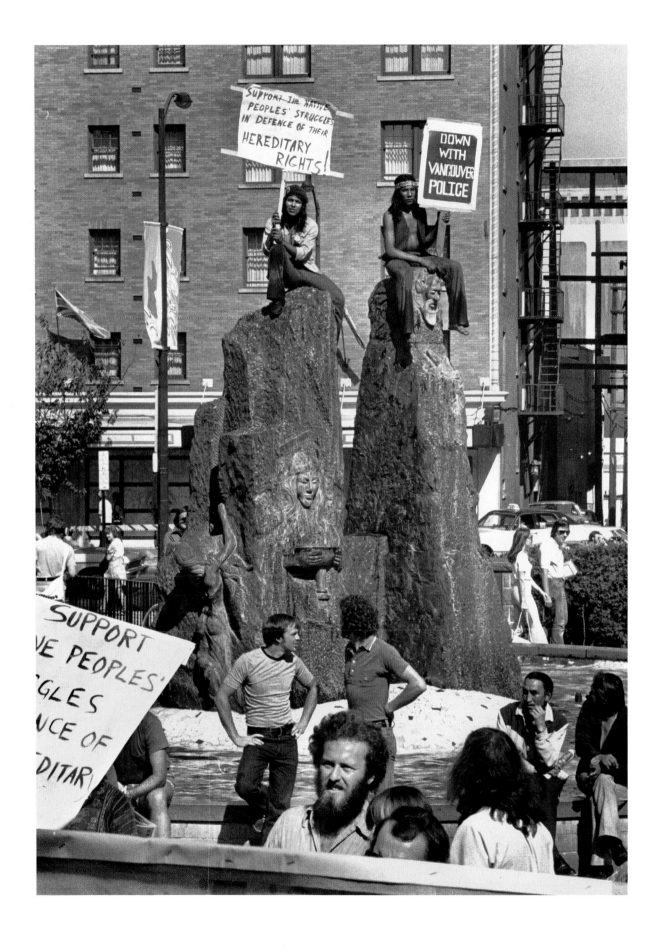

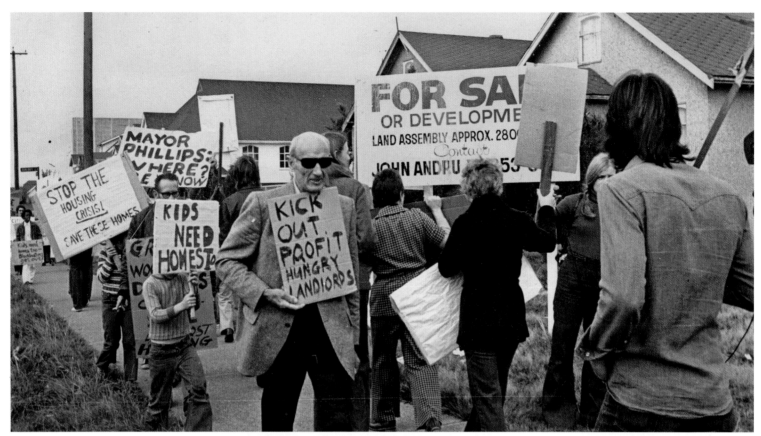

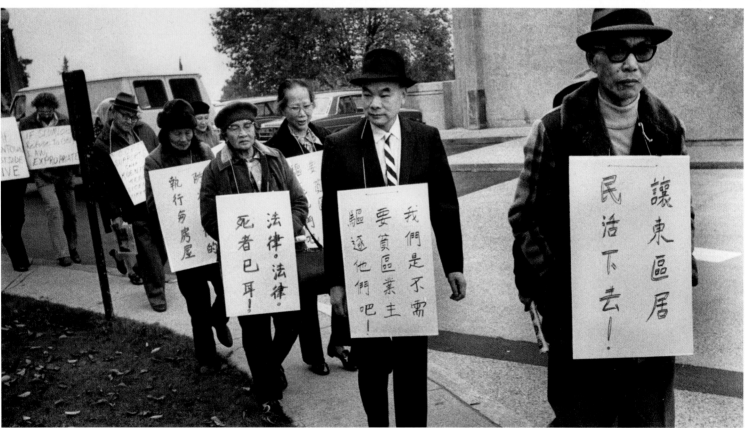

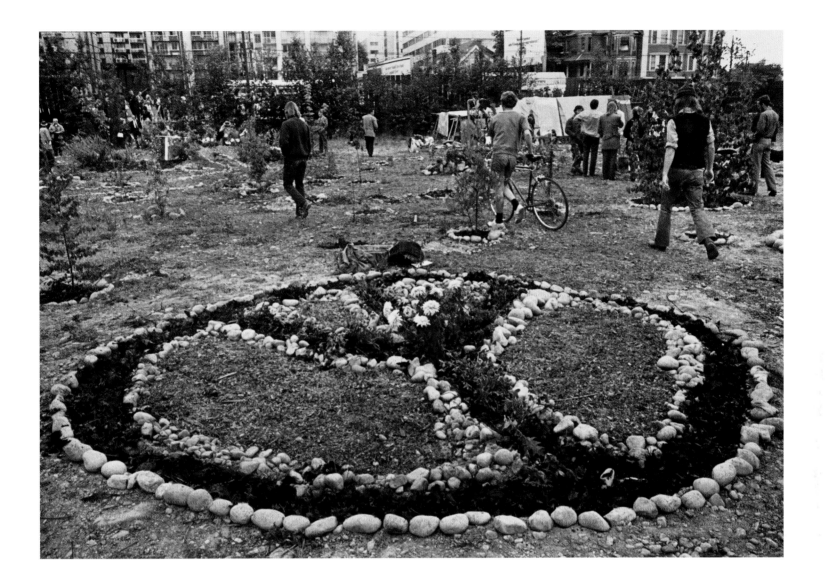

*Above:* A peace sign garden at All Seasons Park, the proposed site for a Four Seasons hotel at the entrance to Stanley Park, on May 30, 1971. The protest site was occupied by people opposed to the development for more than a year, until the government scrapped the plan. **Gordon Sedawie/** *Province*

*Facing top:* Residents and sympathizers picketed on September 28, 1975, in the 2500 block of East Pender to protest a land assembly housing development and to demand an anti-blockbusting bylaw. **Peter Hulbert/***Province*

*Facing bottom:* More than fifty Downtown Eastside residents picketed Vancouver City Hall on November 4, 1974, advocating strict enforcement of fire regulations a few days after a fire at the Georgia Rooms killed three. **Ralph Bower/***Vancouver Sun*

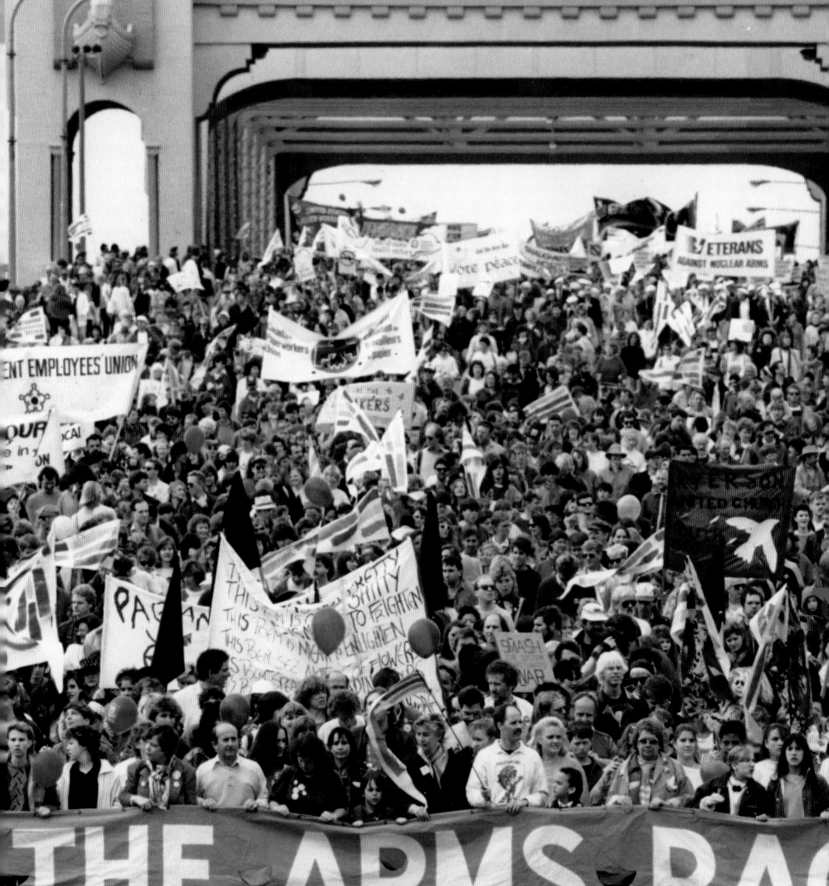

# 1980s

In 1983, Premier Bill Bennett's Social Credit government introduced a controversial fiscal restraint budget which dramatically slashed social spending, and the Solidarity movement was born. The broad coalition of trade unions, advocacy groups, and political bodies organized some of the largest protest demonstrations in Vancouver history, including a 40,000-strong rally at Empire Stadium.

While women continued their fight for gender and pay equity, and prostitutes campaigned for their human rights, reproductive rights championed by the Vancouver Women's Caucus in the 1970s were challenged by anti-choice organizations such as REAL Women. A strange alliance between the Christian right and feminists evolved over the issue of pornography, with demonstrators condemning the film *Caligula* and taking aim at sexist advertising portraying violence against women.

In an email referencing the 1980s Shame the Johns campaign, former *Sun* photographer Peter Battistoni wrote: "When West End residents started protesting prostitutes working on their streets, I covered a march one night that included a confrontation between citizens and some street thugs/pimps that escalated because there were, strangely, no police present. *Province* photographer Les Bazso was being harassed by one guy who was shouting and pushing him. I grabbed the guy to pull him off Les, and the guy swiped at me with a knife. I jumped back and neither Les nor I was injured, and the guy ran off."

For Direct Action and the Wimmin's Fire Brigade, local guerrilla activists influenced by radical groups in the U.S. and Europe, the time for peaceful protest was over and the time for militant action had arrived. In 1982, Direct Action, also known as the Squamish or Vancouver Five, bombed B.C. Hydro's Litton Industries, which produced guidance components for cruise missiles, and the Wimmin's Fire Brigade firebombed three Lower Mainland Red Hot Video stores to attack the burgeoning pornography industry. In January 1983, the Five were arrested and later received sentences ranging from six years to life.

*Facing:* Tens of thousands of British Columbians took over downtown Vancouver streets for the End the Arms Race peace march on April 23, 1988. The annual event, which some years included 80,000 participants, was a Vancouver institution in the 1980s. **Mark van Manen/*Vancouver Sun***

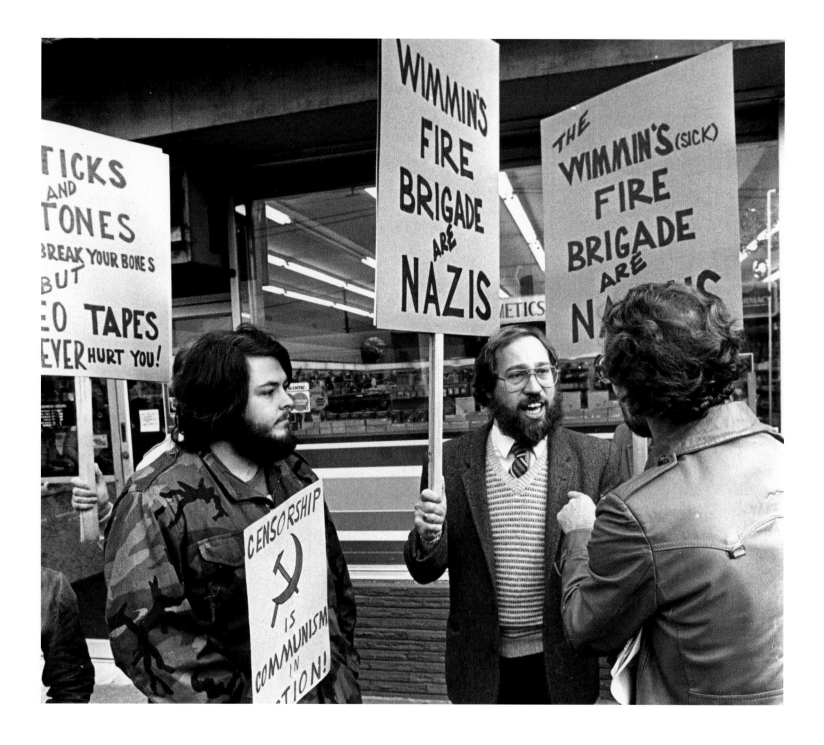

Above: Protesters demonstrated in December 1982 against the Wimmin's Fire Brigade anti-pornography group, condemning the censorship of pornography. **Ralph Bower/*Vancouver Sun***

Facing top: Members of People Against Pornography picketed the Red Hot Video store at 3223 Main Street in Vancouver on May 4, 1983. **Ralph Bower/*Vancouver Sun***

Facing bottom: Direct Action, aka the Squamish or Vancouver Five, and the Wimmin's Fire Brigade were responsible for the bombing of Litton Industries, a manufacturer of cruise missile components near Toronto, and Red Hot Video outlets in the Lower Mainland in 1982. **Ralph Bower/*Vancouver Sun***

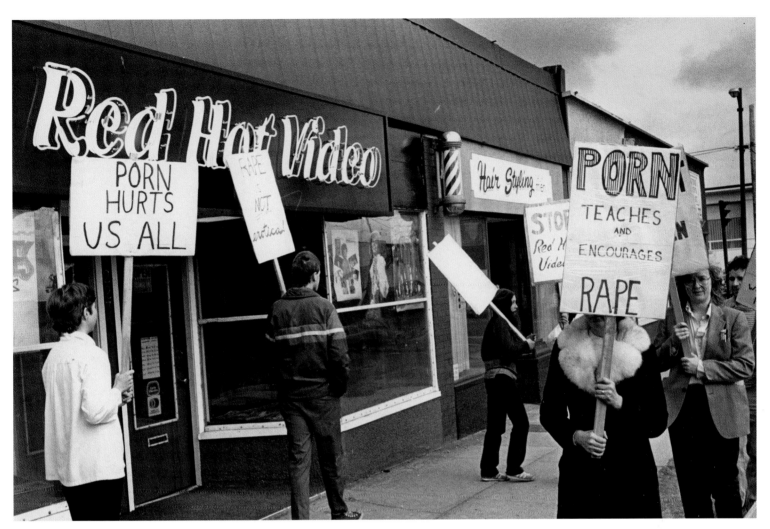

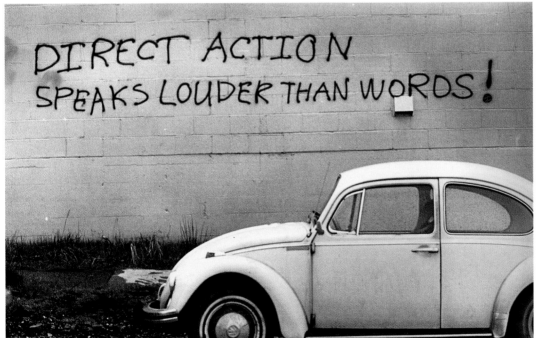

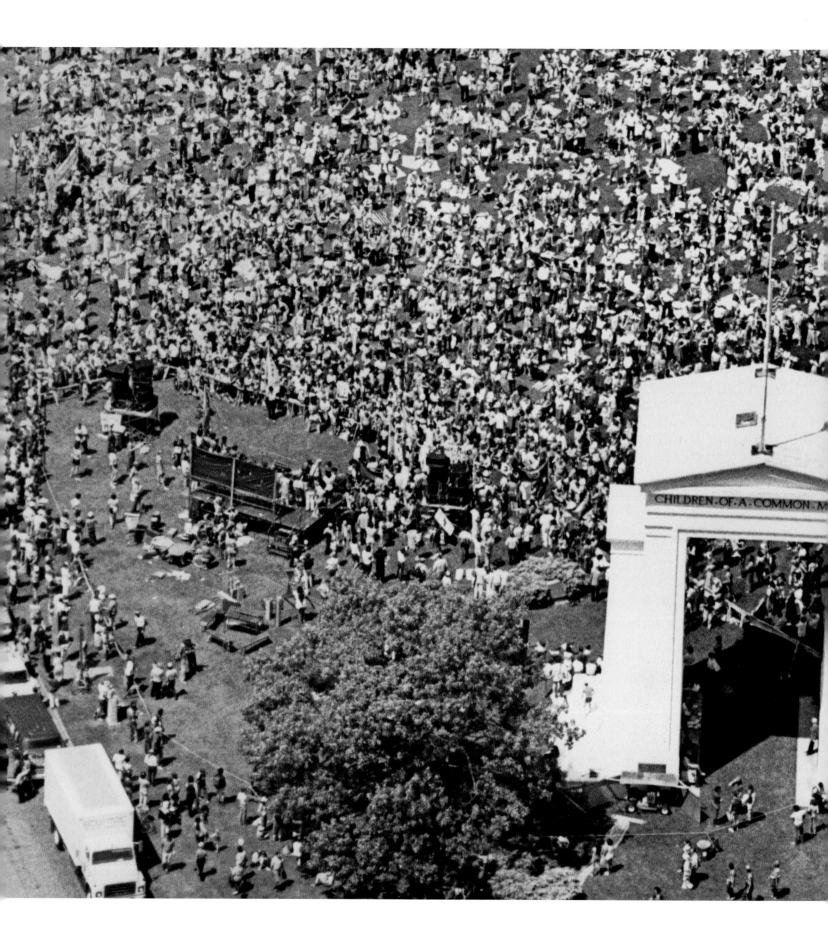

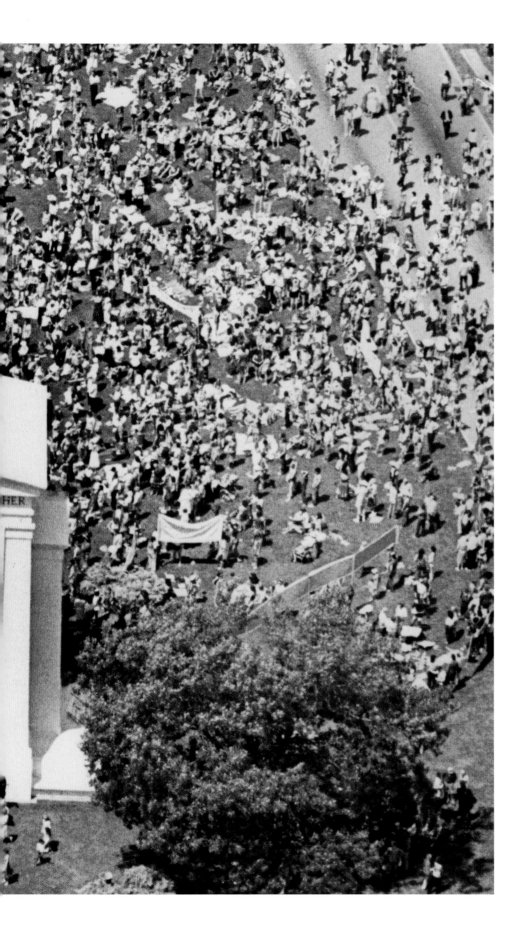

Unite For Peace, a rally at the Peace Arch U.S. border crossing protesting the proliferation of nuclear weapons, was attended by 100,000 people on June 12, 1982. Ralph Bower/*Vancouver Sun*

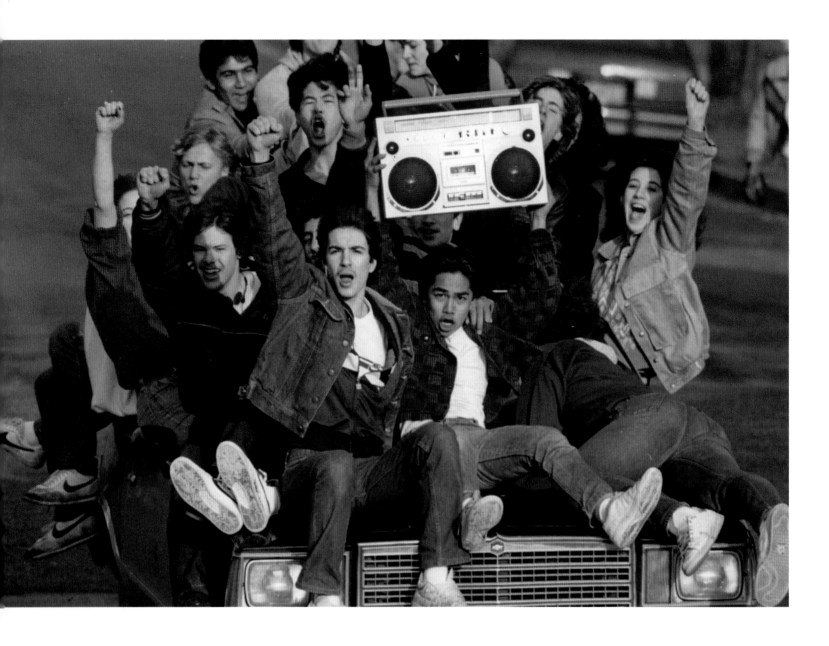

*Above:* Students shouting "Walkout!" swarmed out of six Vancouver secondary schools on January 24, 1985, to protest education cutbacks. **John Denniston/** *Province*

*Facing:* Punks for peace with signs saying "Free the Five," referring to the Squamish Five, at the 65,000-strong annual peace march on April 23, 1983. **David Clark/***Province*

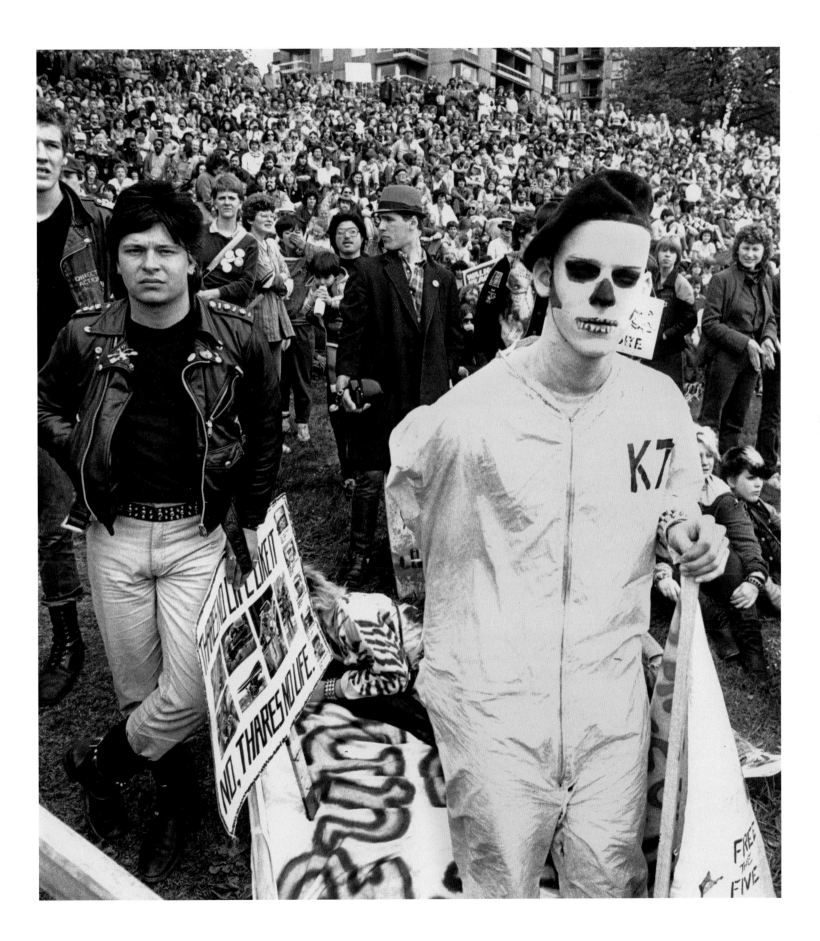

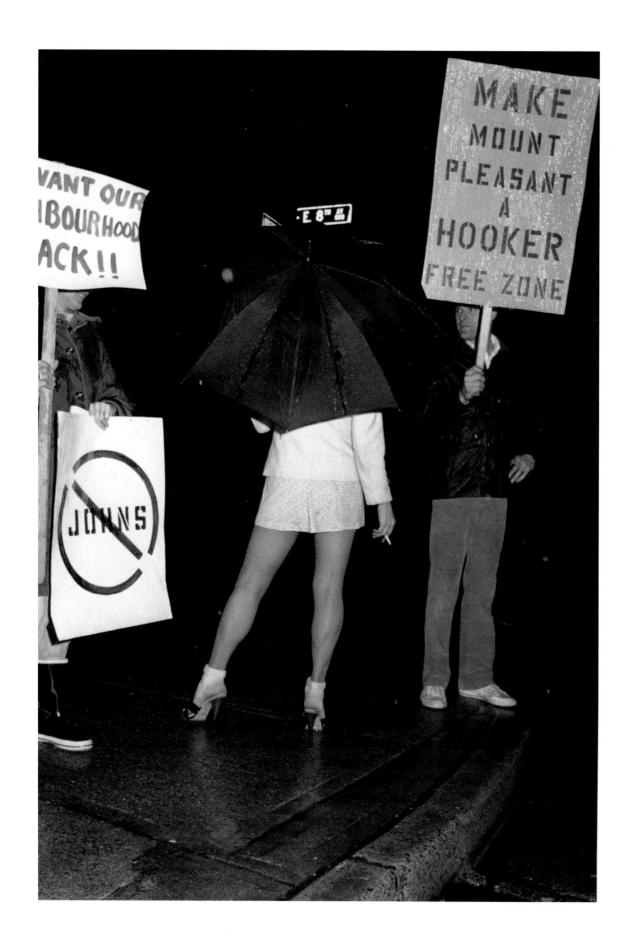

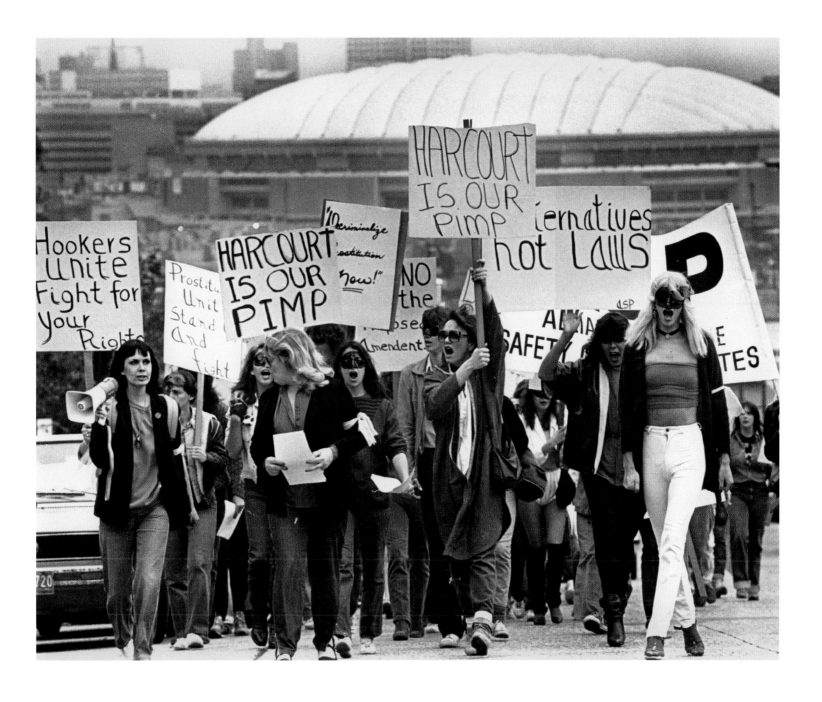

*Above:* Male and female prostitutes and their supporters marched in their first ever demonstration on April 20, 1983, to protest proposed amendments to the Criminal Code making it illegal to buy or sell sex in a public place. **Deborah MacNeill/***Vancouver Sun*

*Facing:* The Shame the Johns campaign, created by citizens' groups such as the Mount Pleasant Action Group and Mount Pleasant Block Neighbours, was aimed at eliminating street prostitution, in this case at the corner of 8th and Quebec on May 16, 1986. **Peter Battistoni/***Vancouver Sun*

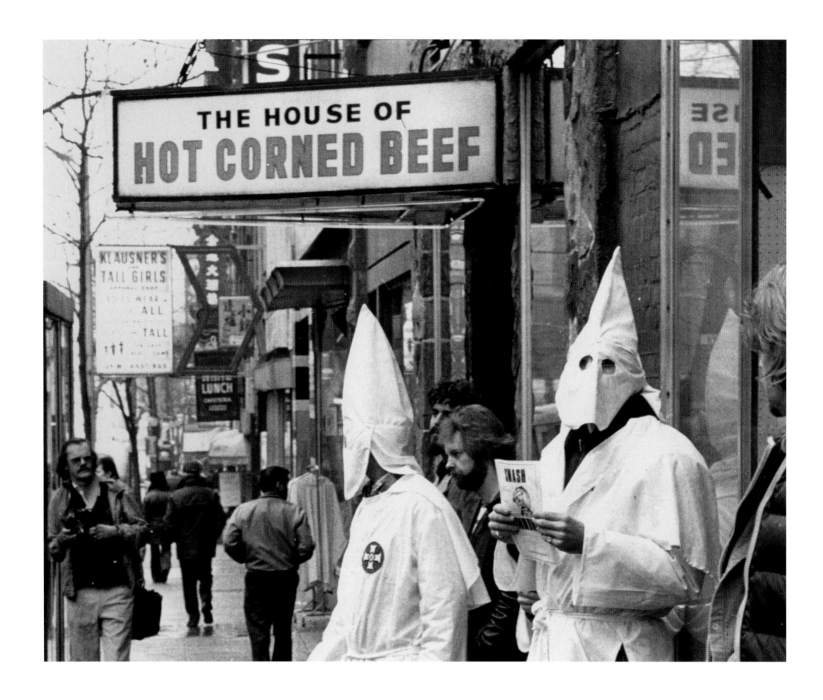

*Above:* Members of the Ku Klux Klan distributed pamphlets protesting communism in the 100-block Hastings Street on February 2, 1982. **George Diack/***Vancouver Sun*

*Facing left:* On September 4, 1989, activists from the Vancouver Persons with AIDS Society protested at Premier Bill Vander Zalm's Fantasy Gardens in Richmond to demand full provincial government funding of AZT and other experimental drugs. **Mark van Manen/***Vancouver Sun*

*Facing right:* Barry Goddard protested at Fantasy Gardens on September 4, 1989, against recent comments by two government ministers who suggested that some AIDS sufferers were personally responsible for getting the disease. **Rick Loughran/***Province*

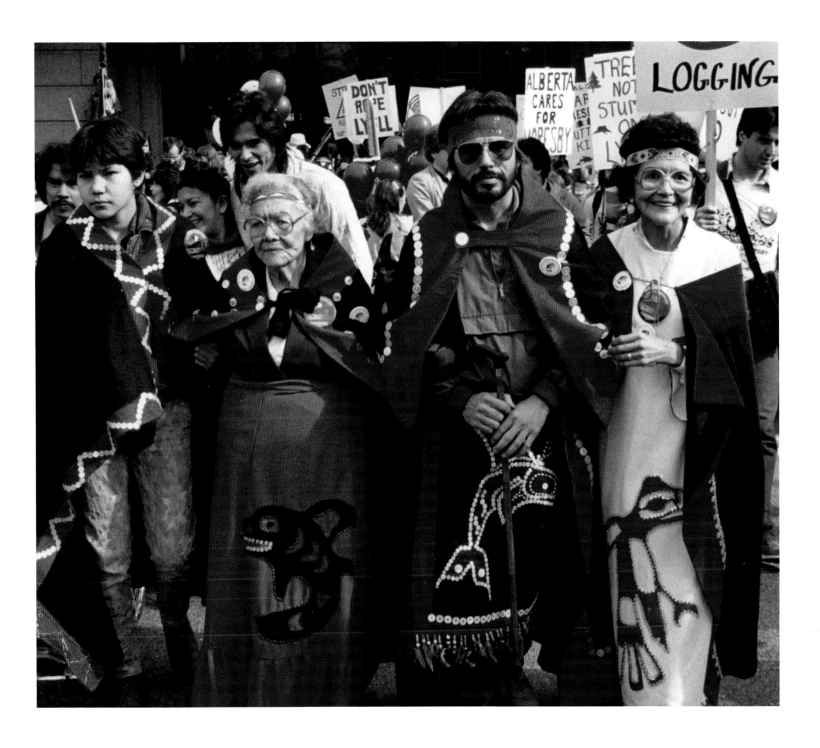

*Above:* Four generations of a Haida family, including ninety-five-year-old Emma Mathews, arrived March 15, 1986, on a cross-country train carrying opponents of proposed logging on Lyell Island and in the South Moresby region of the Queen Charlotte Islands. **Greg Osadchuk/*Province***

*Facing:* A woman protested at a memorial service on June 11, 1989, to honour the several hundred pro-democracy student protesters killed at Tiananmen Square on June 4. **Peter Battistoni/*Vancouver Sun***

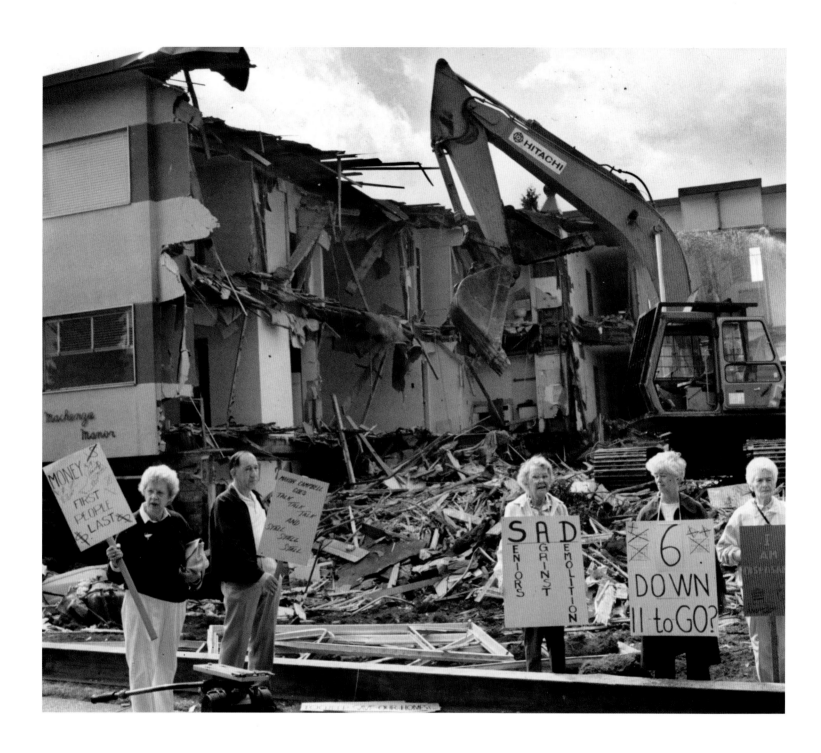

*Above:* Residents protested the demolition of a Kerrisdale rental apartment building on August 14, 1989—one of three scheduled for demolition that week and the sixth apartment building razed in two months to make way for luxury condos. **Ralph Bower/*Vancouver Sun***

*Facing:* On May 2, 1986, Downtown Eastside Residents Association picketers rallied against alleged Expo 86–related evictions at the Regal Place, Metropole, and Rainier hotels in the Downtown Eastside, a day after Prince Charles and Princess Diana opened the World's Fair. **Ian Smith/*Vancouver Sun***

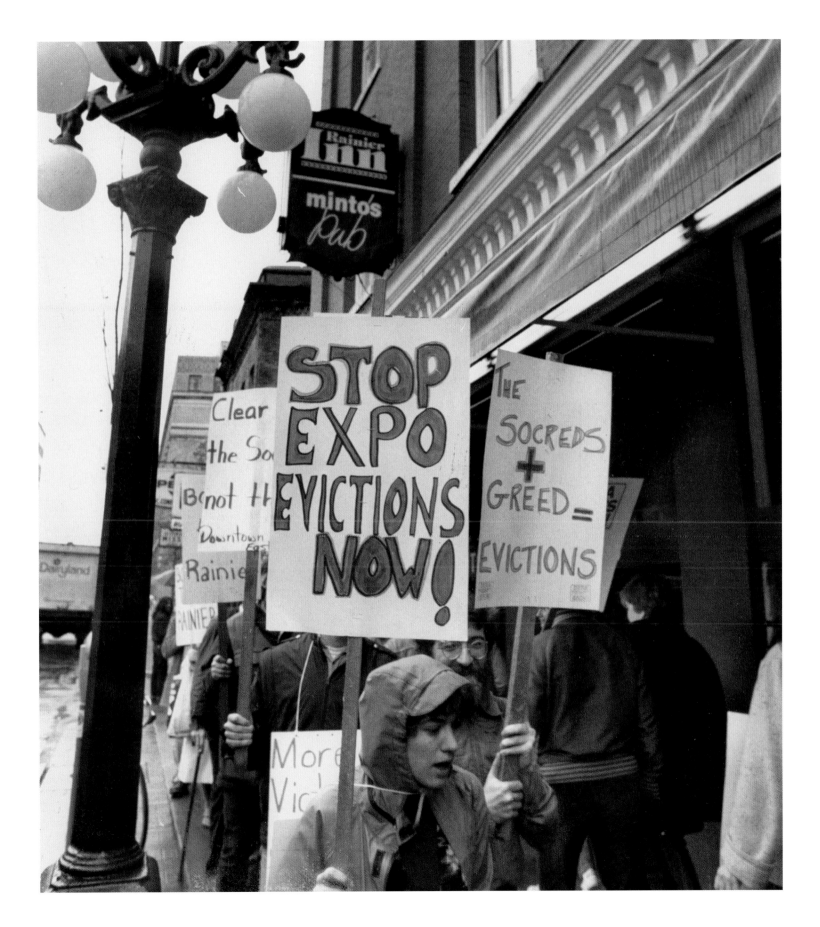

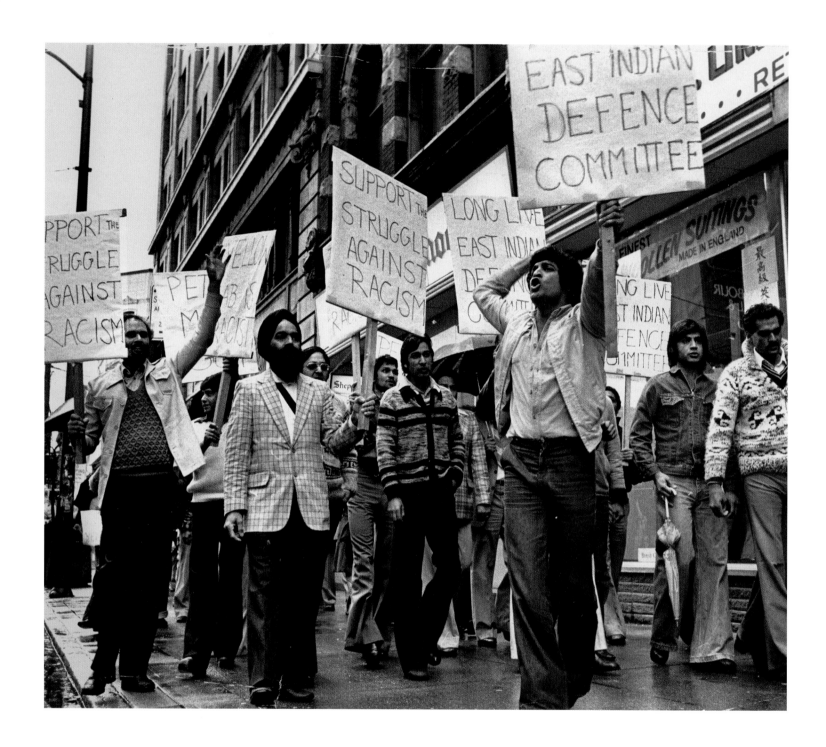

*Above:* A demonstration on March 24, 1980, by Lower Mainland East Indian Taxi Drivers' Association members protested alleged racism by the Yellow Cab company and the firing of some East Indian drivers. **Rob Draper/** *Vancouver Sun*

*Facing:* Farm workers protested on September 27, 1986, against unemployment insurance rules that denied unemployment insurance benefits to seasonal workers who worked less than sixteen weeks a year. **Gerry Kahrmann/** *Province*

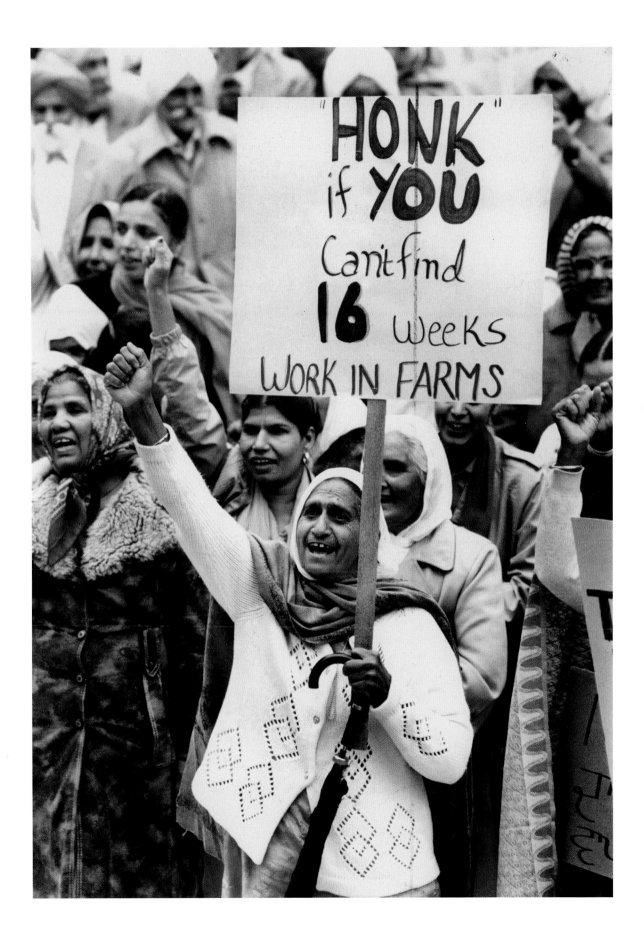

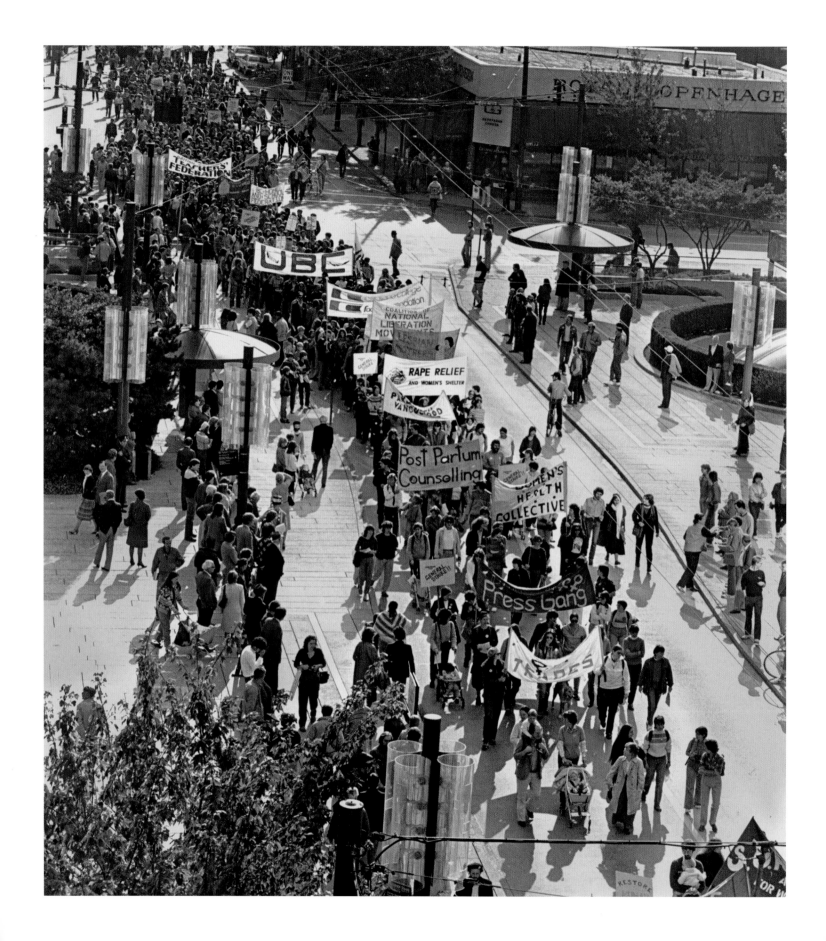

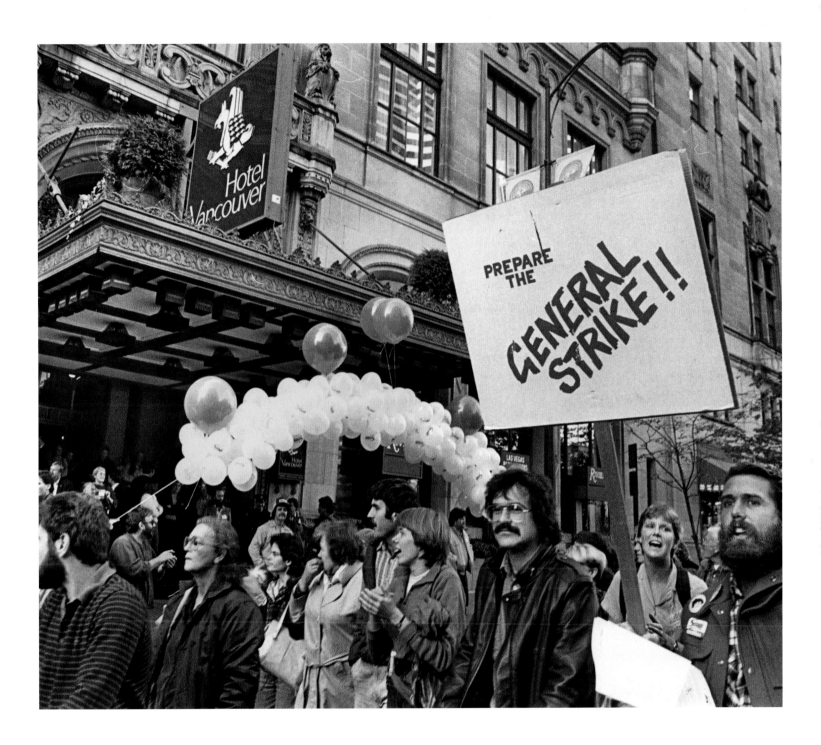

*Above:* On October 15, 1983, a Solidarity protest march against the Socred restraint budget passed the Hotel Vancouver, where the Social Credit Party was holding its annual convention.  **Les Bazso/***Vancouver Sun*

*Facing:* 50,000 people marched down Robson Street in Solidarity's largest protest rally to date on October 15, 1983. The largest anti-government protest in B.C. history, Solidarity was a coalition of more than one hundred labour, church, and student groups opposed to cuts to social services and the firing of 1,600 government workers.  **Mark van Manen/** *Vancouver Sun*

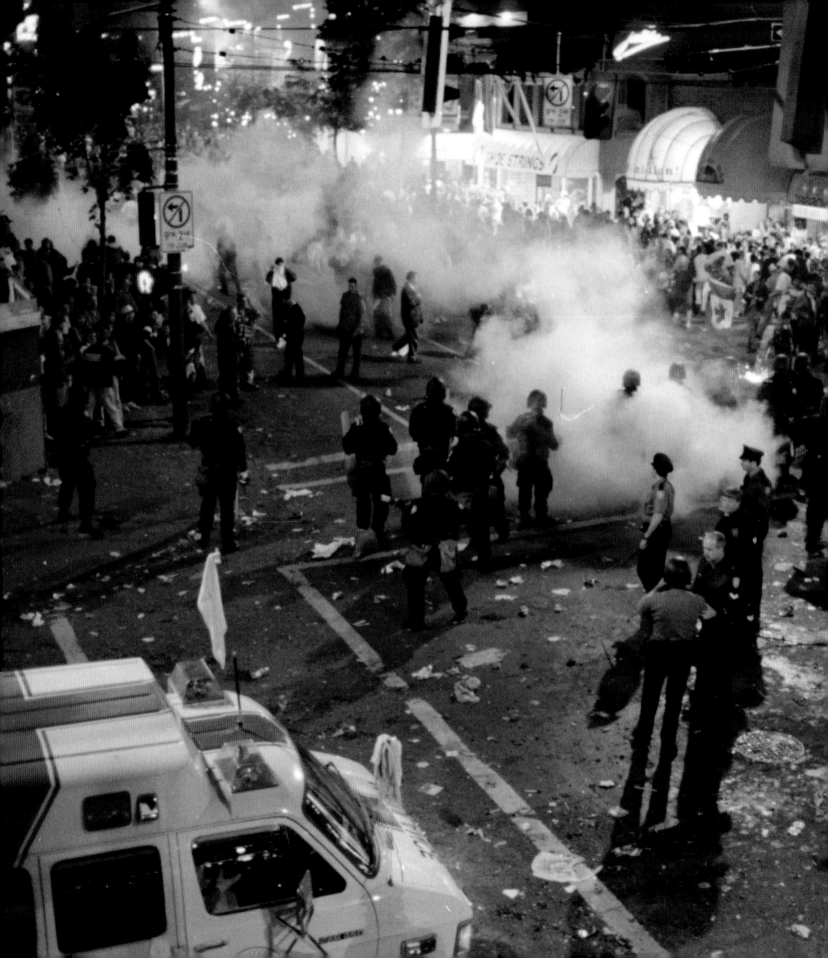

# 1990s

Aggressive activism continued to thrive in the 1990s, with violent clashes between protesters and police in the "Sergeant Pepper" pepper-spraying incident at the APEC protest at UBC, and at the Riot at the Hyatt. Confrontations between police and First Nations escalated at the Gustafsen Lake roadblock, there were mass arrests of anti-logging activists at Clayoquot Sound, and a B.C. fishing boat blockaded an Alaska ferry to protest U.S. fishing of sockeye salmon.

Vancouver's long history of alcohol-fuelled hooliganism erupted into a riot on June 14, 1994, after the Vancouver Canucks' loss to the New York Rangers in the Stanley Cup final. *Province* reporter John Colebourn was downtown covering the riot when he was tossed into a police paddy wagon for an hour before being released. The *Vancouver Sun*'s Malcolm Parry described his experience in his June 18, 1994, Town Talk column: "I was there—mingling with prudence but little fear at the centre of the crowd until an unannounced tear-gas barrage drove us, blinded and retching, east along Robson. Though a million more words may be uttered before the matter gets resolved, most present likely will agree that crowd violence suddenly escalated after the police squad's unannounced and disorienting action."

In the following weeks, both the *Vancouver Sun* and *Province* fought a police warrant to seize photographers' film of the riots, though *Province* photographer John Denniston felt that management didn't resist strongly enough. He recalls that when he suggested they hide the negatives until a legal decision was rendered, they "looked at me as if I was some sort of subversive radical. The implication that our almost-silent acquiescence meant that everyone would think *Province* photographers worked for the police, and how it would make taking pictures in difficult situations even more dangerous in the future, was lost on them." Eventually, after a B.C. Supreme Court ruling, the riot negatives were surrendered to police.

*Facing:* On June 14, 1994, after the Vancouver Canucks lost Game 7 of the Stanley Cup final against the New York Rangers, a crowd of around 50,000 rioted in downtown Vancouver, causing $1.1 million in property damage. Steve Bosch/ *Vancouver Sun*

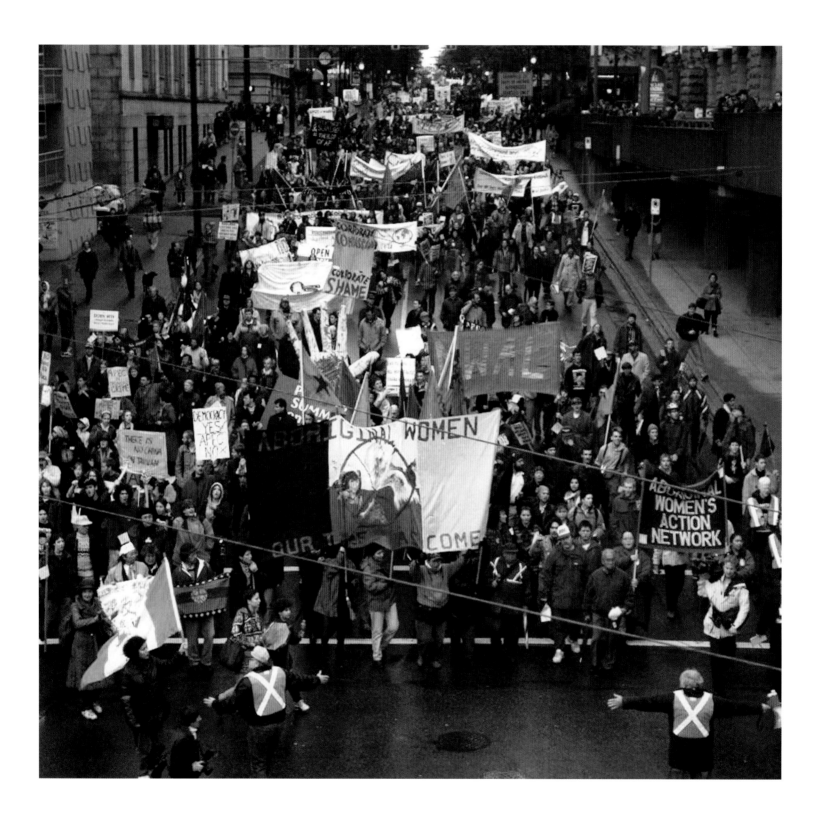

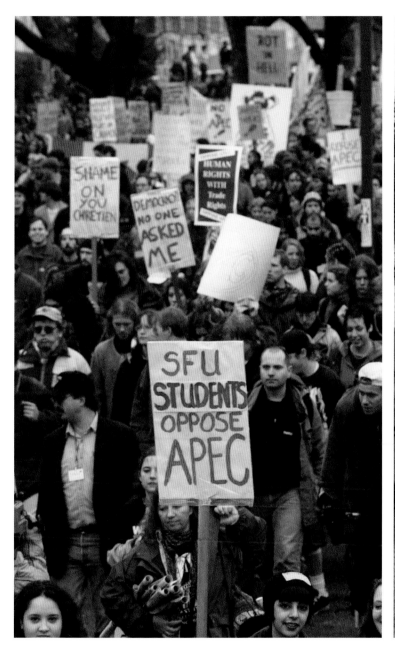

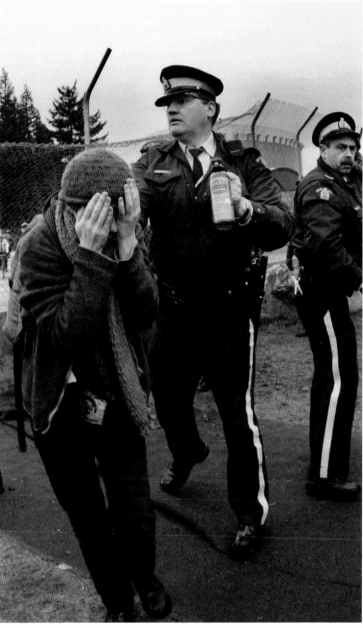

*Above left:* Protesters marched in an anti-APEC (Asia Pacific Economic Conference) demonstration at UBC on November 24, 1997. **Stuart Davis/***Province*

*Above right:* A woman was pepper-sprayed at an APEC protest at the University of British Columbia on November 25, 1997, after demonstrators tried to penetrate a chain-link fence surrounding the Museum of Anthropology where APEC leaders were meeting. **Stuart Davis/***Province*

*Facing:* Thousands of protesters marched down Granville Street to Canada Place on November 23, 1997, to protest APEC and the human rights violations by many of its member nations. **Wayne Leidenfrost/***Province*

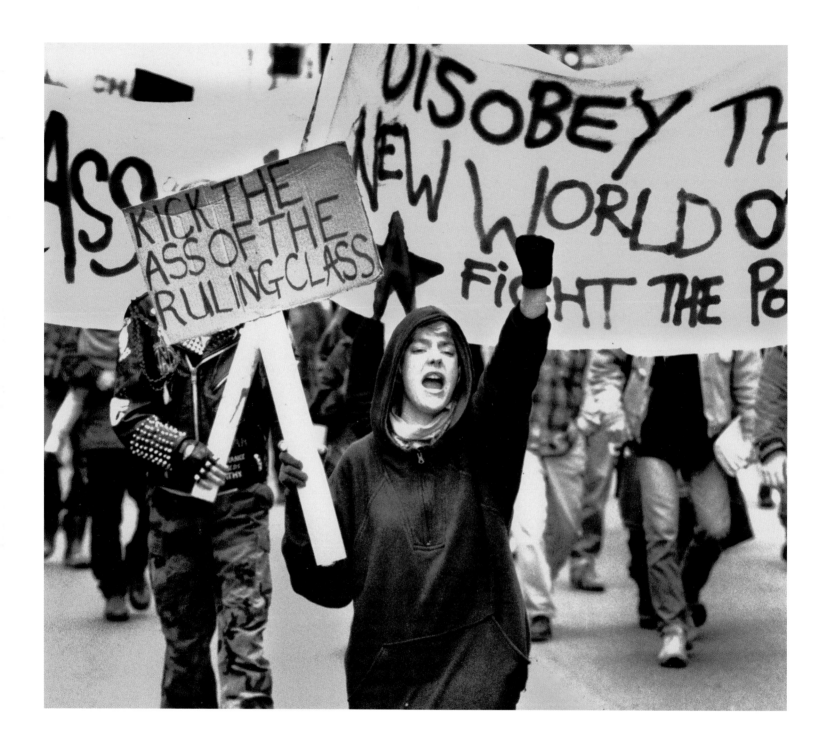

*Above:* A woman protested on April 3, 1993, against the Vancouver Summit between U.S. President Bill Clinton and Russian President Boris Yeltsin. **Greg Kinch/*Province***

*Facing top:* The epicenter of the Stanley Cup riot on June 14, 1994, was the corner of Robson and Burrard. Vancouver Mayor Philip Owen said at the time that the incident indicated "deep social problems across the country." **Steve Bosch/ *Vancouver Sun***

*Facing bottom:* Police in riot gear formed a barrier at the Stanley Cup riot on June 14, 1994. Five hundred and forty officers were deployed, 150 people were arrested, and 200 were injured in the riot. **Stuart Davis/ *Vancouver Sun***

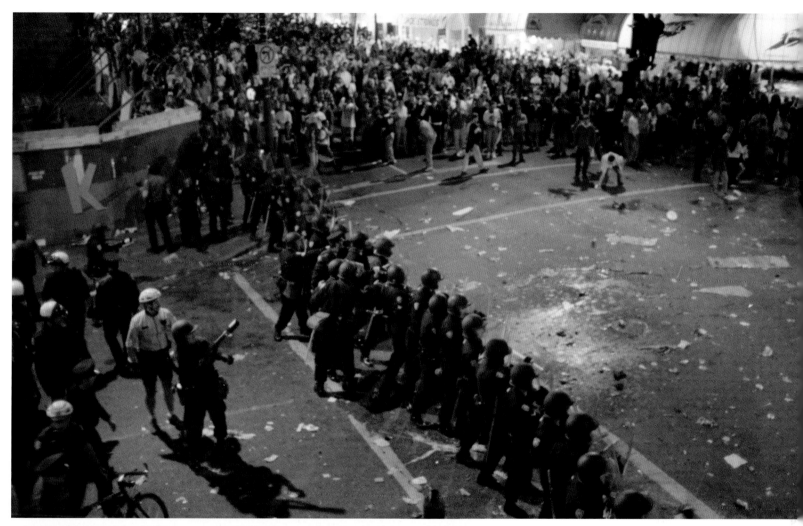

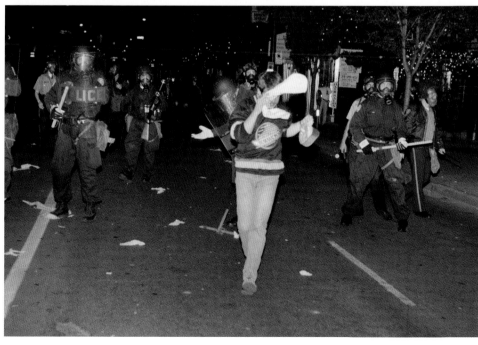

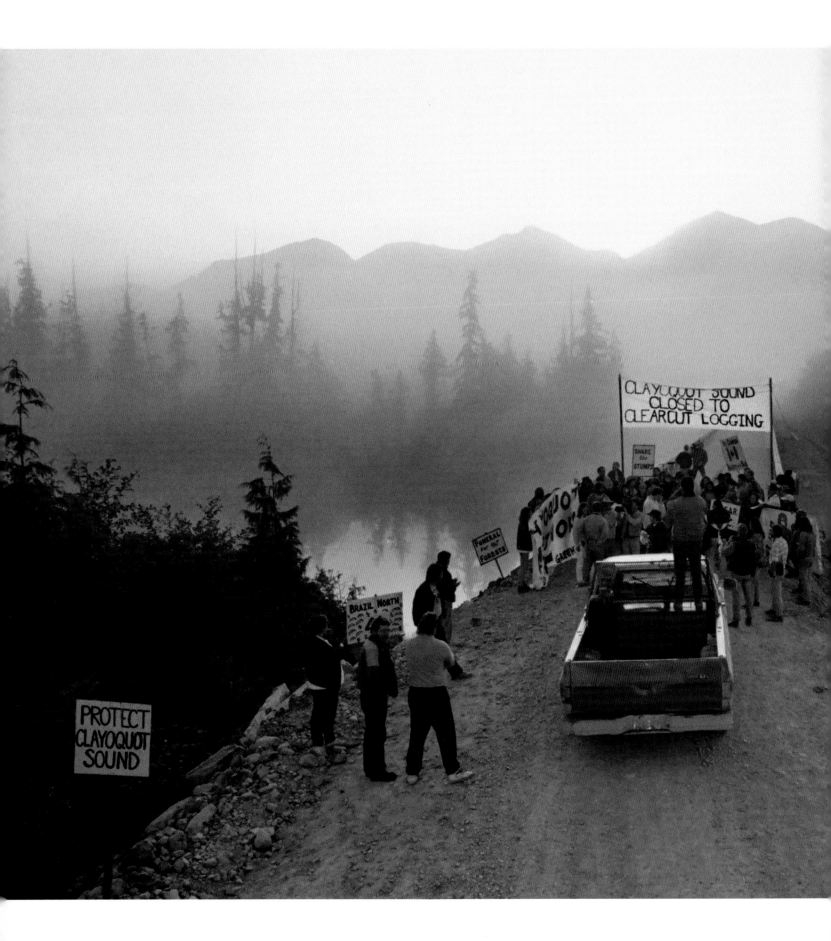

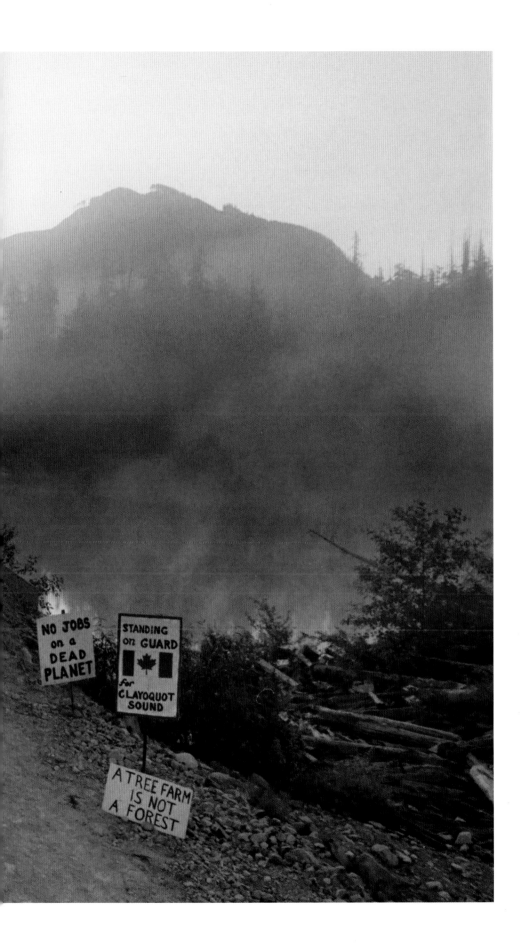

Clayoquot Sound logging protesters gathered at daybreak on July 7, 1993, at the Kennedy River Bridge in preparation for another day of confrontations with loggers and RCMP enforcing a Supreme Court injunction. **Mark van Manen/*Vancouver Sun***

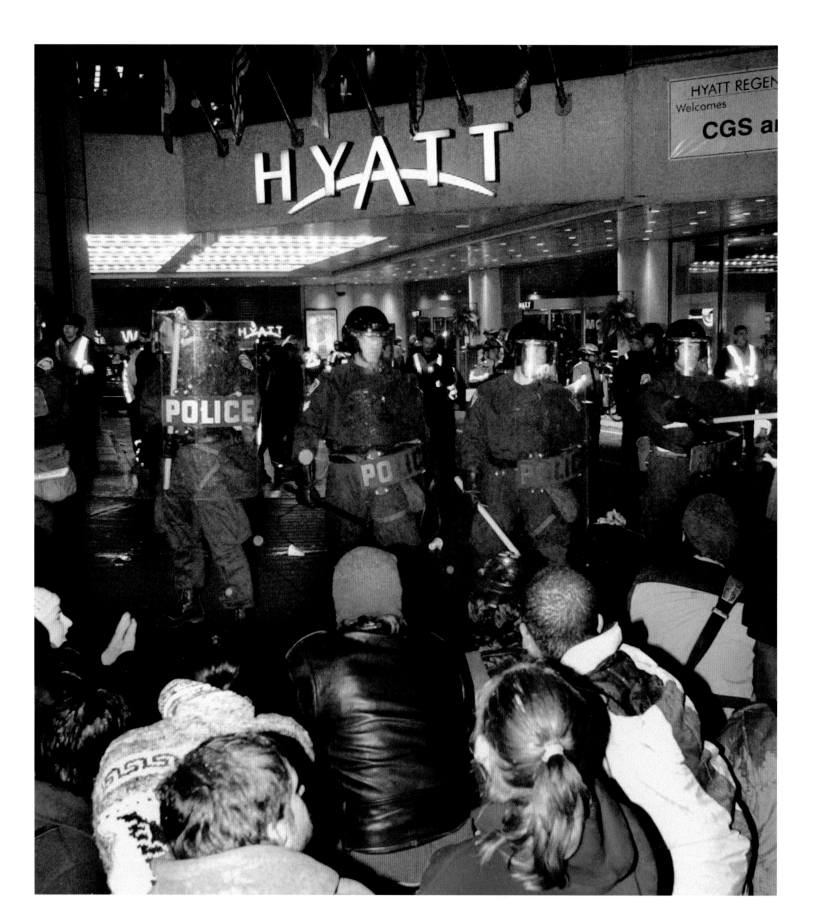

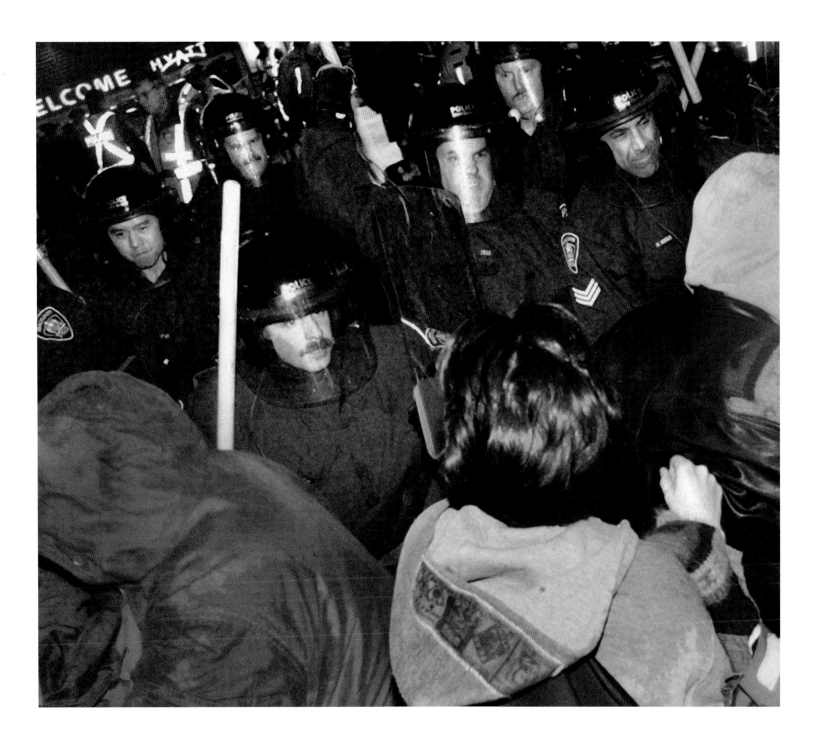

*Above:* On December 8, 1998, the Vancouver Police riot squad clashed with APEC protesters at the Hyatt Regency Hotel, an event dubbed the Riot at the Hyatt, where Prime Minister Jean Chrétien was speaking at a Liberal fundraiser. **Les Bazso/*Province***

*Facing:* APEC protesters, including student, labour, immigrant, First Nations, anti-poverty, and other activist groups, protested outside the Hyatt Regency Hotel on December 8, 1998. **Colin Price/*Province***

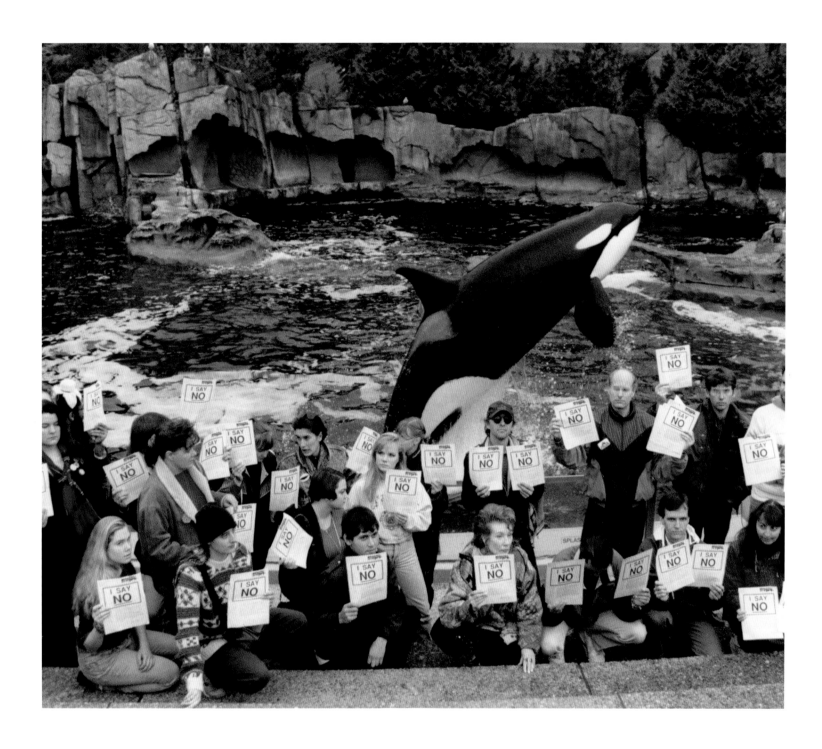

*Above:* Animal rights activists presented signed petitions opposing the captivity of whales to the Vancouver Aquarium on February 11, 1992. **Jon Murray/** *Province*

*Facing top:* Thousands of secondary students protested the looming war in the Persian Gulf on January 15, 1991, hours before the 9 p.m. United Nations deadline for Iraq to quit Kuwait. **Mark van Manen/** *Vancouver Sun*

*Facing bottom:* The Raging Grannies, an activist group of older women, at a Vancouver Art Gallery demonstration by three hundred Serbians on May 9, 1999, protesting the NATO bombing of Yugoslavia. **Ian Smith/** *Vancouver Sun*

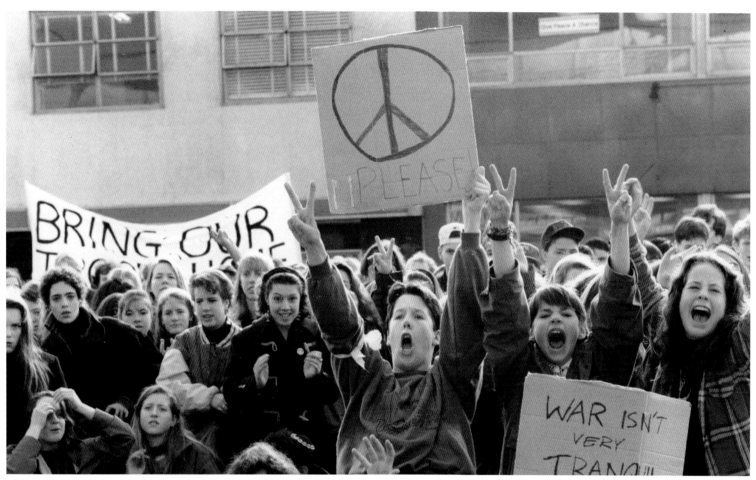

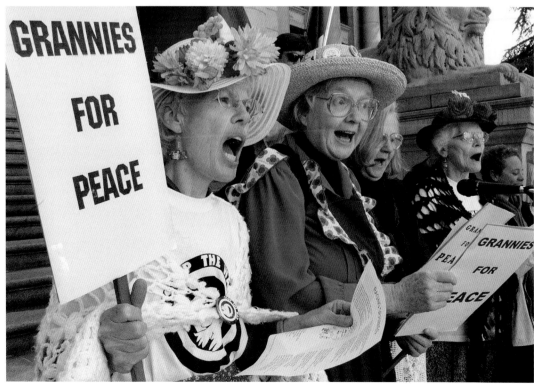

131

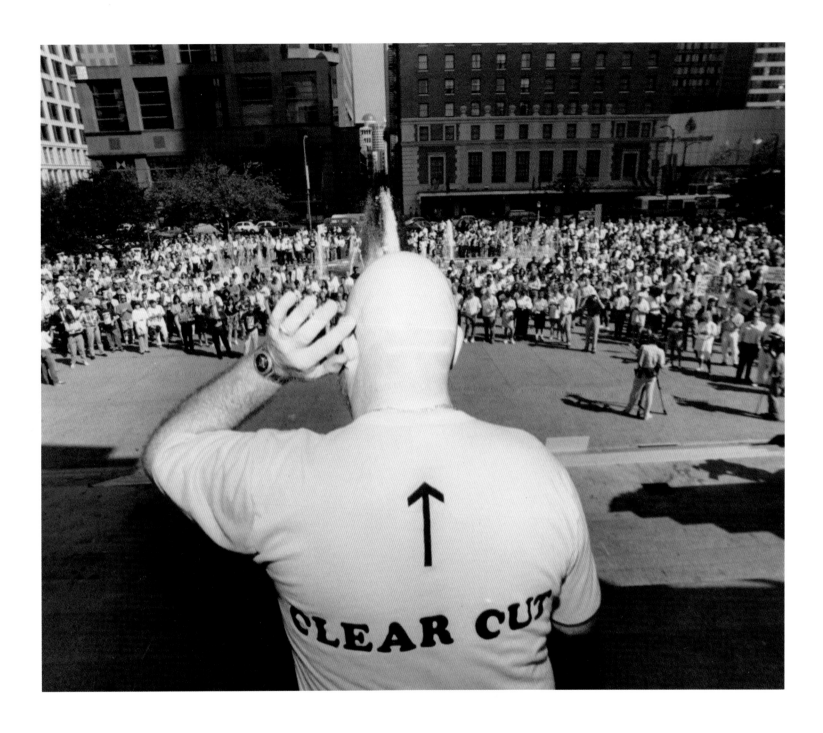

*Above:* A large pro-logging rally organized by Western Forest Products at the Vancouver Art Gallery on September 10, 1993, was supported by IWA-Canada, the Council of Forest Industries, Share B.C., the Mining Association of B.C., Canadian Women in Timber, and the Forest Alliance of B.C. **Jeff Vinnick/***Vancouver Sun*

*Facing top:* On October 22, 1990, six hundred protesters opposed to the Canada-U.S. Free Trade Agreement rallied outside the Hyatt Regency Hotel, where Prime Minister Brian Mulroney was staying during a three-day visit to B.C. **Ralph Bower/Vancouver** *Sun*

*Facing bottom:* Canadian fishing boats blockaded the Alaska State ferry *Malaspina* on July 20, 1997, preventing it from leaving the dock in Prince Rupert for three days. The protest began after Alaskan fishers caught between 350,000 and 500,000 sockeye destined for B.C. rivers, despite the Pacific Salmon Treaty annual limit of 120,000. **Ian Smith/Vancouver** *Sun*

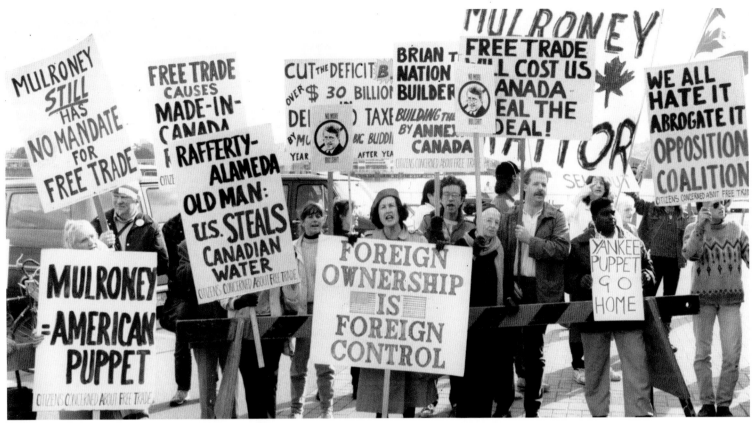

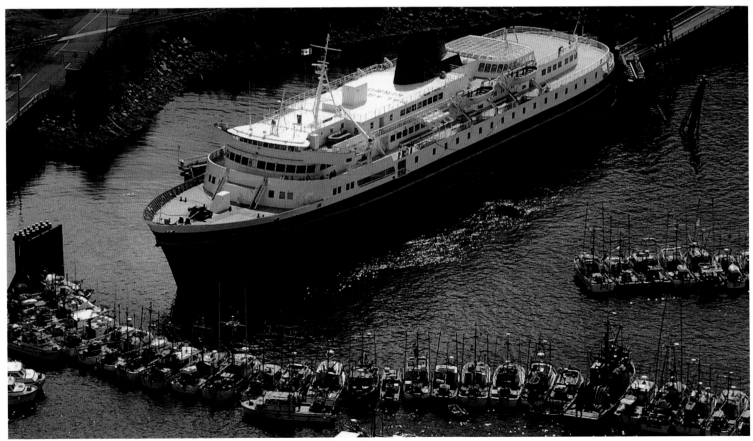

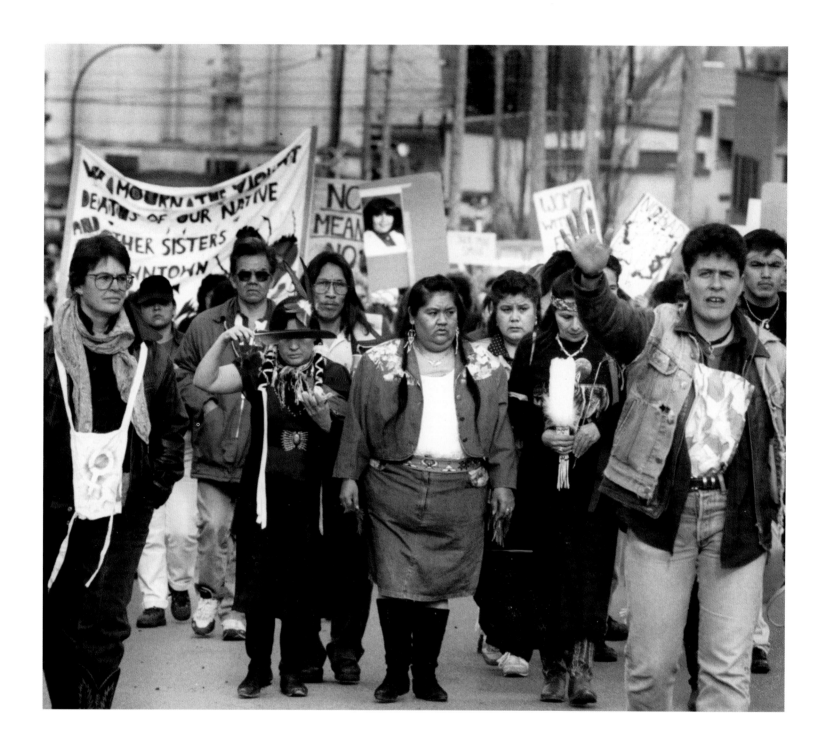

*Above:* A march on February 14, 1992, for missing and murdered women in the Downtown Eastside was sparked by the murder of Cheryl Ann Joe. The march became an annual Valentine's Day event. **Denise Howard/*Vancouver Sun***

*Facing:* Sue Rodriguez, who fought for the legal right to physician-assisted suicide, with member of Parliament Svend Robinson, an advocate in the right-to-die movement, in 1993. **Nick Didlick/*Vancouver Sun***

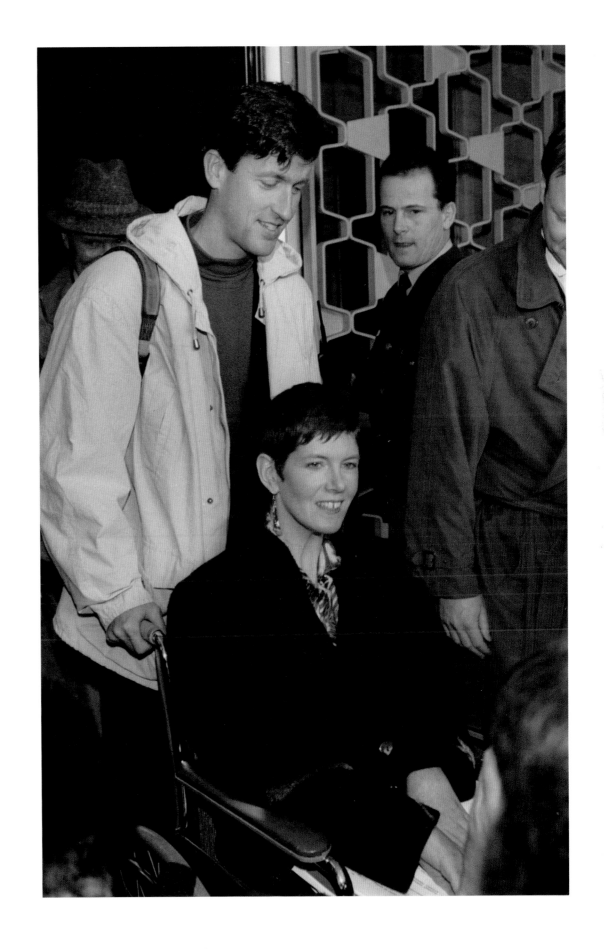

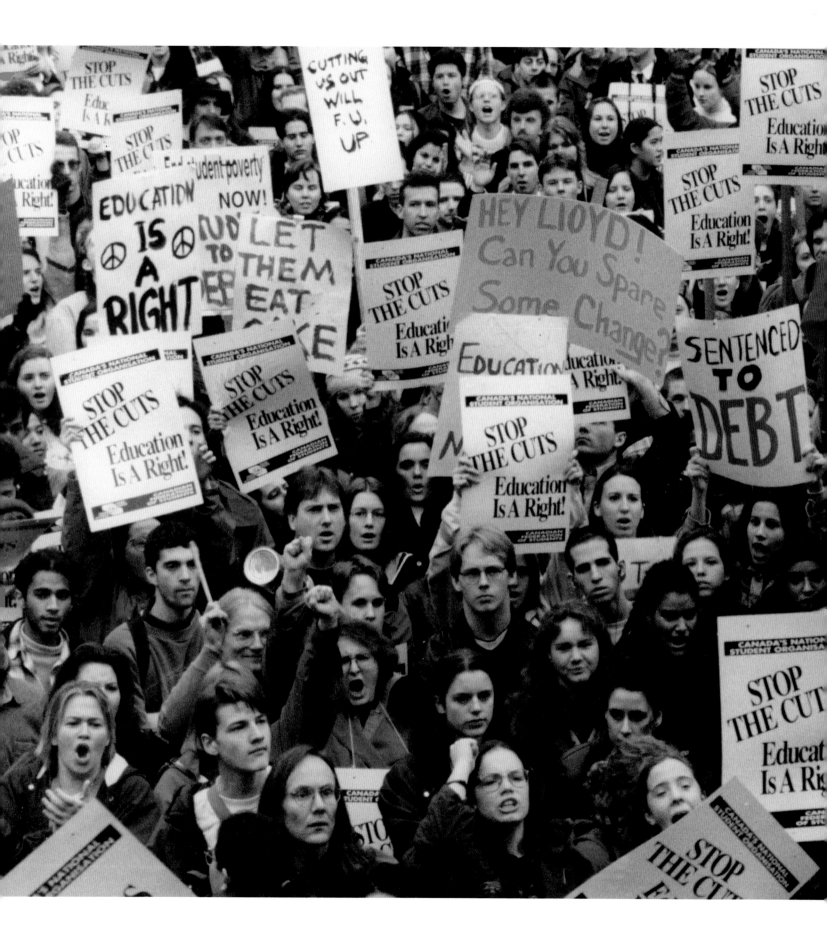

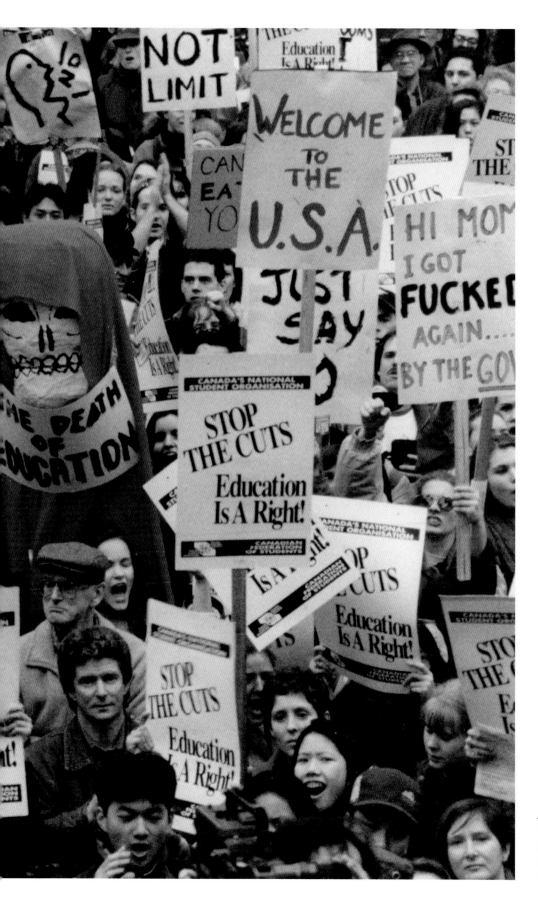

4,000 university students rallied in Vancouver on January 25, 1995, to protest proposed federal cuts to post-secondary education. Mark van Manen/*Vancouver Sun*

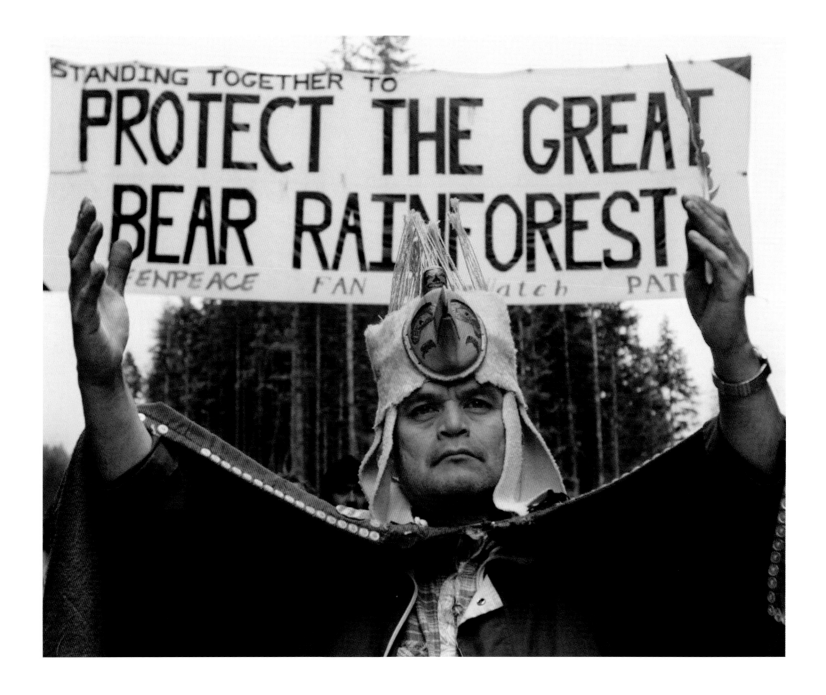

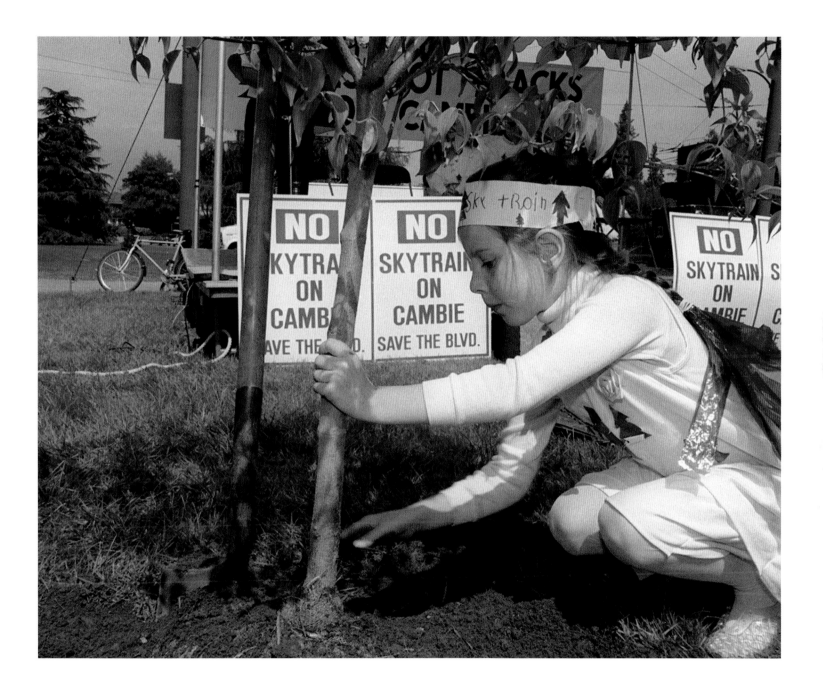

*Above:* Sara Fralin, age seven, plants a tree at a rally on June 9, 1991, to protest the cutting of trees along Cambie Street, the proposed route for a Skytrain extension to the Vancouver Airport. The Canada Line opened in 2009 for the 2010 Olympics. **Denise Howard/** *Vancouver Sun*

*Facing:* Nuxalk hereditary chief Ed Moody greets the RCMP and Kwatna Timber employees who approached the logging blockade on the Fogg Creek logging site on King Island on June 26, 1997. Moody and twenty-three others were arrested a short time later and logging resumed after a twenty day stoppage. **Nick Didlick/***Vancouver Sun*

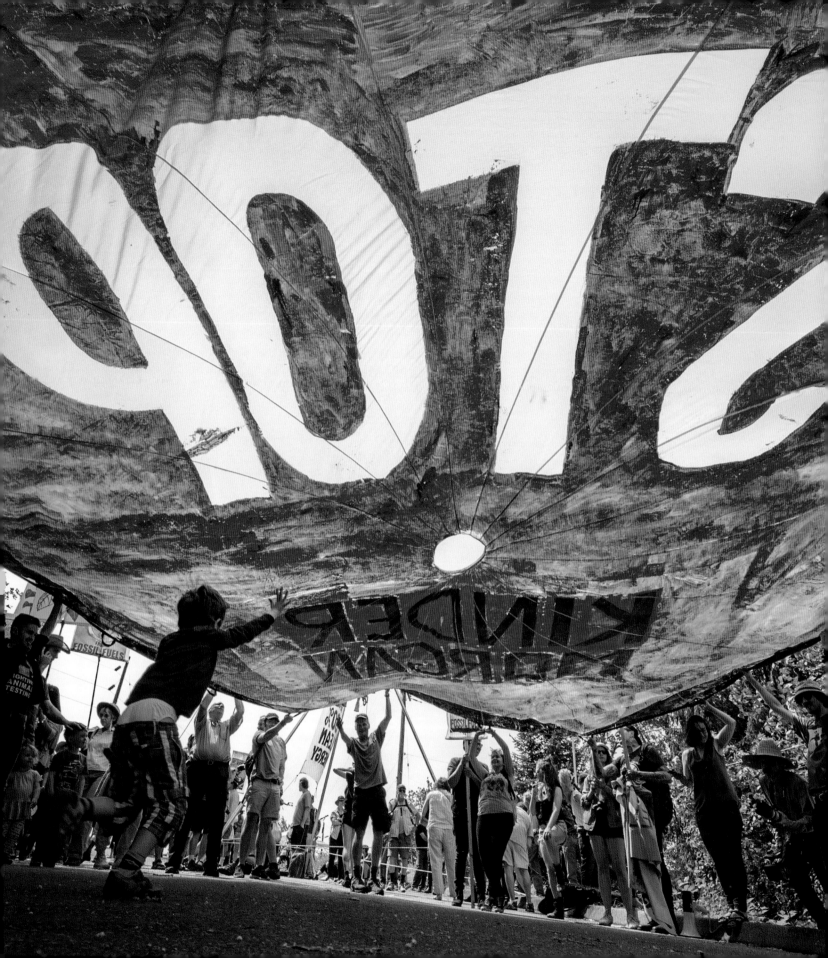

# 2000s

Some of the largest and lengthiest labour strikes in our city's history have occurred since 2000, including a four-month transit strike in 2001, a 2007 municipal strike that lasted thirteen weeks, and a five-week teachers' strike in 2014.

The environment, development, heritage, and land use remain perpetual hot-button issues, and poverty and homelessness sadly endure.

Human rights protests regularly draw thousands to the steps of the Vancouver Art Gallery, and anti-government, and occasionally pro-government, demonstrations on the issues of immigration and refugees, crime and punishment, right-to-life and right-to-die, and war and peace, are as common today as they were a century ago.

In a second Stanley Cup riot in 2011, property damage was estimated at $3.7 million, and prosecution of the rioters cost $5 million. Police assembled 5,500 hours of video evidence and 29,700 photographs, including images shot by PNG photographers.

Photojournalists sometimes find shooting protest demonstrations challenging. Peter Battistoni relates that "at one of the monthly anti-abortion human chain protests from the abortion clinic to VGH by pro-life groups some time in the 2000s, I got into a confrontation when demonstrators started beating me with their protest signs, apparently because they thought the *Sun* was portraying them in a bad light. I fought back by ripping some signs out of the hands of people who were assaulting me. No injuries, and I left to cover less combative members of the group down the street."

And while some feel that their days of demonstrating are over and look back with nostalgia at the protest heyday of the 1960s and 1970s, almost every week, on the steps of the Vancouver Art Gallery and elsewhere in the city, hundreds, and sometimes thousands, of Vancouverites speak up and make their views known on issues as relevant, critical, and urgent today as they have ever been.

Climate change activists surrounded the Kinder Morgan Westridge marine terminal on land and water in Burnaby on May 14, 2016, part of the Break Free from Fossil Fuels global day of action to protest the Trans Mountain pipeline expansion. Arlen Redekop/PNG

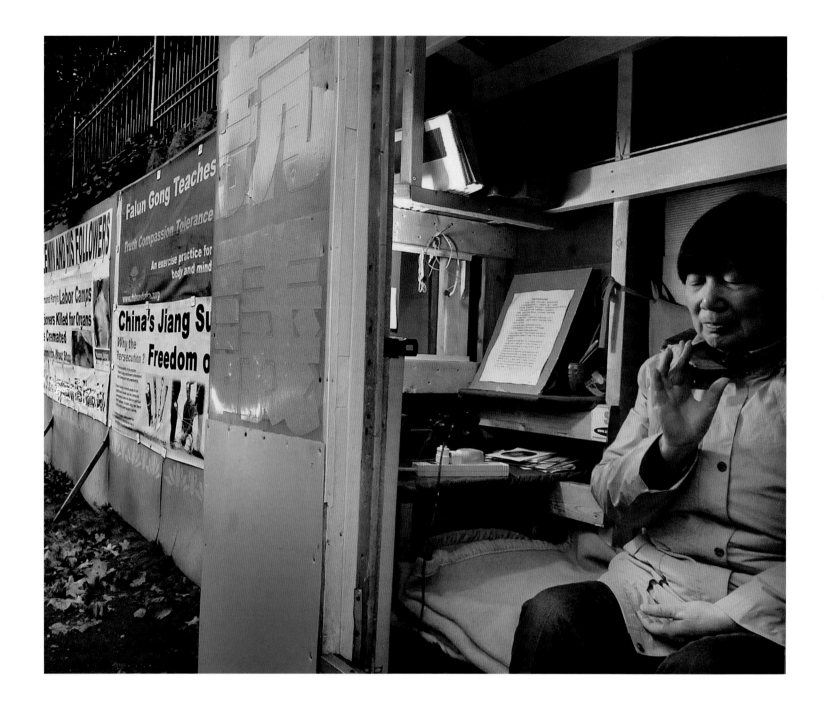

*Above:* Falun Gong practitioners occupied a protest cubicle around the clock beside the Chinese Consulate on Granville Street on November 23, 2007. In 2009, after 2,730 days, the B.C. Supreme Court ordered the structure removed, and the legal battle over the protesters' hut continued for several years. **Peter Battistoni/***Vancouver Sun*

*Facing top:* Members of Community Alliance, representing residents and businesses in Strathcona, Chinatown, and Gastown, marched to Canada Place on September 30, 2000, to deliver a 32,000-name petition opposing government support for programs that "assist, facilitate, or maintain the dealing and use of illegal drugs." **Les Bazso/** *Province*

*Facing bottom:* Protesters representing the Head Tax Families Society of Canada gathered at the Monument to Chinese Railway Workers and War Veterans in Vancouver on July 1, 2011, for the sixth annual Canada Rally. The group was seeking an apology and redress from the federal government for head taxes imposed on Chinese immigrants from 1885 to 1923. **Jason Payne/PNG**

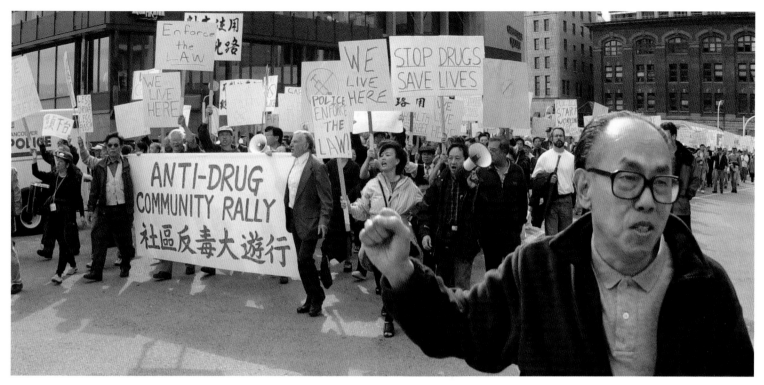

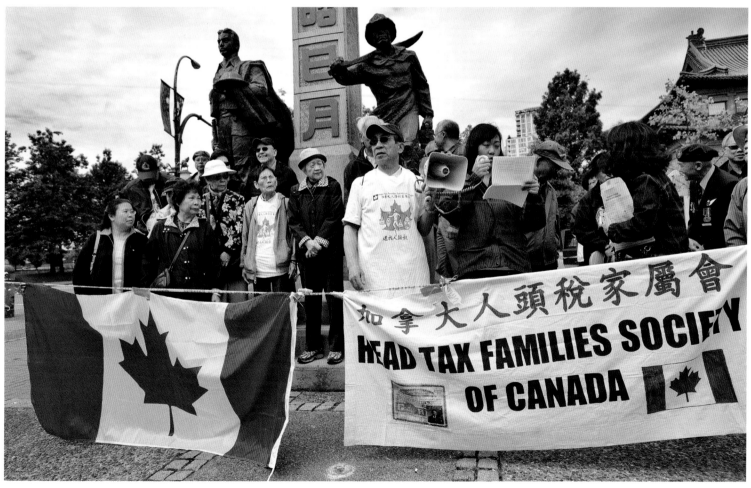

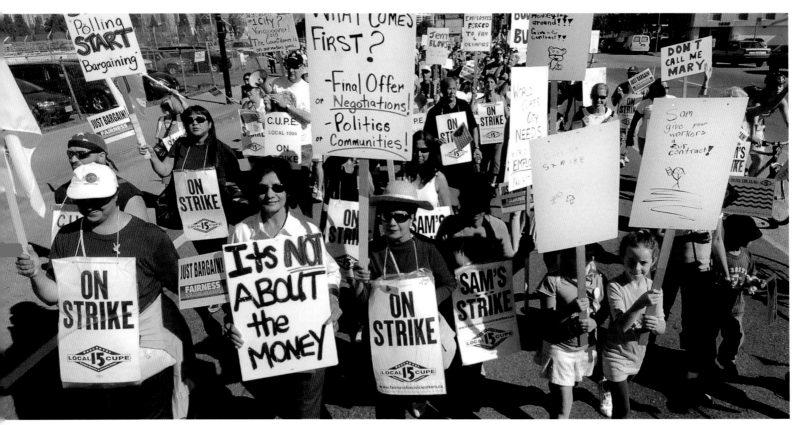

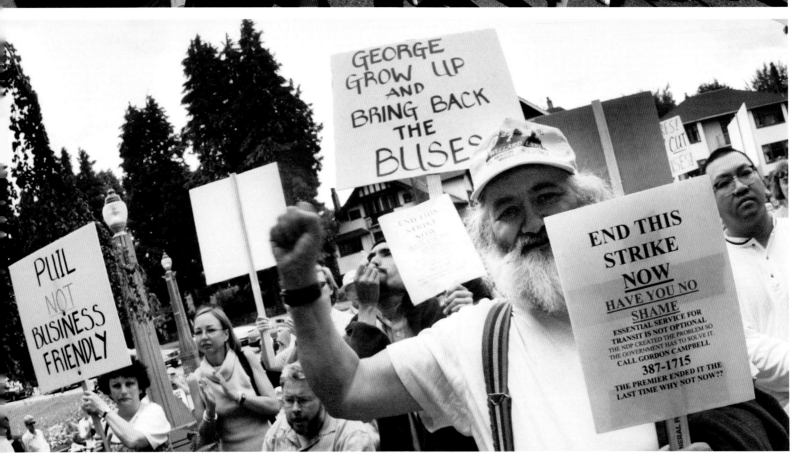

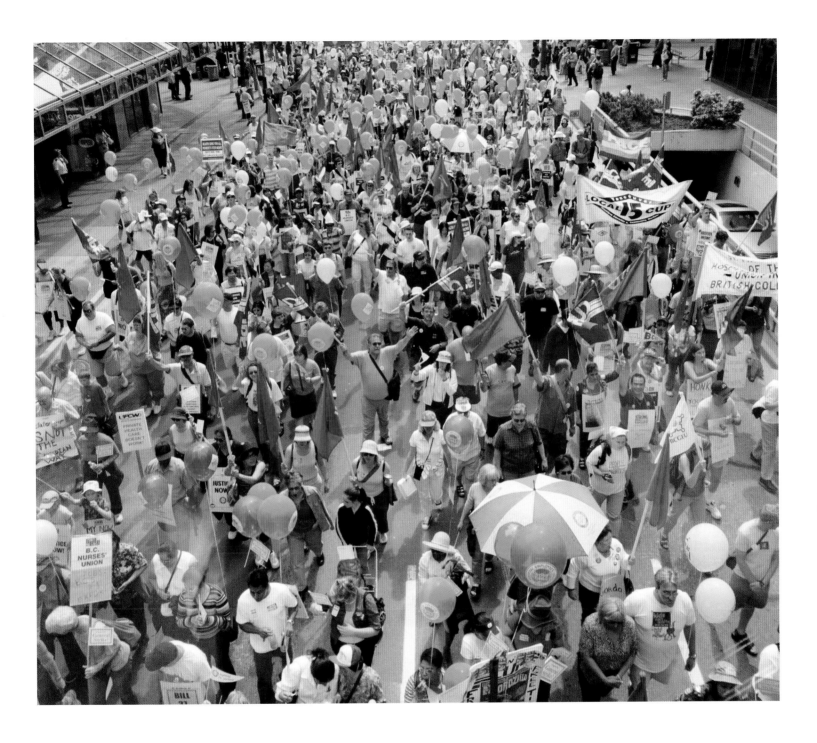

*Above:* At a May Day rally on May 1, 2004, 5,000 pro-union supporters marched to the Vancouver Art Gallery, where union leaders spoke in favour of HEU strike action and against back-to-work legislation imposed by Gordon Campbell's Liberal government. **Kim Stallknecht/***Province*

*Facing top:* Thousands of striking Vancouver municipal workers marched from Science World to Vancouver City Hall on August 29, 2007. The municipal strike lasted eighty-eight days. **Jason Payne/***Province*

*Facing bottom:* Sam Campbell (right) shakes his fist in frustration with the ongoing Lower Mainland transit strike at Vancouver City Hall on June 24, 2001. The transit strike lasted for four months, from April 1 to August 7. **Ric Ernst/***Province*

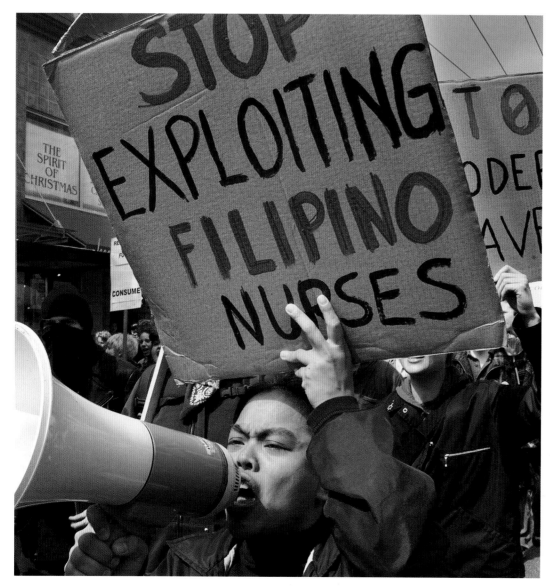

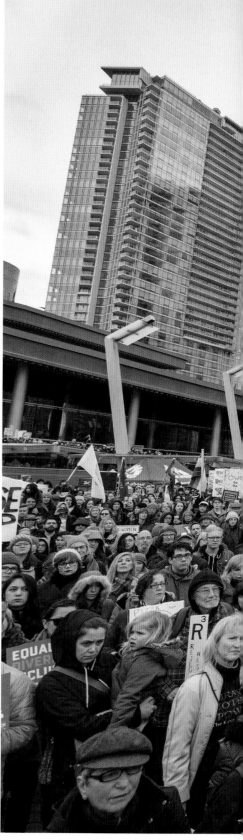

*Above:* About four hundred May Day protesters, including Filipino home-care workers, made their way down Robson Street in a march that began and ended at Victory Square on May 1, 2000. **Ian Smith/*Vancouver Sun***

*Facing:* On January 21, 2017, the day after U.S. President Donald Trump's inauguration, more than 15,000 people demonstrated in support of the Women's March on Washington. **Arlen Redekop/ PNG**

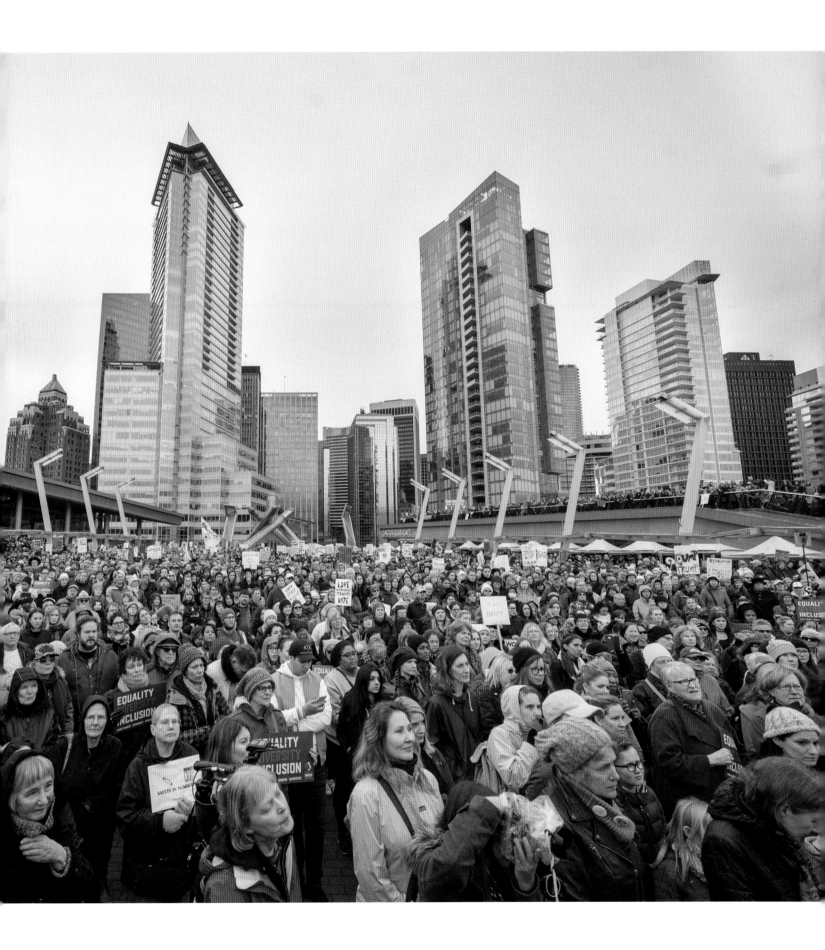

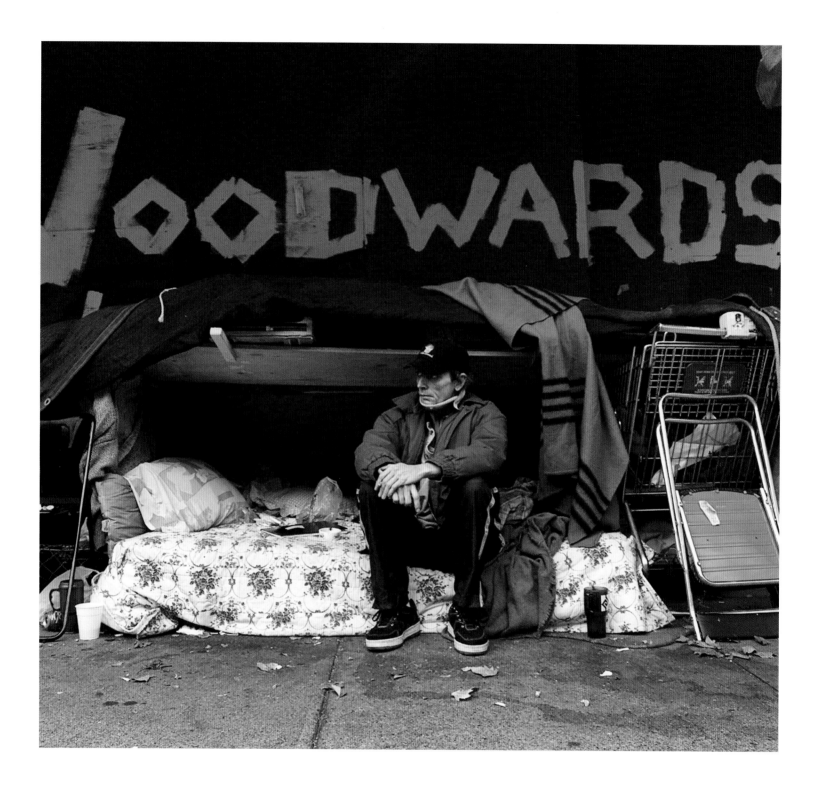

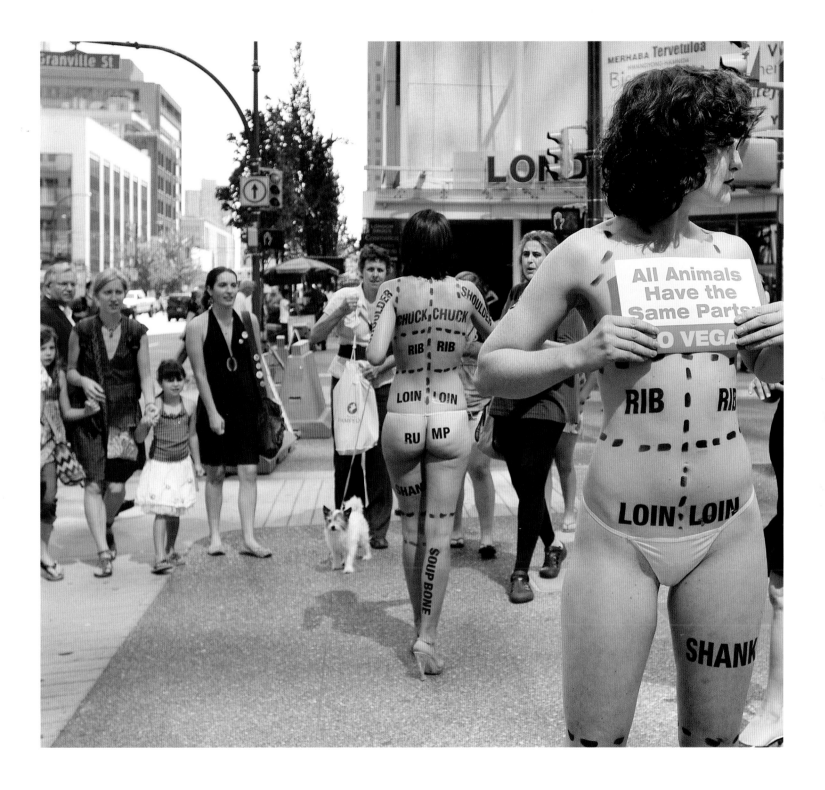

*Facing:* On December 2, 2002, Rob Miller sat in his living area at Woodsquat, a ninety-two-day direct action housing protest at the old Woodward's department store. Ian Smith/*Vancouver Sun*

*Above:* Nicole Matthews (front) and Virginia Fort of PETA—People for the Ethical Treatment of Animals— protested the meat industry on August 17, 2010, at the corner of Granville and Georgia. Ian Smith/PNG

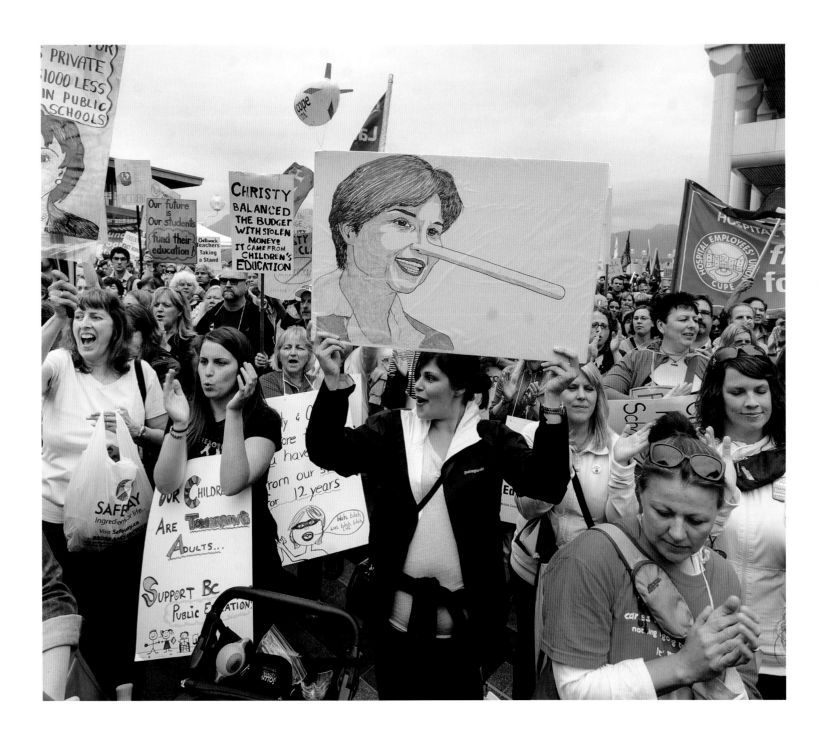

*Above:* Supporters of the B.C. Federation of Labour and the B.C. Teachers' Federation showed their frustration with the ongoing teachers' strike at a large rally at the Vancouver Convention Centre on June 19, 2014. It was the longest teachers' strike in B.C. history; 500,000 students were out of class for five weeks. **Mark van Manen/PNG**

*Facing top:* A rally of around 250 people braved the rain to show their support for the Conservative Party and Prime Minister Stephen Harper at Library Square on December 6, 2008. **Jon Murray/***Province*

*Facing bottom:* NDP supporter Brian O'Neill (left) confronted Mia Taghizadeh (right), who was protesting that a vote for NDP leader Jack Layton was a vote for Conservative leader Stephen Harper during a Jack Layton campaign stop at the Italian Cultural Centre on September 8, 2008. **Ric Ernst/***Province*

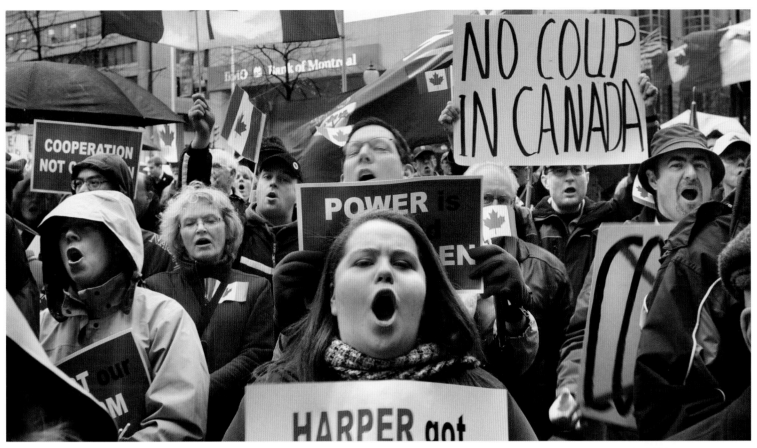

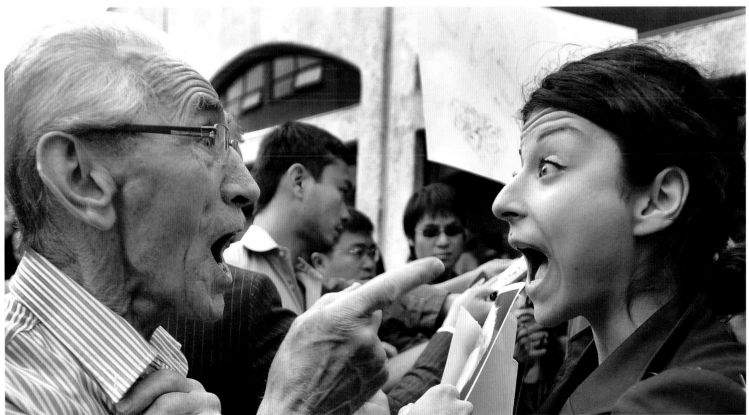

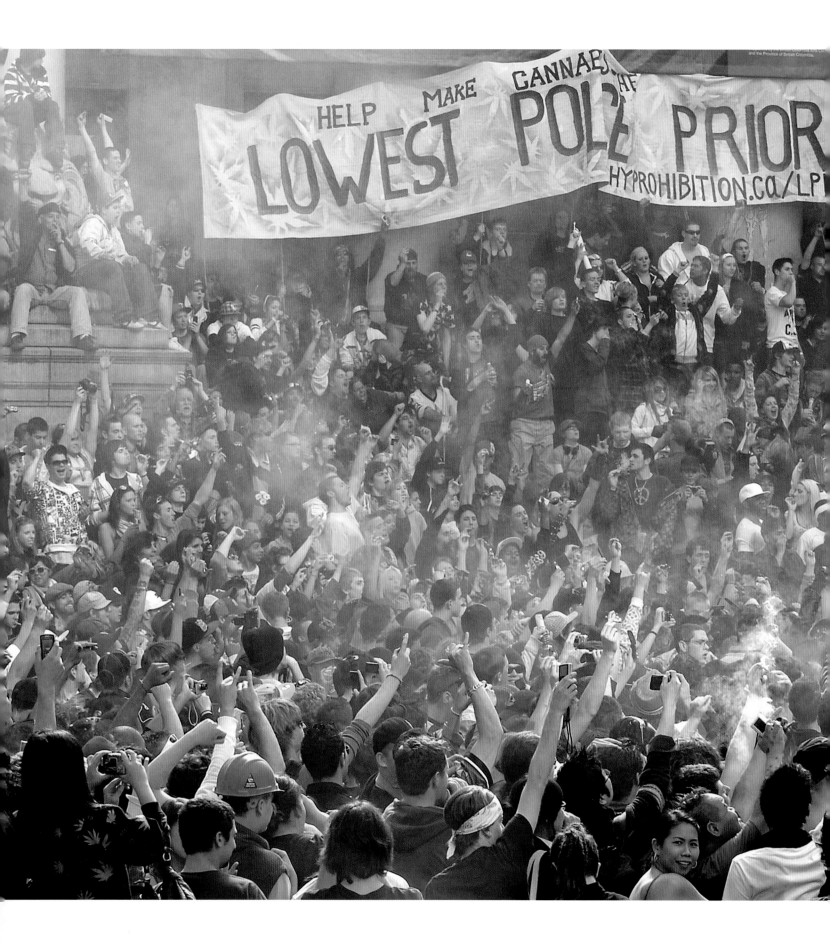

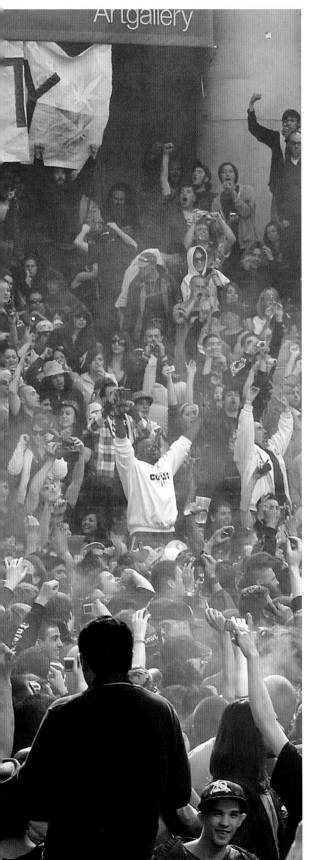

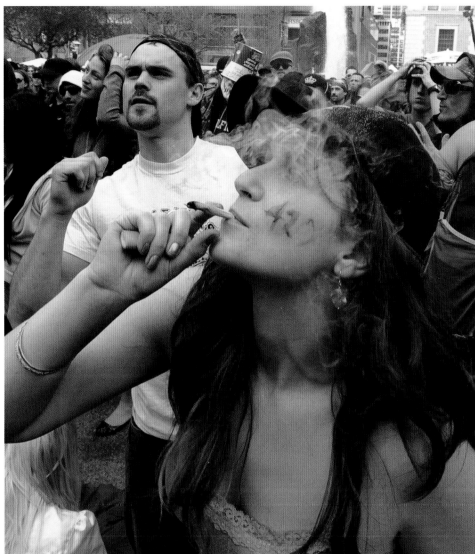

*Above:* The annual 4/20 marijuana freedom rally drew thousands of jubilant pot smokers at the Vancouver Art Gallery on April 20, 2011. **Mark van Manen/**PNG

*Facing:* Thousands of pot smokers lit up joints at 4:20 p.m. on April 20, 2009, at a smoke-in rally at the Vancouver Art Gallery. **Les Bazso/***Province*

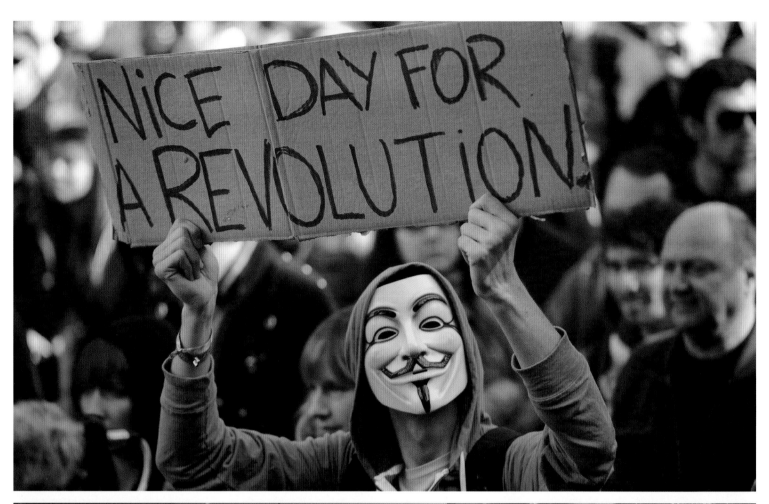

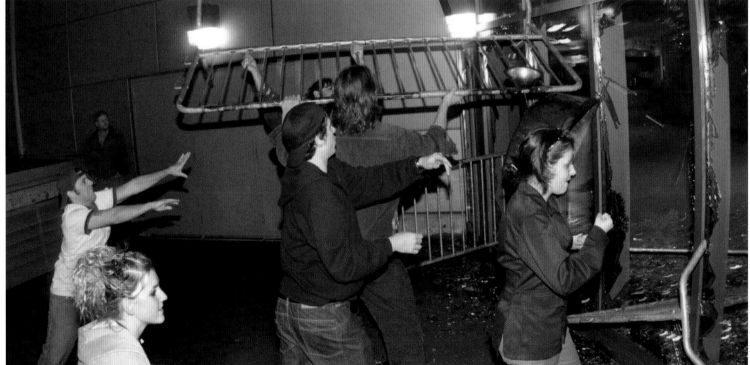

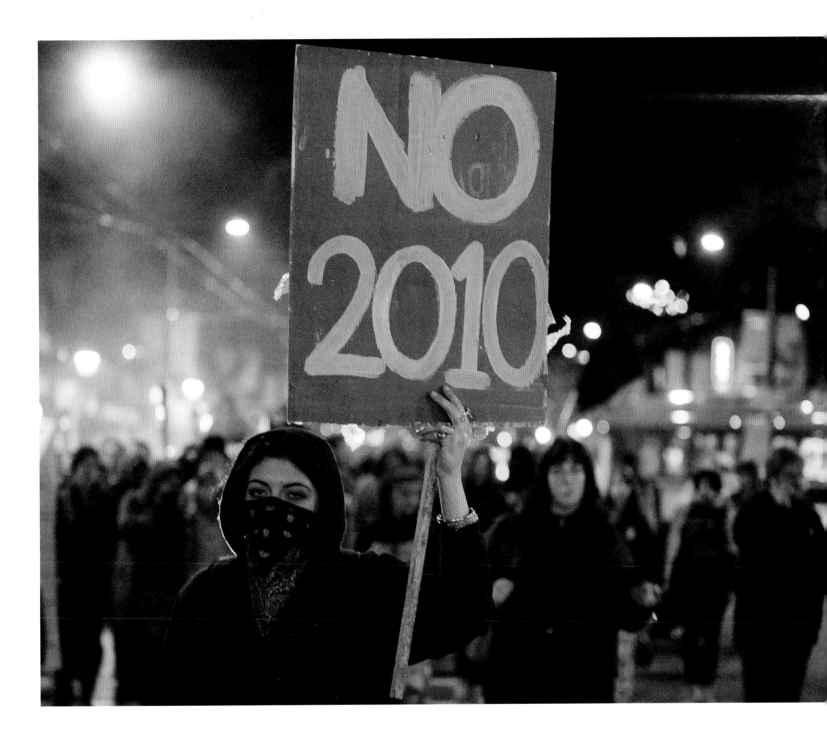

*Above:* A woman opposed to the upcoming 2010 Olympic Winter Games in Vancouver participated in a protest march on January 22, 2010, one of many demonstrations against the Games.  Stuart Davis/PNG

*Facing top:* Thousands of people filled the Vancouver Art Gallery's north plaza on October 15, 2011, part of the global Occupy movement to protest corporate greed, unemployment, and government inaction. The encampment lasted until November 21, when the city enforced its removal.  Jason Payne/PNG

*Facing bottom:* Rioters smashed windows at GM Place and threw rocks and bottles at police on November 7, 2002, after they learned that a Guns N' Roses concert was cancelled.  Arlen Redekop/*Province*

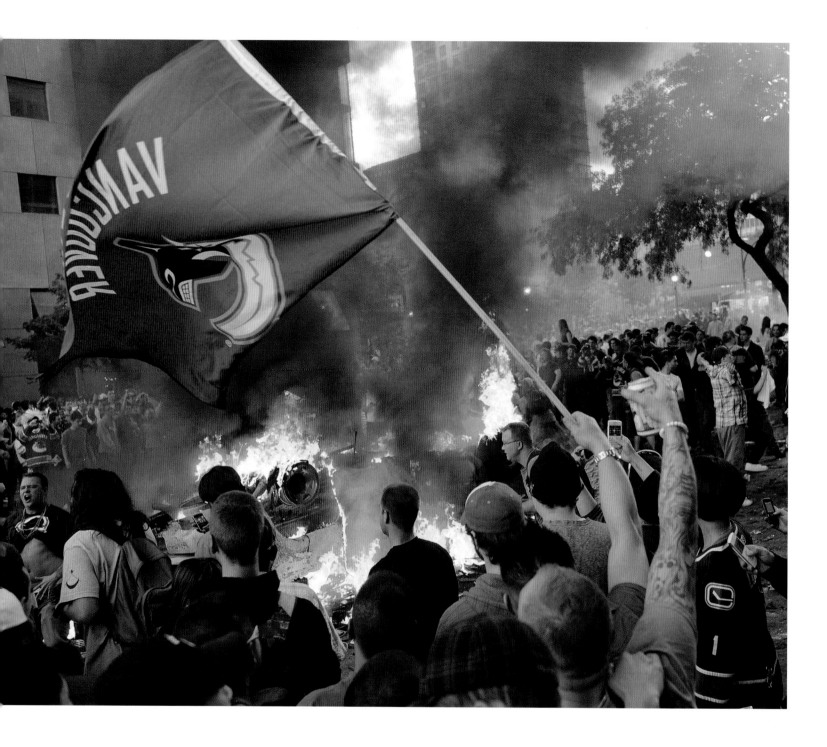

*Above:* A second Stanley Cup riot occurred after the Vancouver Canucks lost Game 7 of the Stanley Cup final against the Boston Bruins in Vancouver on June 15, 2011. Rioters smashed windows, looted businesses, and set cars on fire, including two police vehicles. **Jason Payne/ PNG**

*Facing top:* Nine hundred and twelve charges were laid against 246 adults and 54 youths, it took 500 court days to complete the trials and sentencing hearings, and prosecution of the rioters cost taxpayers almost $5 million. **Mark van Manen/PNG**

*Facing bottom:* There was an estimated $3.7 million in property damage as a result of the Stanley Cup riot on June 15, 2011. One hundred and twelve businesses and 122 vehicles were damaged, fifty-two assaults were reported against civilians, police, and emergency personnel, and one hundred people were injured. **Ian Lindsay/PNG**

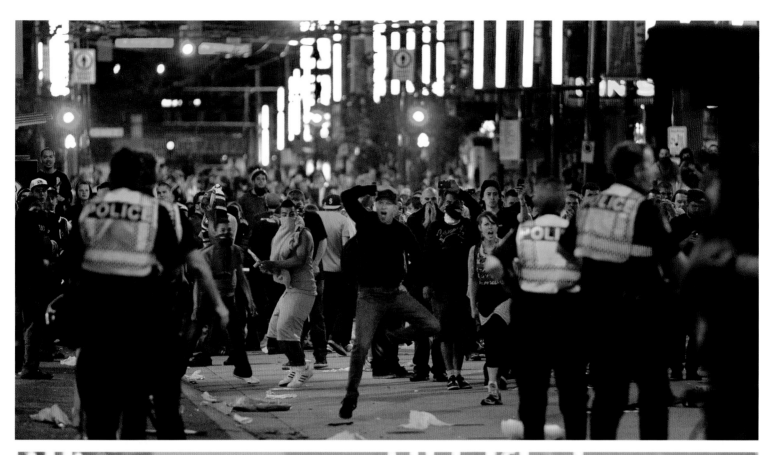
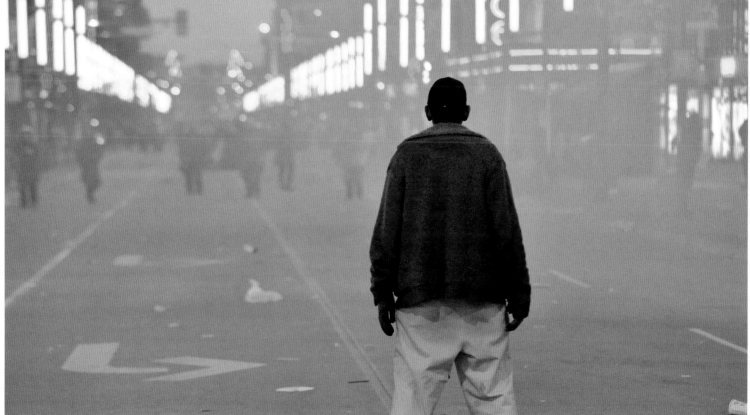

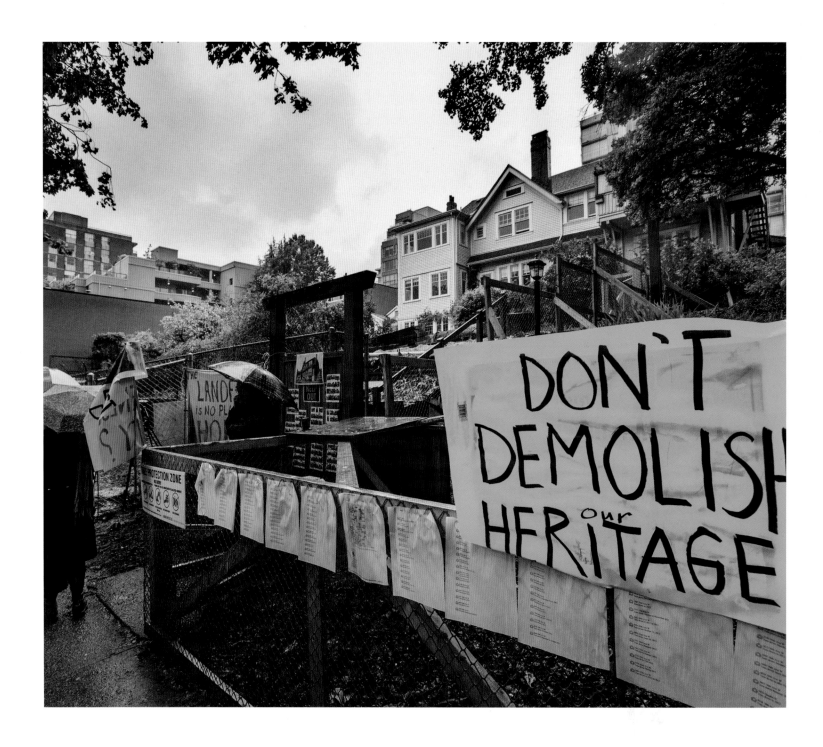

Above: Demonstrators gathered at the Legg House, built in 1899, at 1245 Harwood Street on May 25, 2014, to protest the planned demolition of one of the last heritage mansions in the West End. **Arlen Redekop/PNG**

Facing: Idle No More protesters converged on Vancouver City Hall on January 11, 2013, as part of a national day of protest to coincide with a meeting between First Nations leaders and Prime Minister Stephen Harper in Ottawa. **Jason Payne/PNG**

Overleaf: Over one hundred people turned out for the annual Naked Bike Ride through downtown Vancouver on July 27, 2007, to promote non-polluting modes of transportation. **Peter Battistoni/Vancouver Sun**

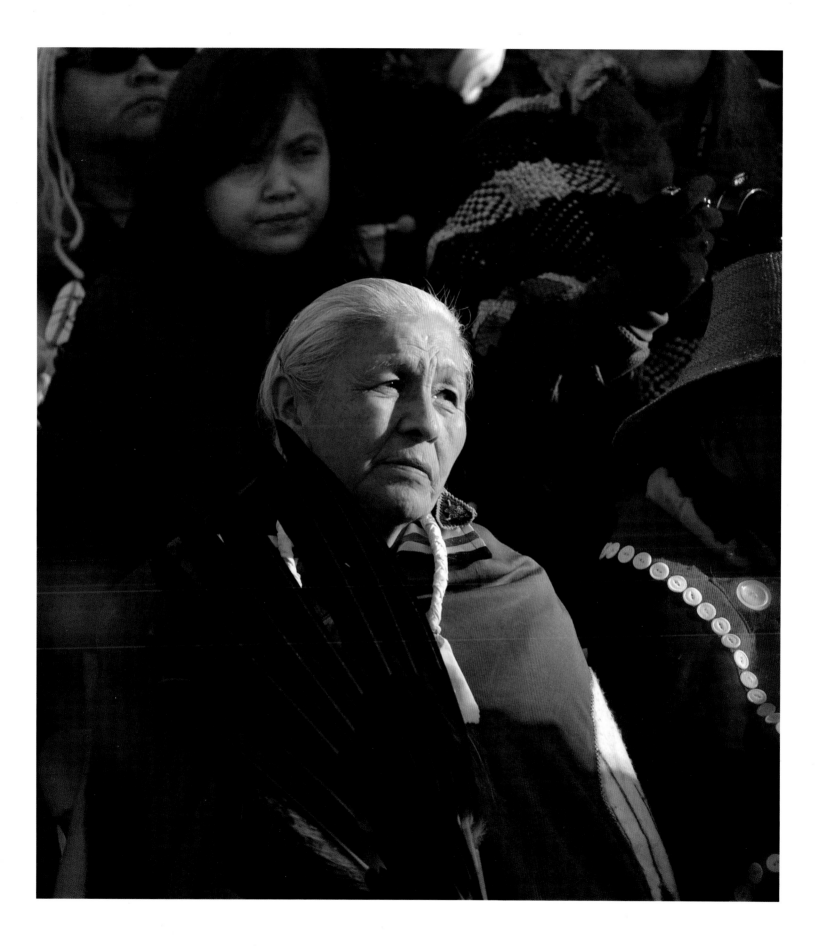

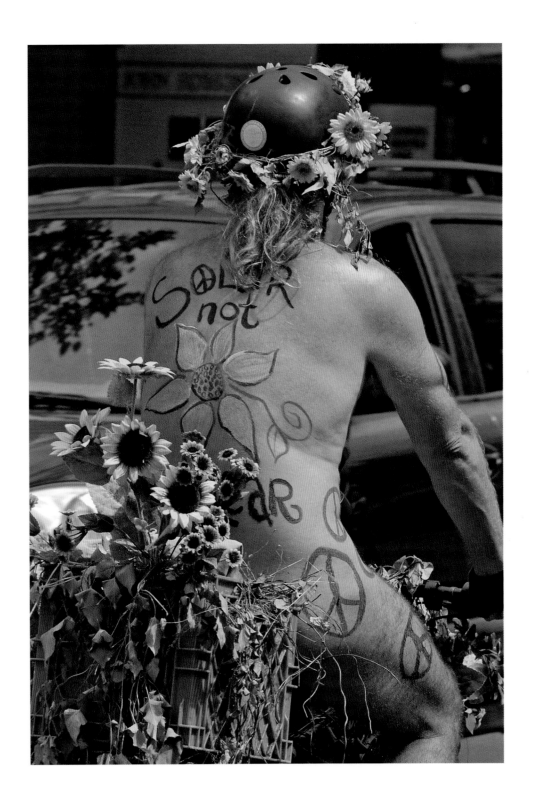